THE PARTHENON SCULPTURES

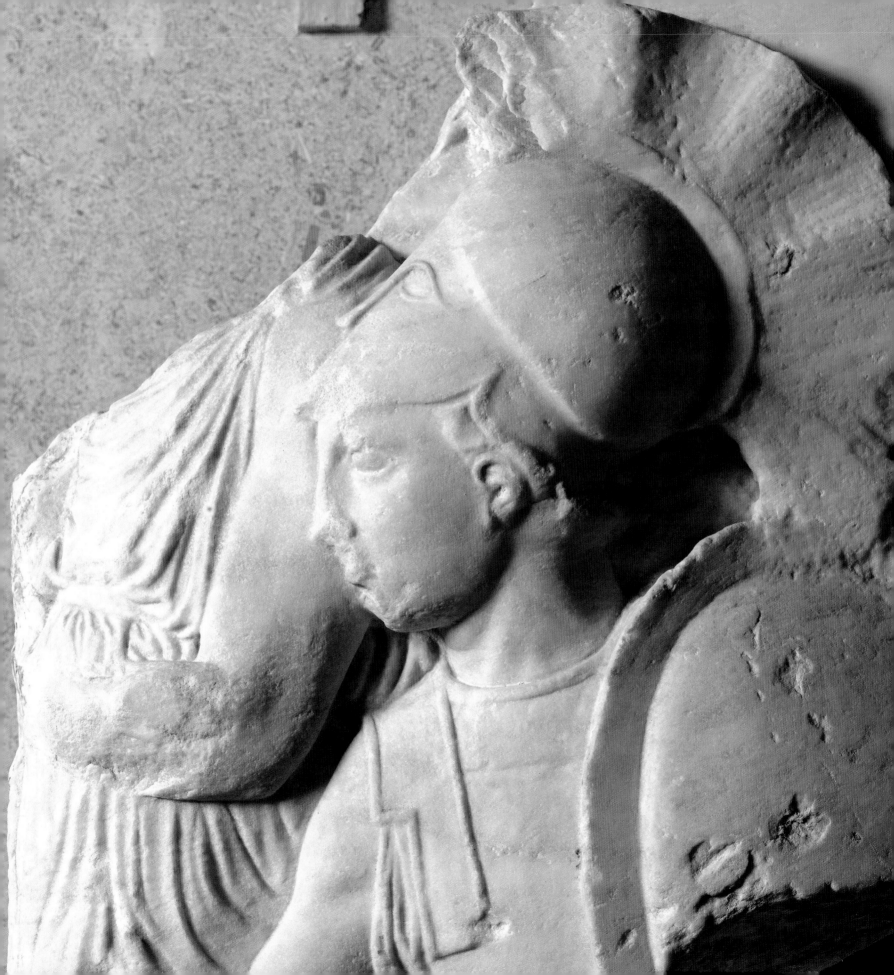

THE PARTHENON SCULPTURES

IAN JENKINS WITH PHOTOGRAPHS BY IVOR KERSLAKE AND DUDLEY HUBBARD

HARVARD UNIVERSITY PRESS
CAMBRIDGE, MASSACHUSETTS
2007

FRONTISPIECE North Frieze XXVII. Armed soldier and tunic-clad charioteer ride side by side in the chariot race of the north frieze.

PAGE 6 North Frieze XLII. The composition of the cavalcade with its layering of one horse and rider over another is especially complex in the north frieze.

PAGE 8 North Frieze XXXVIII. It is a mark of the humanism of the age in which they were carved that the riders of the frieze appear larger than they should in relation to the horses.

Ian Jenkins has asserted the right to be identified as the author of this work

First published in 2007 in the United Kingdom by The British Museum Press
A division of The British Museum Company Ltd

Library of Congress Cataloging-in-Publication Data

Jenkins, Ian.
 The Parthenon sculptures / Ian Jenkins; with photographs by Ivor Kerslake and Dudley Hubbard.
 p. cm.
 ISBN-13: 978-0-674-02692-6 (alk. paper)
 ISBN-10: 0-674-02692-6 (alk. paper)
 1. Elgin marbles. 2. Parthenon (Athens, Greece) I. Title.
 NB92.J46 2007
 733'.309385--dc22
 2007017408

Printed in China by C&C Offset Printing Co., Ltd

CONTENTS

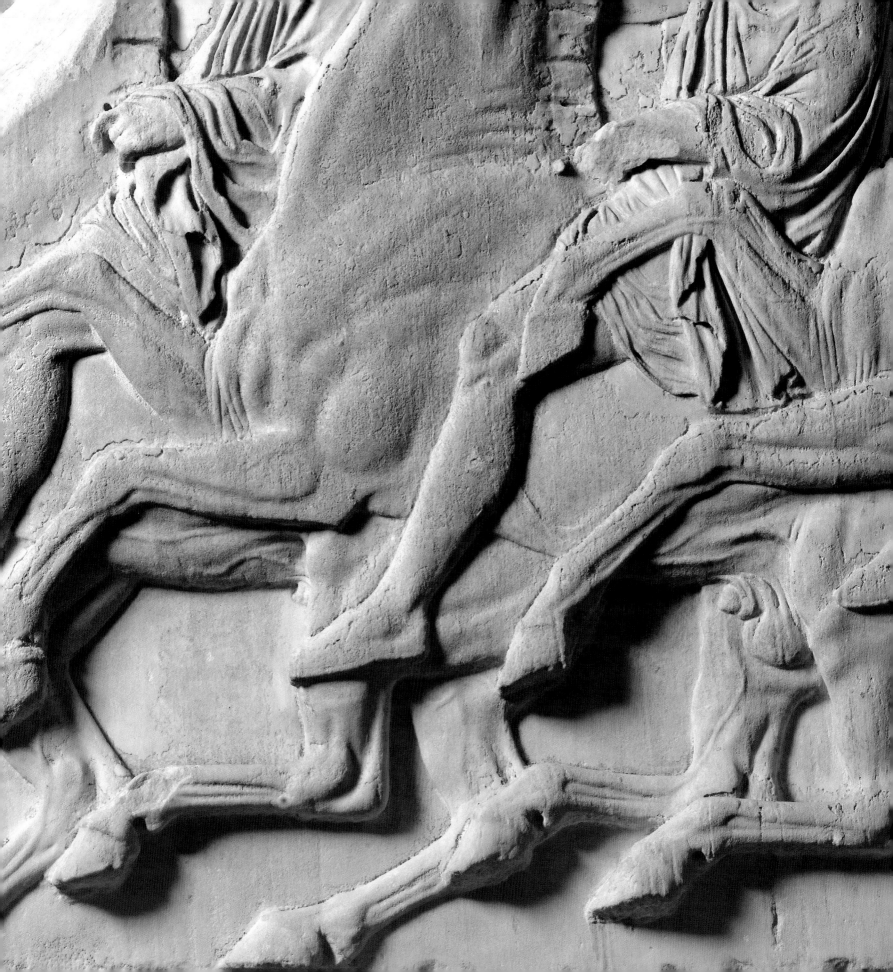

DIRECTOR'S FOREWORD

THE PARTHENON SCULPTURES IN THE BRITISH MUSEUM ARE FAMOUS THROUGHOUT THE WORLD as great works of art from Classical Greece. Carved around the middle of the fifth century BC, they are the product of a creative culture that is credited with the invention of such aspects of modern western civilization as democracy, philosophy, history, medicine, poetry and drama.

The British Museum's sculptures from the Parthenon were acquired in 1816 and, ever since, they have played a vital role in the Museum's purpose to be an encyclopaedia of knowledge and a material record of human history, ancient and modern. The global reach of the Museum's collection as a whole qualifies it, almost uniquely, to be a world museum and invests it with a responsibility to share its holdings with an international audience. The Parthenon sculptures are one of the highlights of the British Museum that bring millions of visitors to it every year from all over the world.

At the beginning of the nineteenth century, interest in ancient Greece among the leading luminaries of the European Enlightenment was at its most intense. As exemplars of ancient Greek art, the Parthenon sculptures appealed not only to Hellenists, but also to Philhellenes in their determination to bring about a Greek state, free of Ottoman rule. From their first display in London in 1807, the sculptures were destined to have modern purpose and meaning attached to them, both as evidence of human artistic achievement and as symbols of Greek culture, ancient and modern. At times these meanings have conflicted with one another, provoking debate about where the sculptures should best be displayed – in a world museum or in one dedicated to the history of Athens. The current, roughly equal, distribution of the surviving sculptures between two very different museums in London and Athens allows two complementary treatments in presentation. A third possibility of restoring the sculptures to the building itself is, on grounds of conservation and access, out of the question.

This book shows the sculptures at their best. These dramatic photographs can startle even those who think they are familiar with them into seeing the sculptures as if for the first time. It is the mark of all great works of art that we can never exhaust our fascination for them. Rather they beckon us to participate in a never-ending exercise of looking and thinking, which is rendered enjoyable as well as instructive by the images and words that follow.

Neil MacGregor
DIRECTOR

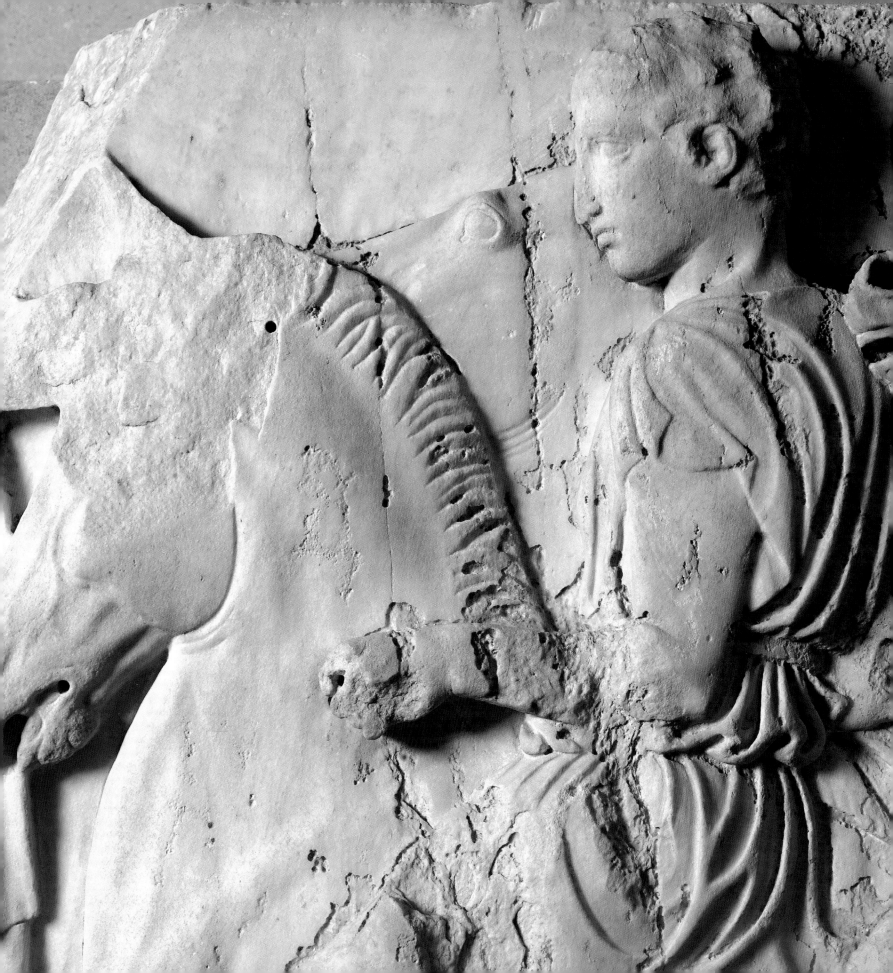

PREFACE

IN 1807, EXACTLY TWO HUNDRED YEARS AGO, THE SCULPTURES SALVAGED BY LORD ELGIN FROM the wreck of the Parthenon went on public view in London. A makeshift museum on the corner of Park Lane and Piccadilly became a meeting place where artists and connoisseurs gathered and gazed in wonder at the sculptures displayed at eye level and available for close study in a way that had not been possible since they were installed on the Parthenon two and a half millennia earlier. The thrill that many experienced then and since on seeing the Parthenon sculptures for the first time is captured in Dudley Hubbard's and Ivor Kerslake's beautiful photography for this book. These striking images remind us that, for all the notoriety of the Elgin Marbles as objects of disputed cultural property, they remain deservedly famous as great works of art. Displayed, moreover, in the British Museum, where many cultures are gathered but none is privileged, and where many faiths are represented but none is preached, the sculptures serve as bearers of many meanings for a world audience and participate in the telling of a world history of human civilization.

This picture book does not aim at an archaeological reconstruction of the now scattered remains of the sculptures of the Parthenon. Other books perform this function, some of which are listed here under Further Reading, along with my own *Parthenon Frieze* (1994). In order, however, to explain how the sculptures came to be where they are, and in the condition they are in, an accompanying essay traces the long and complex history of the Parthenon up to the present day. During that time the temple has been shaken by earthquake, ravaged by fire, exploited as a vehicle for propaganda, turned into a church and then a mosque, bombarded, blown up, quarried for building materials and subjected to restoration, both bad and good. The current excellent restoration programme of all the Acropolis monuments aims gradually to bring down from the Parthenon all the weathered sculpture that remained on the building after Elgin's time and thus will complete a rescue operation begun over two hundred years ago by Lord Elgin.

This book is the original idea of Laura Lappin, senior editor at the British Museum Press. It has been seen into print by her colleague Felicity Maunder. Katherine Wilson greatly assisted in the production of the text, which has been read and improved by Andrew Burnett, Dyfri Williams, Jonathan Williams and Susan Woodford. Photography was assisted by Niki Kampanou.

Ian Jenkins
SPRING 2007

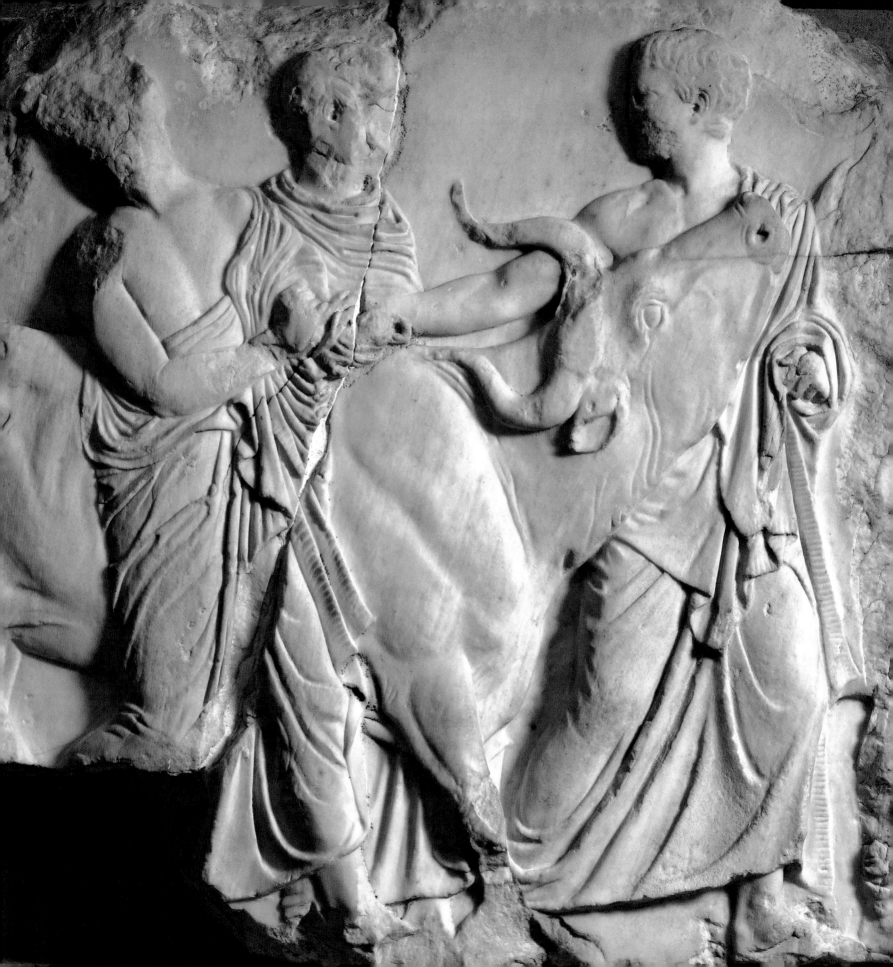

THE PARTHENON AND ITS SCULPTURES

THE BREATHING VITALITY OF THE PARTHENON SCULPTURES SHOWS THROUGH THE VEIL OF LOSS and damage that they have suffered since they were first carved 2,500 years ago. Human and animal form alike is represented with startling realism, and every detail seems closely observed from a living model. The Parthenon sculptures are not stylized like those of the earlier temple of Zeus at Olympia and they lack the slick perfection of the later Altar of Zeus at Pergamon. Instead in the sculptures of the Parthenon there is a youthful and refreshing exuberance. It is as though the beauty of the world has been discovered and represented for the first time. Not only are they great works of art to look at, but they instruct us in the very art of looking.

It is a mark of their supreme humanism that, wherever in the world we come from and whatever our own culture may be, we can always find ourselves, so to speak, in the Parthenon sculptures. Masai youths pictured under an African sky, restraining a bolting cow, call to mind the cattle drove of the frieze, while huntsmen meeting in the morning chill of an English winter resemble the mustering of the frieze's cavalcade (figs 1–4). The realism of the Parthenon sculptures is more than a record of fifth-century BC Athenians and their anthropomorphic gods. Human figures in the frieze are more than mere portraits of the Athenian people of the day. Rather they represent a timeless humanity, one which transcends the present to encompass a universal vision of an ideal society. In his *Ode on a Grecian Urn*, the only truly great work of art in the modern era to have been inspired by the Parthenon sculptures, the romantic poet John Keats intuitively captured the frieze's wistful and melancholy longing for the immortality of time stood still:

FIGURE 1 *left* Scene from the cattle drove of the Parthenon frieze. South Frieze XLIV, *British Museum*.

FIGURE 2 *below* Masai youths restrain a bolting cow.

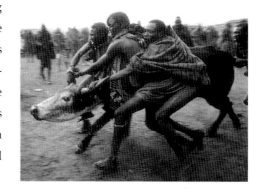

When old age shall this generation waste,
Thou shalt remain, in midst of other woe

Although not immortal like their undying gods, the people of ancient Athens regarded themselves as descended from an indigenous folk, sprung from the native soil of Attica. In a focus upon the intrinsic merits of the Parthenon and its sculptures alone, there is always a danger of regarding these great works as similarly earth-born and not as the fruit of many harvests that they are, harvests gathered in the earlier Greek world and from other early civilizations with which the Greeks came into contact. Set down in the midst of other cultures in the British Museum, the sculptures of the Parthenon are one episode in a greater story of human achievement in art and architecture. That story may, for example, invite a comparison between the Panathenaic procession of the Parthenon frieze and the procession of offerings brought before seated dignitaries on the Standard of Ur (fig. 5), made in Sumerian Mesopotamia around 2,600 BC. Such comparison may, as here, bring out similarity between two works or it may emphasize difference. Often the contrast of opposites helps to define the objects being compared: we see what a thing really is by seeing what it is not. The humanity of the gods of the Parthenon sculptures is all the more striking when compared, for example, with the extraordinary zoomorphism of Egyptian deities. And the brutal reportage of Assyrian palace-reliefs places their scenes of war atrocities, so depressingly reminiscent of recent events in Iraq (fig. 6), in stark contrast to the tranquil idyll of the Parthenon frieze. When violence does erupt in the Parthenon metopes, we are spared the pain of witnessing actual events by the setting of conflict in a mythical time and place.

FIGURE 3 *below left* Huntsmen meet at an English manor house.

FIGURE 4 *below right* Horsemen preparing for the cavalcade of the Parthenon frieze. Plaster cast in the British Museum of West Frieze XII.

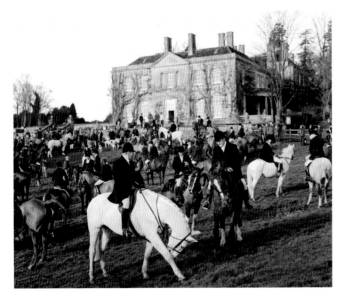

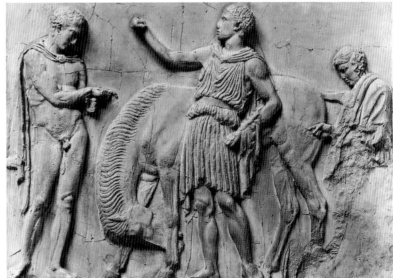

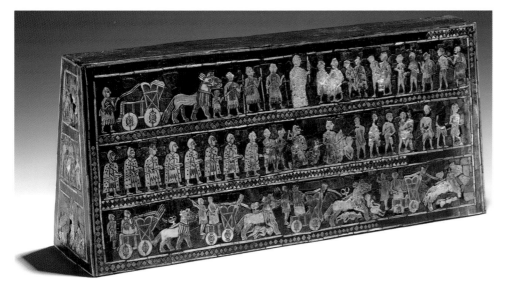

FIGURE 5 Offerings are carried and animal victims led in procession towards a seated group of human dignitaries or perhaps gods. This mysterious object was excavated in the Sumerian Royal Cemetery of Ur in southern Iraq and dates to around 2600–2400 BC. The whole scene, depicted in a mosaic of red limestone, shell and lapis lazuli on wood, calls to mind the procession of the Parthenon frieze, carved two thousand years later. *British Museum.*

In the British Museum it is possible not only to look over the shoulder of fifth-century BC Athens to see what went before, but also to look forward at what followed. The golden age of Athens was brought to an end by defeat in the Peloponnesian War, fought with her arch-rival, Sparta. Following Athens' final capitulation in 404 BC, the city's building industry collapsed. Masons and sculptors were forced to cross the Aegean Sea and seek work with the rulers of kingdoms on the west coast of what is now Turkey. We see their legacy in the Greek temple-like tomb built around 390–380 BC for the Lycian dynast Erbinna, which is now known as the Nereid Monument. It is named after its statues of Nereids (fig. 8), daughters of the sea-god Nereus, which are so reminiscent of the Iris of the west pediment of the Parthenon.

THE PARTHENON AND ITS SCULPTURES AS BEARERS OF MEANING

Some buildings in the world are instantly recognizable. They include such ancient and modern wonders as Stonehenge, the Taj Mahal and Sydney Opera House. Such is their fame that it can travel without knowledge of what makes them deserving of renown and, to many people, they may be famous simply for being famous. Why, it may be asked, is the Parthenon, a 2,500-year-old ruin at the heart of a modern European city, held in such high regard (fig. 7)? Ask that question on the streets of Athens and the answer is likely to be that the Parthenon, and the Acropolis on which it stands, are cultural symbols of European democracy and of the modern Greek state. This national sentiment embraces not only the temple and its setting but also the detached sculptures of the Parthenon, especially those acquired at the beginning of the nineteenth century by Lord Elgin, which are now in the British Museum.

FIGURE 6 Assyrian torture: prisoners taken by Sennacherib's siege of Lachish in 701 BC are stretched out for flaying alive. This kind of documentary cruelty was avoided in Greek temple sculpture. Acts of violence, when they do appear in Greek art, tend to occur in mythological subjects. Alabaster panel from the South-West Palace at Nineveh, northern Iraq, carved around 700–681 BC. *British Museum.*

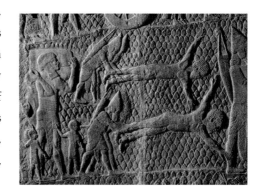

FIGURE 7 The ever-changing Parthenon after 2,500 years is changing still. In its long history it has been subjected to earthquake, fire and vandalism, converted into a church and then a mosque, bombarded, blown up, quarried for building material and undergone restoration both bad and now good.

FIGURE 8 Sea-nymph from the Nereid Monument. The flimsy drapery moulding itself to this Nereid's body and flying out at the sides to flap free in the wind calls to mind the figure of Iris from the west pediment of the Parthenon (see p. 67). *British Museum.*

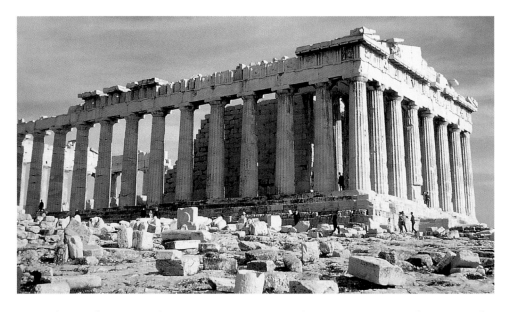

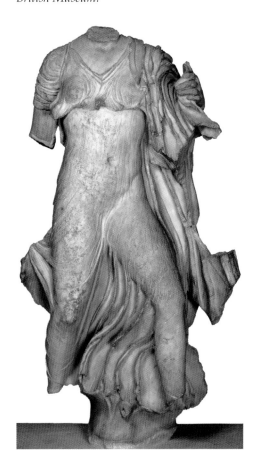

For those who do not, however, subscribe to such national symbols, how does the Parthenon deserve its fame? The answer to this question for many has been that the temple and its sculptures transcend national boundaries and epitomize universal and enduring values of excellence. Since modern interest in the Parthenon began in the European Enlightenment of the eighteenth century, generations of admirers have marvelled at its exceptional degree of craftsmanship. Its sculpture, moreover, has at times attracted such veneration as to take on a political and moral value. Not only has it been seen as beautiful, but also emblematic of freethinking, right-doing society itself. The frieze especially, with its assembly of god-like human beings and human-like gods, has often seemed to modern observers eloquently to evoke the encomium of Athenian civic life set out in the Funeral Speech of Perikles, under whose political premiership the Parthenon was built. In 431 BC Athens was at war with her rival Greek state Sparta. There were Athenian casualties from a recent engagement and, in the historian Thucydides' account, Perikles delivered an oration at the public burial rites of these war heroes. Taking an opportunity to praise not only the dead but also their city, Perikles contrasted the openness and moderation of his fellow Athenians with the militaristic and secretive character of the Spartans.

From the constitution drafted by the founding fathers of the American democratic republic to the war-time speeches of Winston Churchill, many have found inspiration for their brand of liberal humanism, and for a doctrine of the open society, in the Funeral Speech of Perikles. Citizens of free societies everywhere have been knowing, or even unknowing, stakeholders in the legacy of ancient Greece. 'We are all Greeks', wrote the English romantic poet Percy Bysshe Shelley in the preface to *Hellas*, his great hymn to

the cause of Greek independence from Ottoman rule, published in 1821. Shelley's Hellenism was not only to be identified with the making of a modern Greek state, but was also a prescription for the moral condition of human society everywhere and of civilization itself. After the French Revolution the cry of liberty resounded dangerously for monarchies throughout Europe, and for some radicals ancient Greek art born of ancient Greek democracy came pictorially to represent the youthful spirit of political freedom. When, therefore, in 1807 the sculptures acquired from the Parthenon by Lord Elgin first went on public display in London, they became objects charged with new meaning for those who placed them at the centre of a debate over the value of art in society. The renegade historical painter Benjamin Robert Haydon (fig. 9) and the political thinker and pamphleteer William Hazlitt hailed them as a new school of art, one that would challenge the established schools of the Royal Academy, where drawing was taught through copying a narrow repertory of plaster casts after Roman sculpture, many of which were themselves copies of earlier, lost Greek originals. They included such world-famous pieces as the Apollo Belvedere and the Medici Venus. These paradigms of what was deemed good taste in ancient statuary were normally to be found, respectively, in the Vatican at Rome and the Uffizi at Florence. Only recently, however, they had been plundered by Napoleon and installed in his great new public museum at the Palais du Louvre in Paris. With the French bragging of their Trophy of Conquest and of

FIGURE 9 *The horse of Selene,* by Benjamin Robert Haydon. Black and white chalk, 1809. Haydon was thrilled by his first encounter with the sculptures and hailed them as a 'new school' of art for students. His own drawings of the sculptures capture their lifelike drama and can now inform our own visual appreciation and understanding of them. *British Museum.*

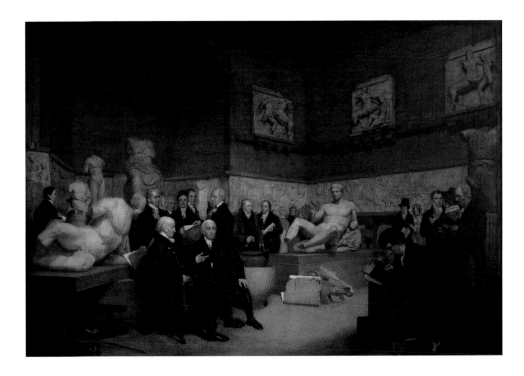

FIGURE 10 *The Temporary Elgin Room*, by Archibald Archer. Oil on canvas, 1819. Benjamin Robert Haydon is probably the solitary figure sketching on the extreme left, behind the river god from the west pediment. Seated in front of the same sculpture are (left) the painter Benjamin West, President of the Royal Academy, and (right) Joseph Planta, Principal Librarian (Director) of the Museum. *British Museum.*

transforming Paris into a new Rome, Britain was to see in the sculptures of the Parthenon a timely opportunity to adopt not the mantle of imperial Rome, but rather that of ancient democratic Athens. The defeat of Napoleon in 1815 at the battle of Waterloo came to be hailed as Britain's battle of Marathon, where in 490 BC ancient Athens had triumphed over the tyrant Darius and his Persian army of invasion.

Against a background of British post-war patriotism and a new-found sense of self as liberator of Europe, a Parliamentary select committee sat in 1816 to investigate the prospect of acquiring Lord Elgin's Athenian Marbles for the nation. Leading artistic luminaries of the day – sculptors, painters, collectors, connoisseurs and critics – were interrogated and their opinions were recorded in a remarkable report. Lord Elgin himself gave evidence in response to questions about his conduct and motives. His actions were found to be ethical and the Marbles were vested in the Trustees of the British Museum, acquired with money voted by Parliament. They went on show at the British Museum in a temporary makeshift gallery that opened to the public in 1817 (fig. 10).

From the time of their first arrival in London until the present day, these sculptures of the Parthenon have been objects of exceptional fascination. Even those, moreover, who revile his actions must admit that Lord Elgin's acquisition of them is now an irreversible part of their history and, indeed, has to a large extent made them what they are. The assertion 'no Elgin no Marbles' is true not only in the material sense – many of the sculptures simply would not have survived had not his agents acted as they did – but also because

the way we now think of the sculptures is inextricably bound up with his removal of them from the building. On the Parthenon the sculptures had gone largely unremarked. At best they were treated as objects of antiquarian curiosity, while at worst they were defaced as victims of religious prejudice, blown up as casualties of war or quarried as building material. Removed from their original setting and exhibited at eye level, in close proximity to the spectator, the sculptures were transformed from architectural ornament into objects of art. This art, moreover, was from the school of Pheidias, whom antiquity itself praised as the greatest of all ancient sculptors. The Elgin Room of the British Museum in the nineteenth century came to be compared with the sculptor's workshop where, in Pheidias' own day, according to Perikles' biographer Plutarch, the inner circle of Perikles' society was escorted by the great man himself to see work in progress. So in the British Museum to see the sculpture at close quarters was to be translated back in time to ancient Greece:

> Make the sculptures of Pheidias your personal friends, live with them, commune with them, become acquainted with every fold in the drapery, every change in the curve of the muscles . . .

Thus Charles – later Sir Charles – Newton, an assistant in the Department of Antiquities at the British Museum lecturing to the Oxford Art Society in 1849, spoke with the enthusiasm of an evangelist seeking converts. For Newton, as for generations of connoisseurs of antiquity throughout the nineteenth century, the Parthenon sculptures were quite simply the greatest artworks known to man.

Where idealistic Victorians such as Newton had dealt confidently in absolute values, the twentieth century was to be more circumspect. Old certainties had been shattered in the cataclysm of the Great War and, in a new era of cultural relativism, there was less inclination to privilege Greek art above that of other civilizations. Instead each came to be judged on its own terms, and art previously dismissed as 'primitive' and excluded from western art histories took on new value and meaning. Prehistoric idols and African masks, previously discounted for their perceived lack of representational correctness, were now admired precisely because they appeared to eschew realism and thus provided inspiration for a new conceptual movement of modern art (fig. 11). The Parthenon sculptures continued to be valued as one of the great treasures of the world, but no longer were they *the* treasure. They had not gone down in people's estimation, but rather everything that once had been located below them in a hierarchy of taste came up.

The British Museum itself was well placed to accommodate this shift, for it had always been a collection of world cultures where the art of one civilization could be studied for itself or compared and contrasted with that of other cultures, ancient and

modern. Charles Newton, the Hellenist whose advocacy of the sculptures was pressed with such conviction, was no less a champion of the universal view of history by which 'a museum of antiquities, not of one people or period only, but of all races and of all time, exhibits a vast comparative scheme of the material productions of man'. This idea of the British Museum as a comparative assemblage of human experience and understanding is very much alive today and is rooted in the Museum's Enlightenment origins as an encyclopaedia of world knowledge (fig. 12). The cosmopolitanism of the something-for-everyone museum is predicated on a pluralist idea of history where the making and understanding of one culture informs and is informed by knowledge of others, and complements the kind of national museum that is able to exhibit its own culture only.

THE PARTHENON IN ANTIQUITY

It is ironic to reflect upon the fact that the exceptional place the Parthenon and its sculptures have held in the modern imagination is nowhere found in antiquity itself. In Greek and Latin literature, for example, there is hardly a mention of the temple and such as there is comes chiefly from the Roman period with the brief notes on the building and its sculptures that Pausanias included in his travel guide to Greece. Even then the Parthenon is not singled out as being especially noteworthy, but is treated as just one of the catalogue of monuments that Pausanias visited on the Athenian Acropolis.

FIGURE 11 Satirical drawing by E.T. Reed (1860–1933). Black chalk, c. 1920–30. The political cartoonist Reed makes fun of the contemporary taste for so-called primitive art by showing how the east pediment of the Parthenon (above Ionic columns!) would have looked had it been designed by the sculptor Jacob Epstein. The quotation is from P.G. Konody, an art critic of the day: 'Now, if Mr Epstein had designed the Parthenon Frieze, we might have had something "with a logic and significance of its own, and an abstract beauty based on instinctive feeling for rhythmically related shapes and planes . . ." (Thank you Mr Konody!).'

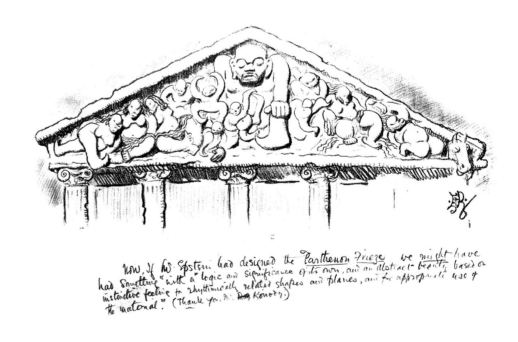

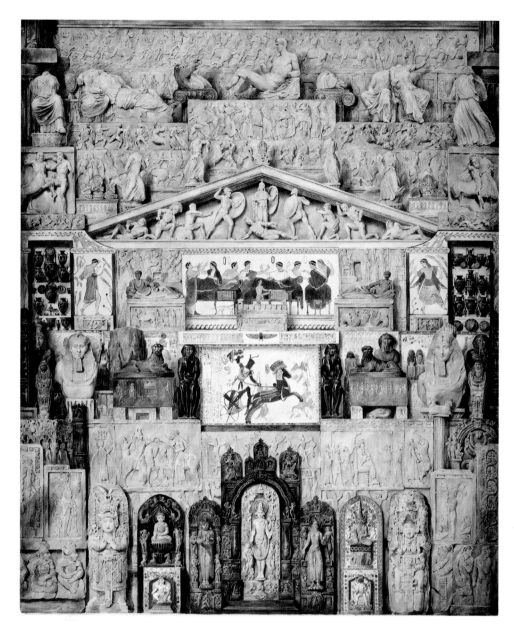

FIGURE 12 The rise and progress of ancient civilization as conceived by the imaginative nineteenth-century water-colourist James Stephanoff. The arts of antiquity are piled one on another: from the bottom up we see Indian, Javanese and Central American sculpture, Achaemenid Persian palace reliefs, Egyptian sculpture and wall painting, Etruscan sculpture, tomb and vase-painting, the archaic Greek pediment from Aegina, all crowned by various Classical Greek architectural sculptures culminating in the sculpture of the Parthenon. Exhibited 1845.
British Museum.

Furthermore it was not the Parthenon so much as the colossal gold and ivory statue of the goddess Athena he found inside the temple that really interested Pausanias. In his biography of Perikles, also written in the Roman era, Plutarch does provide the modern reader with the sort of hyperbole often associated with the Parthenon today. The art and architecture of Perikles' Athens, we are told, uniquely combined venerability with the appearance of retaining a perpetual bloom of youth. This is a general statement, however, about the work of the golden age of Athens, and Plutarch does not here make specific reference to the Parthenon.

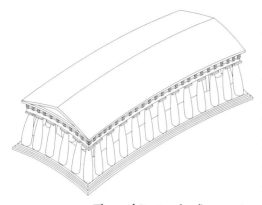

FIGURE 13 The architectural refinements of a Doric temple greatly exaggerated.

FIGURE 14 Cut-away drawing to show the Parthenon's three kinds of external sculpture.

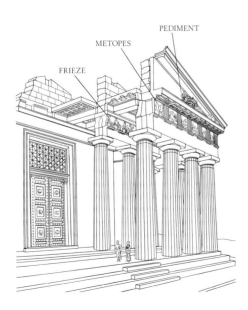

A treatise about the Parthenon was written by Iktinos, one of its architects, and a certain Karpion. Ever since the early sixth century BC, when the first colossal Greek temples were erected on Samos in the eastern Aegean Sea and at Ephesos on the coast of what is now western Turkey, architects had written technical descriptions of their work. Not one of these tracts survives. We catch glimpses of some of them from Vitruvius' quotations in his own architectural treatise, but we can only guess at the content of the text about the Parthenon. There must have been mention of the geometric proportions of the temple and, in particular, the 9:4 ratio in its design. On the short ends of the building this is to be found, for example, in the width in relation to the height, measured from floor to cornice. Iktinos and Karpion may also have explained features that are today referred to as the architectural refinements. These are of a kind that occurs in other Greek temples, but not so subtly and consistently, and the Parthenon is rightly famous for them. They include, in both the width and length of the building, the upward curving of horizontal lines, worked in at foundation level and carried up through each course of masonry (fig. 13). To this distinctive feature may be added the fact that vertical walls and columns are made to lean inwards, so much so that if the columns of the long sides were extended they would meet two kilometres above the temple floor. These and other refinements determined that virtually no two stones in the construction of the Parthenon are ever the same. The cutting and jointing of the stone, moreover, is finer than a pencil can draw, finer even than a human hair and of such fineness that, compressed by the weight from above, some lower courses of masonry have fused with their neighbours.

Fascinating as they may be now, such features of design and workmanship were probably not especially noticed by the townspeople of Athens and those who visited the city during and after the building of the Parthenon. They will, however, have been struck by the size of the temple, the largest of its day in mainland Greece, and by the lavish use of white marble, which extended even to the roof tiles. Particularly striking will have been the quality and quantity of the marble sculpture that added greatly to the external opulence and interest of the building (fig. 14). Most notable were the two great compositions of freestanding sculpture in the two gables (pediments) at either end showing, in the east, the birth of Athena and, in the west, her contest with the sea-god Poseidon for the right to preside over Athens and the surrounding countryside. Then there were the ninety-two panels (metopes) with scenes of mythical battle carved in exceptionally high relief and incorporated into the entablature above the colonnades on all four sides. Furthermore, within the columns and high up on the exterior walls of the Parthenon on its long sides and over the porch columns on the short sides, there ran a continuous 160-metre-long frieze carved in low relief. It must have intrigued the Athenians to see themselves in this frieze, idealized as participants in a festival procession received by the gods of Olympos.

More even than this marble sculpture, however, it was the awesome statue of Athena Parthenos (maiden) standing within the temple that grabbed the attention of visitors, as indeed it did that of Pausanias (fig. 15). Constructed by Pheidias from sheets of gold and ivory veneer over a wooden armature, the statue together with its base stood some twelve metres high. And yet, wonder as it was to behold, it was not this work that was considered Pheidias' greatest achievement, but rather the colossal Zeus that he made, again in gold and ivory, for the god's temple at the panhellenic sanctuary at Olympia. This seated statue, not the standing Parthenos, would be listed as one of the Seven Wonders of the ancient world.

Grand and imposing as it was in its setting on the Acropolis, the Parthenon was never very famous in antiquity, unlike the much larger temple of Artemis at Ephesos. In the centuries after it was put up, the Parthenon attracted less attention for itself than it did for being placed at the heart of a world city. Athens' prominence as an imperial power in the fifth century BC was short-lived. Her glory days, especially as gallant victor over the Persians at Marathon in 490 BC, had, however, won her eternal celebrity and later the city was to become a university- and museum-town to which Hellenistic kings from far-flung regions of the wider Greek world would send their sons to be educated. The Romans too, when they became the dominant power in the Mediterranean, regarded Athens as the centre of the Greek culture that they so admired. 'There is no end to it in this city, wherever we walk, we set foot upon some history', wrote the Roman republican orator and statesman Cicero to his friend Marcus. In the poetry of Propertius, Roman infatuation with Athens is treated like a love affair, the pain of which will not subside until the longing has been satisfied:

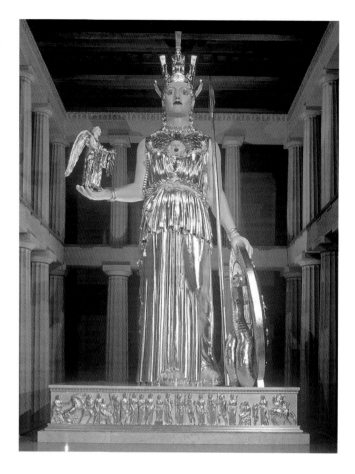

FIGURE 15 Athena Parthenos in gilded plaster. Full-scale replica by Alan LeQuire, *Nashville Parthenon, Tennessee.*

> To break this hard passion
> I must make the great journey
> Take the long road
> To erudite Athens

In this legendary city the Parthenon had become a vehicle for advertising the deeds of famous men. In the later fourth century BC Alexander the Great hung shields taken in battle like a trophy on the exterior of the temple. In the late third and early second centuries the Attalids of Pergamon, one of the kingdoms carved out of Alexander's short-lived empire, commemorated victory over the Gauls by erecting a number of

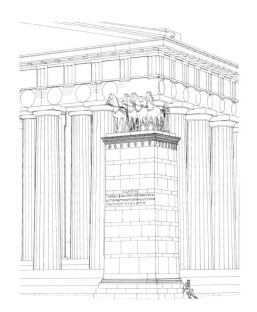

FIGURE 16 Reconstruction by Manolis Korres of a commemorative monument set up hard by the north-east corner of the Parthenon for one of the Attalid rulers of Pergamon.

monuments on the Acropolis, including a chariot group on a high pedestal constructed hard up against the north-east corner of the Parthenon (fig. 16). Around 20/19 BC Octavian, later the Roman Emperor Augustus, a master at the art of self-promotion, deemed the Parthenon sufficiently important to obstruct the view of the east front with a round temple dedicated to his deified self and the goddess Roma, commemorating his victory over the Parthians. Alexander's victories over the Persians and other peoples of the east, the Attalids' over the Gauls, Augustus' conquest of the Parthians were all, through their respective interventions on or around the Parthenon, deliberately linked to the legendary victories of the Athenians over the Persians. They could, moreover, be associated with the triumph of cosmic reason over primeval chaos as represented in the battle between Olympian gods and giants shown in the east metopes of the Parthenon. Thus the Parthenon, itself a commemoration of Athenian valour, acted as a platform for trumpeting the triumphs of Athens' admirers.

One Roman whose name was literally attached to the Parthenon was Nero (AD 54–68), that much defamed emperor of the Julio-Claudian dynasty, who in AD 61/2 was honoured by an inscription fixed to the Parthenon in 251 large bronze letters. The actual letters long gone, the message can be deciphered in the fixing holes peppering the architrave of the east façade. More deserving of such self-congratulation was the Emperor Hadrian, whose interest in and promotion of Greek culture rendered his reign (AD 117–138) something of a renaissance for Greek cities of the Roman empire. His statue, we are told by Pausanias, was set next to that of Athena Parthenos in the Parthenon.

The statue of the Parthenos was not by Hadrian's day exactly as Pheidias had made it. The plates of gold that formed much of its surface were detachable bullion and had been carefully weighed and inventoried by officials of the litigious democracy that had first sanctioned this use of state funds. Hardly was the statue completed than Pheidias was obliged to contest a charge of embezzlement by having the plates of gold removed and weighed again. Worse was to come, however, for in 295 BC the tyrant Lachares, finding himself bankrupt, once more stripped the statue and, indeed, others in and around the temple of their gold and cashed in the value. The ivory, we may presume, survived but, by the time Pausanias saw the statue in the second century AD, the gold must have been replaced with gilded copper. A century or more later, all will have been lost in the fire that ripped through the Parthenon, destroying the interior and bringing down the roof. The original two-tier interior colonnade that once framed the Parthenos was weakened beyond repair. It is not known precisely when this fire struck – some time in the third century AD seems likely – nor when the interior was restored, but the restoration seems to have taken place before the eventual conversion of the temple into a church around AD 500–600.

THE CHURCH OF OUR LADY OF ATHENS

The arrival of Christianity saw many pagan temples converted into churches. Such re-use was, on the whole, good for the Parthenon in ensuring its survival as a living building. The early Christian community of Athens, however, was not kind to the external sculptures of the Parthenon and set about systematically destroying them. The metopes of the north, east and west sides had their carvings chiselled away. Only one at the north-west angle was spared, probably because its subject of a goddess in flowing robes standing before a seated woman was taken for a representation of the Annunciation (fig. 17). This iconoclasm seems to have been interrupted before the zealots could reach the metopes of the south side, which were spared destruction at this time (fig. 18). Equally the frieze and west pediment sculptures were largely untouched. The figures in the angles of the east pediment were also spared. Those at the centre, however, showing the moment immediately after the birth of Athena from the head of her father, Zeus, were perhaps destroyed already in the fire that wrecked the interior of the temple, probably in the third century AD. If not then, these sculptures disappeared when the great east doorway was closed off by a Christian apse in the sixth century AD. Henceforth, the building would be entered from the west, and the hall in which the Parthenos had once stood became the place of congregation for Christian worshippers, facing the high altar, over which the Holy Spirit hovered in the form of a golden dove.

Byzantine Christianity was to embellish the Parthenon with its own artistic grandeur. Renamed Our Lady of Athens, it was revered as one of the grandest and most beautiful

FIGURE 17 *below left* Only one of the metopes on the north side of the Parthenon at the north-west corner (North Metope 32) has survived in relatively good repair. The Christians who vandalized the others probably saw here a subject from the Scriptures, perhaps the Annunciation. Plaster cast moulded from the sculpture in Athens, when still on the Parthenon. *British Museum.*

FIGURE 18 *below right* The south metopes were spared destruction by Christian iconoclasts. Those that were not destroyed in the explosion of 1687 were largely removed by Elgin. South Metope 1 at the south-west corner remained on the building and this plaster cast was moulded from it. *British Museum.*

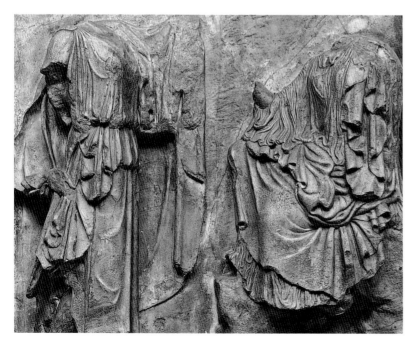

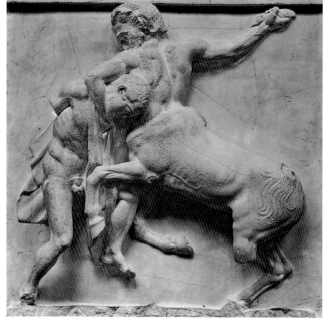

churches of Christendom. The greatest changes were made in the twelfth century, when the apse was substantially enlarged (fig. 19), pushing eastwards to incorporate the porch columns and thus knocking out the central block of the east frieze (fig. 20). The inside of this apse was decorated with a colourful glass and gold mosaic of the Virgin and Holy Infant. Colour was added to the interior walls of the Parthenon by paintings showing, among others, scenes of the Last Judgement, the Sufferings of Christ and portraits of saints and bishops. More changes were made in the west end of the Parthenon, including construction in the south-west corner of a tower with an internal staircase. The stone was quarried from the rear of the Roman monument of Athens' second-century AD benefactor Philopappos, which still overlooks the Acropolis from a hill to the south.

The bungled Fourth Crusade of 1201–4 was intended as an assault on Islam to capture the holy city of Jerusalem, but it soon turned into an attack by western Christianity upon the capital city and dominions of Byzantium. The shameful sack of Constantinople by the Venetians threatened Athens with the same fate when crusaders arrived at its gates. Rather than see their city destroyed, the Athenians surrendered and, for the next 250 years, they found themselves governed by a succession of Frankish and other western European authorities, while the Parthenon, now a cathedral, was presided over by a Catholic archbishop.

FIGURE 19 Reconstruction by Manolis Korres of the east porch of the Parthenon, as it looked after its twelfth-century alterations, when the apse of the church was enlarged and the long central block of the east frieze was displaced.

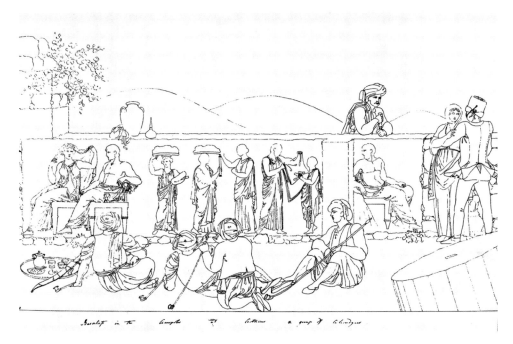

FIGURE 20 Tea and tobacco in front
of the Parthenon frieze. The central block
of the east frieze survived its displace-
ment by the twelfth-century apse (fig. 19)
and was built into a wall where, in
the eighteenth century, it was drawn
by the English collector and traveller
Thomas Hope. Pen and ink, 1796–7.
Benaki Museum, Athens.

THE MOSQUE

In 1453 the Ottoman ruler Mehmet II, the Conqueror, took Constantinople and finally
brought to an end the reign of the formerly powerful Byzantine emperors. In the subse-
quent expansion of the Ottoman empire westwards, Athens was taken in 1456. A last
resistance held out on the Acropolis for two more years, before it fell in 1458. Having been
previously a pagan temple and a Christian church, the Parthenon now became a mosque.
Where once, from the tower in the south-west corner, a bell had rung the faithful to
worship, there now rose a minaret. The high altar at the end of the building was displaced
by the sacred furniture of the Islamic faith, while the Christian paintings on the interior
walls were whitewashed. By and large, however, there were no drastic changes to the
fabric of the building, such as those occasioned by its conversion into a church. Nor did
the Muslim faithful engage in the fanatical defacement of infidel images that had previ-
ously destroyed so many of the Parthenon's sculptures.

The fall of Byzantium and Ottoman appropriation of mainland Greece took place at a
time when the world of Classical antiquity was enjoying renewed interest among artists
and writers of the European Renaissance. Rare evidence of the inclusion of the Parthenon
in the repertory of ancient art and architecture known to the Renaissance are the surviv-
ing copies of written descriptions and sketches made by Cyriac of Ancona, a merchant
and diplomat who visited Athens during the 1430s and 1440s (fig. 21). To us, Cyriac's
jottings may seem disappointingly inaccurate when not only the subject and sequence of

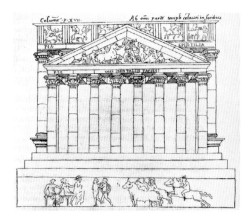

FIGURE 21 Drawing thought to be a copy by Giuliano da Sangallo or his son Francesco of a lost original by Cyriac of Ancona showing the Parthenon relatively recognizable in some details and wildly eccentric in others.

FIGURE 22 The Parthenon engraved in the account of J. Spon and G. Wheler, stripped of its modern additions and changes to become the model of a seventeenth-century idea of an ancient Doric temple.

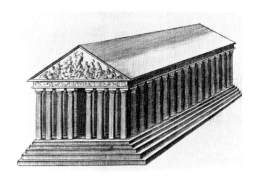

the sculpture is changed, but also its position on the temple, which itself seems wilfully misrepresented to our archaeological eye. Such departure from the original is, however, commonplace in the Renaissance response to antiquity, and often an artist did not slavishly copy a source but instead creatively adapted and reinterpreted it to suit his purpose. Although archaeological recording is not part of Cyriac's purpose, there is nevertheless in his drawings evidence of a quasi-modern desire to strip away post-antique alterations and additions to the Parthenon, and to present exclusively what may be deemed Classical. This Neo-classical tendency in the antiquarian perception of the Parthenon is to be found also in one of the earlier published accounts of the building, that of the travelling antiquaries Jacob Spon and George Wheler, who visited the Acropolis in the 1670s. Spon and Wheler are now usually remembered for their understandable mistake in thinking that the western doorway of the Parthenon as a church was the main entrance of the building when it was a temple and thus confusing Pausanias' description of the west pediment with that of the east. Nonetheless, their dissection of the building to arrive at the original, ancient temple and their attempt to distil from it an exemplar of the Doric order in Classical architecture is modern in intention, if not in understanding (fig. 22).

By far the most systematic and important of the early travellers was the artist Jacques Carrey, who went to Athens in 1674 in the entourage of Louis XIV's ambassador Charles François Olier, marquis de Nointel. Carrey's near complete record of all the sculptures that had survived up to his time was tragically to be rendered indispensable to future archaeologists by the catastrophe that befell the Parthenon just thirteen years later (figs 23a and b). Around 7 p.m. on 26 September 1687 a shot was fired from a cannon belonging to a force besieging the Ottoman garrison of the Acropolis (fig. 24). It entered the Parthenon through the roof and fell among a store of gunpowder, put there for safekeeping in what had seemed to the Turks the strongest part of the castle that the Acropolis had become. Such was their trust in the stout walls of the ancient temple, three hundred Turks had also taken shelter there. They were all killed when the bomb ignited the gunpowder causing an explosion, which blew off the roof and brought down the central part of the flank walls and their external colonnades. The captain of the attacking force was a Swede, Count Koenigsmark, but the overall commander of the crusade-like alliance that had invaded mainland Greece and mounted a major assault against the Ottomans was the Venetian general and nobleman Francesco Morosini. Destruction of the Parthenon, by now famous among European travellers, was a shocking event. Insult, moreover, was added to injury with a failed attempt by the perpetrators to lower to the ground the as yet unscathed central figures of the west pediment. The lifting tackle broke and the sculptures were smashed to pieces in their fall.

THE RUIN

Pagan temple, then church, then mosque, the Parthenon now entered a new phase as romantic ruin. Morosini's occupation of Athens was short-lived and the Turks returned within months to an increasingly fortified Acropolis. Within the ruin of the great temple, now open to the sky, they built a small mosque standing directly on the ancient stone-paved floor (fig. 25). The power of the Parthenon to survive was now at its lowest ebb. Both its undecorated masonry and its sculpture were quarried for construction works. At best the ancient worked marble was incorporated into dry-stone walls, at worst it was tipped into kilns and burnt to produce lime for mortar.

While in their remote corner of the Ottoman empire the Parthenon and the other monuments of the Acropolis were wasting away, elsewhere in Europe interest in the legacy of ancient Greece intensified with the burgeoning of eighteenth-century romantic Classicism. There is no more telling nor, indeed, enjoyable way of experiencing the hold of ancient Greece over the eighteenth-century European imagination than to turn the beautifully engraved pages of one or other of the great illustrated books produced by that age. To do so is to be transported to the picturesque land of the ancients and there to stand before their works, both in their actual ruined state and, through elevations, plans and sections, restored to former grandeur. Principal among these books is Julien-David Le Roy's *Ruines des plus beaux monuments de la Grèce* (fig. 26), published in 1758, and James Stuart and Nicholas Revett's *Antiquities of Athens*, the first volume of which appeared in 1762. Both publications, each in its own way, represented a mission on the part of the authors to revive Greek architecture and to see it transplanted to their own countries. Stuart and Revett's project was

FIGURE 23(a) *below left* Jacques Carrey's drawing of South Metope 15 and 16. The sculpture was smashed by the explosion of 1687.

FIGURE 23(b) *below right* Two joining fragments from South Metope 16 of a falling figure are in the British Museum, while other fragments are in Athens. *British Museum*.

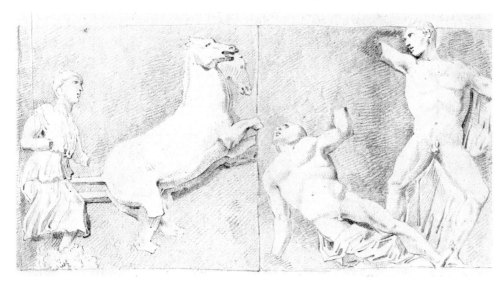

FIGURE 24 The Parthenon exploding in 1687.

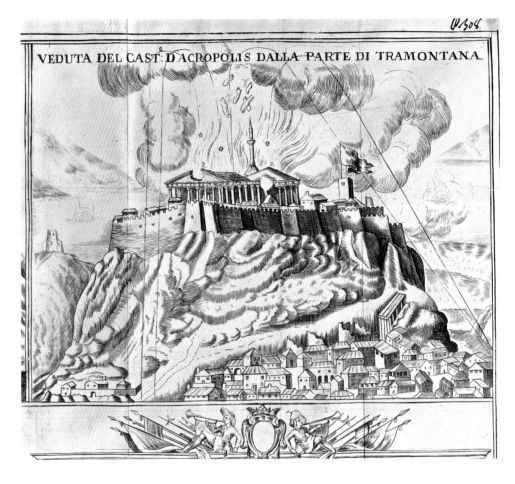

VEDUTA DEL CAST: D'ACROPOLIS DALLA PARTE DI TRAMONTANA.

FIGURE 25 The interior of the Parthenon with its mosque drawn by William Gell in 1801. This view looking down into the building from the west illustrates the shocking extent of the damage wrought by the explosion of 1687. Gell Sketch Book 13, fol. 79. *British Museum.*

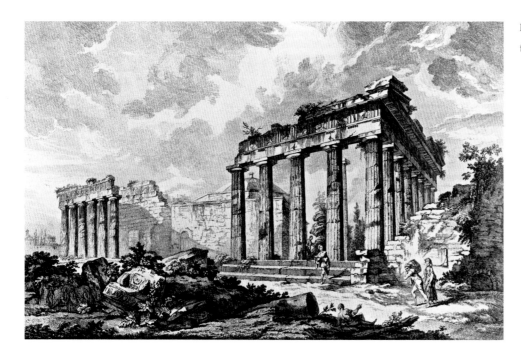

FIGURE 26 J.-D. Le Roy depicts the Parthenon as romantic ruin.

conceived in the late 1740s in Rome, while they were following a by then well-trodden path among the Classical ruins of that city. Their proposal for a study that would take them across the Adriatic Sea to the much less familiar Classic ground of ancient Athens found a willing sponsor in London's Society of Dilettanti, a fashionable club of conversation and conviviality for wealthy gentlemen who had been on the Grand Tour to Italy. Stuart and Revett arrived in Athens in March 1751 and stayed until September 1753. This was to be the first of a number of such journeys sponsored by the Society, including one undertaken in 1764 to western Turkey by Nicholas Revett, the Classical scholar Richard Chandler and the painter William Pars. Ostensibly concerned with what they collectively called Ionian Antiquities on the far side of the Aegean Sea, on their return journey in 1765 these travellers also visited Athens, where Pars spent two months perched high up on the Parthenon drawing the sculptures. Some of these drawings were to be incorporated into Stuart and Revett's publication of the Parthenon in the second volume of *Antiquities of Athens*.

In their Neo-classical simplification, idealization and tendency to restore missing parts, the engravings of Stuart's and Pars's drawings of the Parthenon sculptures are unmistakably of their time. They were, nonetheless, the first published images to give a sense of the architectural grandeur of the original sculptures and thus to simulate the impression they made on the privileged few who had seen them *in situ*. Captured in the pages of *Antiquities of Athens*, the sculptures were brought into libraries and society meeting rooms, where they became vicariously public objects of wonder and desire.

SCULPTURE AND ARCHITECTURE: RESCUE AND RESTORATION

One perhaps not unforeseen consequence of this recording of the sculptures was to provide a gauge for measuring their continuing destruction and disappearance (figs 27a and b). The tendency of Stuart and Pars to restore the sculptures as they drew them means that their work cannot always be relied upon to give an accurate rendering of what was then extant. In some instances, however, when compared with the sculpture itself, their drawings provide clear evidence of wilful damage that took place after the sculptures were drawn and before Lord Elgin's agents rescued them at the beginning of the nineteenth century (figs 28a and b).

Elgin's removal of many of the architectural sculptures from the building is sometimes represented as a disastrous act of vandalism. Was it so? It is sanguine to reflect that just twenty years after his men dismantled the frieze blocks crowning the long flank walls of the temple, the Turkish garrison that was defending the Acropolis at the outset of the Greek war of independence demolished the remainder of these same walls, which then stood up to eleven metres high. The frieze blocks, including those that represent the great cavalcades of mounted horsemen and the procession of cattle, would certainly have been damaged, if not lost altogether, had they not already been removed to safety.

Elgin's removal of the Parthenon sculptures, their transport to England, first display in London and eventual acquisition by the British Museum were all momentous events in their history. Contrary to what is sometimes thought, objects do not become frozen in time when they enter a museum collection. The display of the Parthenon sculptures in the British Museum bridges three centuries, and during this time they have had as eventful a life as they did while still on the building. They have been redisplayed several times and in several different rooms. In wartime they have been evacuated from the Museum altogether as a precaution against enemy bombing. More than once they have been moulded for the

FIGURE 27(a) *below left* Heroes or magistrates in the east frieze reconstructed from casts taken before the sculptures were vandalized in the late eighteenth century. The damage had already occurred when they were rescued by Lord Elgin.

FIGURE 27(b) *below right* The same figures as they were found by Elgin's men. East Frieze VI, *British Museum*.

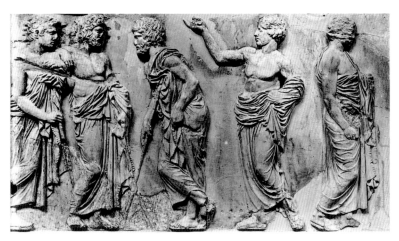

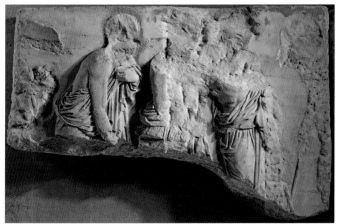

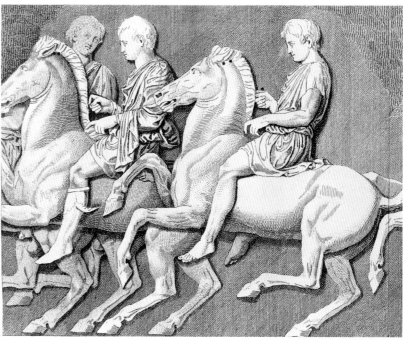

manufacture of plaster copies and they have been cleaned with varying degrees of vigour, especially frequently in the years between 1850 and 1950, when the notorious London smog entered the Museum and deposited oily soot on the surface of the marble.

Few episodes in the Museum history of the sculptures can be judged to have damaged them. There is, however, the notorious incident of the unauthorized cleaning of some of the sculptures with abrasives that took place over a period of months during 1937–8. The sculptures were being prepared for exhibition in the current gallery, the gift of the art dealer Lord Duveen. Because the method of cleaning with copper tools and carborundum had not been sanctioned by the officials in charge, when discovered it caused a scandal and was much reported in the popular press of the day. With the outbreak of the Second World War the matter was dropped and then largely forgotten, to the extent that when, in 1953, Greek workmen cleaned one of the friezes of the temple of Hephaistos in Athens – a sister temple to the Parthenon – employing even more astringent tools than those used in the British Museum a few years earlier, nobody complained. An attempt in 1998 to revive the scandal prompted the British Museum to hold an international conference the following year to re-examine exactly what had happened to the sculptures in the 1930s.

If the sculptures in the British Museum have had their share of controversy, so too have those that remained on the Parthenon after Elgin had removed others. These comprise three figures in the north corner of the west pediment, fourteen of the original sixteen blocks of the west frieze (and its return onto the corner of the south frieze) and many of

FIGURE 28(a) *above left* Fragment of the north frieze cavalcade as found by Elgin's men. North Frieze XXX, *British Museum.*

FIGURE 28(b) *above right* The full block from the north frieze cavalcade, of which (a) is the only surviving part. Engraving from James Stuart and Nicholas Revett, *Antiquities of Athens*, London 1787, II, ch. 1, pl. 17.

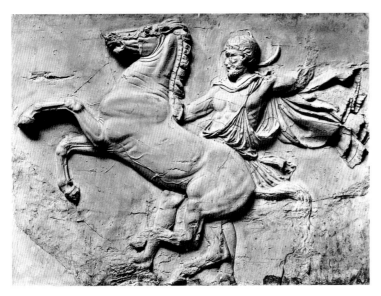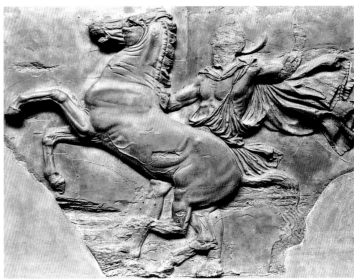

FIGURE 29(a) *above left* Horse and rider of the west frieze in a plaster cast moulded for Lord Elgin in 1802. West Frieze VIII.

FIGURE 29(b) *above right* The same figure in a cast moulded in 1872 with the face missing. The west frieze came down from the building for protection and display in the Acropolis Museum in 1993.

the metopes. Virtually all these metopes were badly defaced by the early Christians of Athens, but two, one on the south-west and another on the north-west corner, had not been defaced like the others (figs 17 and 18). The continuing exposure of all these sculptures to the weather became a matter of growing concern. Elgin's men had made plaster casts of the sculptures that they did not remove, and these casts were exhibited in the British Museum. It thus became possible to compare the condition of the sculptures when cast in 1802 with the way they appeared after subsequent weathering. A second casting, for example, of the west frieze in 1872 produced evidence of inevitable further deterioration of the sculptures owing to their continued exposure to the elements (figs 29a and b).

As for the Parthenon itself, following the war of independence the mosque and other traces of the later use of the building were swept away as the Athenian Acropolis and its Classical monuments were adopted as symbols of Greece's newly won national identity. Two columns were re-erected in the gaping void of the north-side colonnade left by the explosion of 1687. Apart from these and other minor interventions, during the 1800s more was taken away than was added to the Parthenon. The aim was to purge it of the cultural 'pollution' of the intermediate past, and to present the raw shell of the ruined building as an inviolable token of the golden age of Classical Athens. In the twentieth century, however, this would change dramatically during two extensive campaigns of restoration, which could not be more different from each other.

In 1894 an earthquake caused minor damage to the Parthenon and prompted a heated debate as to how the damage should best be repaired and the extent to which modern interference with the ancient fabric of the building was ethical. A committee was formed to oversee the repair work, which was ultimately carried out between 1899 and 1902 by

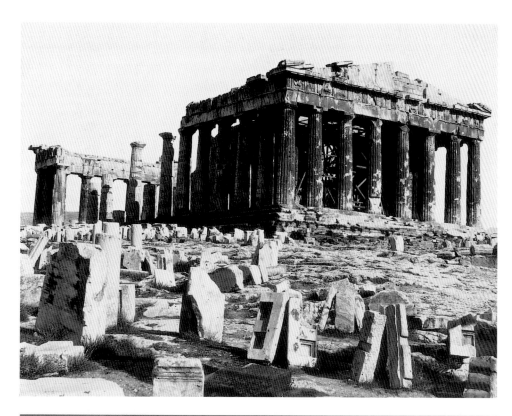

FIGURE 30(a) Late nineteenth-century photograph of the Parthenon showing how it looked before Nikolaos Balanos's extensive restorations of the twentieth century.

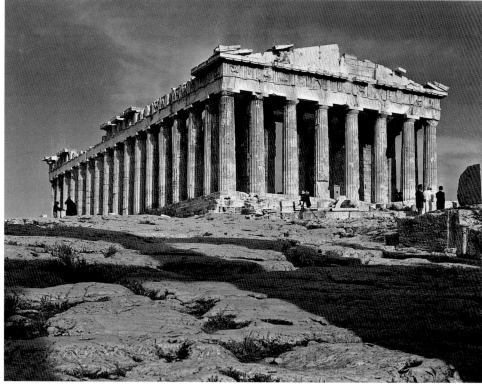

FIGURE 30(b) The Parthenon restored by Balanos.

the civil engineer Nikolaos Balanos. For the next twenty years Balanos was preoccupied with restoration work on two other surviving Acropolis monuments, the Erechtheum and the Propylaea. In 1922, however, he returned to the Parthenon where he was to proceed with what is now regarded as a drastic and disastrous project of reconstruction (figs 30a and b). In theory Balanos's vision of the Acropolis monuments was laudable. At the same time as rendering them more stable and more resistant to the natural forces of storm and earthquake, he conceived the notion of making the ancient buildings more complete and comprehensible ruins by incorporating in their restoration as many as possible of the unattached members that lay scattered around them. Himself no archaeologist, Balanos proceeded virtually unchallenged in creating a patchwork of joined fragments, often with no knowledge or regard for their exact original position on the building or for their actually being part of the same architectural member. Worse still for the well-being of the monument was the mechanical method of this work, stapling the broken pieces together using iron rods. The ancient technique for clamping together adjacent elements in the construction of stone buildings was to pour molten lead around metal clamps to prevent exposure to air, thus insulating the stone from the ill effects of the metal, should it corrode and expand. Balanos knew but chose to ignore this, and in 1943, only ten years after a long campaign of restoration work came to an end, the first cracks began to appear in the marble as the rusting iron expanded.

In the years that followed the Second World War there was increasing concern for the welfare of the Parthenon. Apart from Balanos's restoration, there was by the 1960s a new danger from atmospheric pollution. Acid rain, the curse of the modern city, was eating away the surface of the worked marble, blunting its carved details and threatening its survival.

While the corrosive effects of the very air it breathes remains a danger to the Parthenon, in other respects great progress has been made since the mid-1970s in reversing the mistakes of the Balanos era, and in re-restoring its fabric with a scientific regard for its archaeological integrity. Working under the Greek Ministry of Culture's appointed Committee for the Conservation of the Acropolis Monuments, a highly skilled team of architects, engineers, archaeologists and historians, conservators and masons has been at work for four decades now to bring the Parthenon back from the precipice of destruction, to which nature and mankind have brought it over a period of two and a half millennia. As a consequence of this work and the detailed research that underpins it, more is now known about all aspects of the building's history and construction than ever before.

One aim of the current programme of works on the Parthenon is to take down all the sculpture that remained on the building after Elgin's time. In 1976 three figures remaining in the west pediment were removed and replaced with copies. In 1993 the fourteen blocks of frieze remaining on the west side of the Parthenon were dismantled

and, after a lengthy conservation process, eventually went on display in the Acropolis Museum. Meanwhile the removal of the remaining metopes and their replacement with casts is ongoing. This decision to privilege the sculpture over the architecture has now forever separated the one from the other and completes the rescue operation begun by Lord Elgin over two hundred years ago.

THE SCULPTURES

PEDIMENTS

The triangular spaces at the gable ends of a Greek temple are called pediments. Those of the Parthenon measure around 27.5 metres long and about 3.3 metres high at the centre. The horizontal cornice provided a shelf, on which were displayed sculptures carved all the way round, but visible only from the front (fig. 33). These sculptures made up two great compositions, each telling its own story. The elongated triangle of a pediment was not a convenient shape for continuous pictorial narrative: figures in the apex of the Parthenon's pediments could stand almost twice life-size, while those in the corners could not stand at all and were necessarily reduced in size as well as stature. It is a mark of the quality of their design that in both pediments of the Parthenon this obstacle to pictorial coherence was overcome with such panache.

In his *Description of Greece*, Pausanias informs us that the east pediment showed the birth of the goddess Athena. Her father, Zeus, had mated with the goddess Metis, personification of female intelligence. When Metis fell pregnant Zeus feared that children by her would grow up more powerful than him. He thought, therefore, to put an end to mother and child by swallowing Metis whole. Athena lived on, however, in the head of her father who, when he could stand the pain of pregnancy no longer, called upon his son Hephaistos, god of smiths. Hephaistos split open the head of Zeus and, by this unique Caesarian delivery, Athena was born as, literally, the brainchild of her father. The west pediment also told an episode from the life of Athena, which was set on the Acropolis of Athens. There Athena and Poseidon, god of the sea, competed for the right to preside over Athens and its countryside as patron deity.

EAST PEDIMENT

The central figures of the east pediment are lost and, were it not for Pausanias, it would be impossible to say what their subject was. There remains, however, the question of how it was shown. The relief carving of a Roman altar, now in Madrid (fig. 32), is thought to hold the best clues. Here Zeus is shown seated, while his armed and fully grown daughter Athena, newly released from her father's head, strides out into the world,

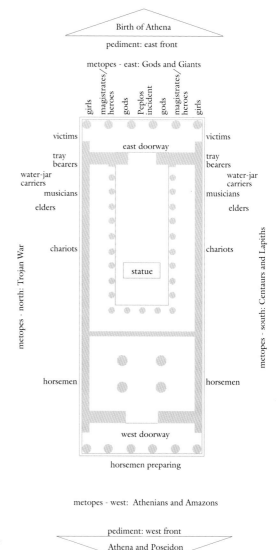

FIGURE 31 Diagram to show the subjects of the Parthenon sculptures.

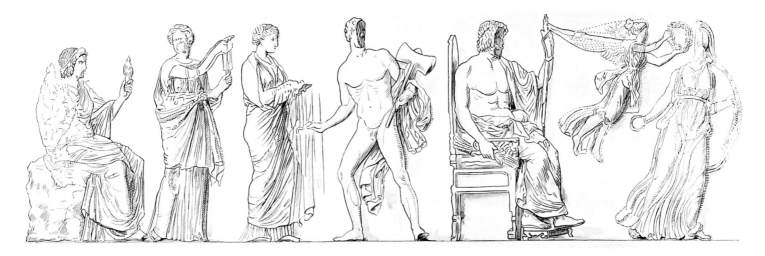

FIGURE 32 The birth of Athena shown on a Roman altar in Madrid.

FIGURE 33 Computer animation with the Dionysos figure of the east pediment rotated to show that it is carved all the way round.

looking back as she does so. On the other side of Zeus, Athena's half-brother Hephaistos retreats with the axe while, to the left, three Fates spin out Athena's destiny, as they did that of every newborn, mortal and divine.

The birth scene had already disappeared from the east pediment when Jacques Carrey came to draw the remaining sculptures in 1674 (fig. 34). The greater part of the sculpture that survived the explosion that wrecked the Parthenon thirteen years later is now in the British Museum (fig. 36). Athena was born at daybreak and from the left-hand angle comes the sun-god Helios and the heads of two of his four horses, which were shown emerging from the floor of the pediment as if from the sea. Helios' own head is broken away, and all that we see are his neck, shoulders and arms. The rest of Helios' body and of his chariot and team of horses were not represented at all and, as a solution to the problem posed by the sharp corner of the pediment, the spectator was invited to imagine the sun-god submerged beneath the waves. Remarkably, given the fact that they could not have been visible once the sculpture had been placed on the building, waves are drawn across the back of Helios' shoulders and between his outstretched arms. To the right of Helios and at three-quarters to the spectator is Dionysos, god of wine, reclining on a rock softened by the skin of a panther. This remarkable male nude is the only human figure from the east pediment to have retained its head. He does not observe the dramatic event taking place at the centre of the pediment, but instead gazes out as if to admire the breaking dawn. To his right are two female figures, probably the goddess Demeter and her daughter Persephone. The mother is likely to be the one on the right who, unlike her daughter, feels the blast of energy coming from the centre. Her head is missing, but she must have turned her gaze towards the right and, with upraised arm, acknowledged the advance of a running girl. With drapery flying behind her, this girl dashes away from the miraculous birth that she has just witnessed.

At the right-hand side of the birth scene, balancing the gods on the left, there is a group of three goddesses (fig. 36 K, L, M). The figure nearest to the centre has evidently been sitting at rest but now, responding to the disturbance to her right, she is about to rise. She tucks her right foot under her and uses it as a lever with which to raise herself from her seat. The drapery over her flexed knee is taut with effort and eloquently expresses the tension of her mood. Two more goddesses to her left are carved from the same block of marble. One sits rather awkwardly at three-quarters to the spectator, and we can sense her desire to turn and witness the event happening behind. She is prevented from doing so, however, by the figure reclining luxuriantly in her lap. This sexually charged person, perhaps the goddess Aphrodite, stretches long in her body-revealing drapery, which moulds itself like wet tissue to her ample form. Her languor, undisturbed by Athena's birth, complements the pose and mood of the male nude reclining in the opposite corner. Whereas he, however, looks out at the sunrise in the east, her missing head directed its gaze after the chariot of the moon-goddess Selene, sinking in the western sky. The head of Selene's horse is an exquisite study of strain and fatigue induced by the night-long task of drawing the moon and her chariot across the great expanse of the universe. With its muzzle overhanging the cornice, the horse of Selene sinks perfectly into the pediment corner.

Together, these two groups of figures, arranged to right and left of the missing central scene, cleverly carried the eye into the narrowing corners of the pediment, reducing in stature from standing to sitting, then lying on and, finally, sinking into the pictorial ground line. The height of each figure is measured in proportion to the degree of engagement with the birth scene. The running girl recoils from the shock of Athena's birth like a spring released, while the reclining gods are in a state of relaxed unawareness. Helios and Selene, meanwhile, are not even present, but mark the boundaries of the pediment by fixing the horizon of the world visible from Olympos.

FIGURE 34 The surviving sculptures of the east pediment drawn in 1674 by Jacques Carrey.

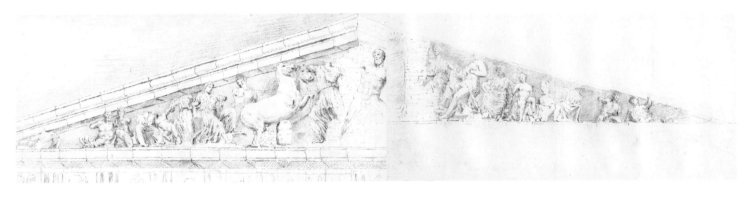

FIGURE 35 The west pediment
drawn by Jacques Carrey in 1674.

WEST PEDIMENT

Although the west pediment is even less well preserved than the east, more is known about the original composition because of drawings made of it by Jacques Carrey in 1674 (fig. 35). The centre was dominated by the colossal figures of Athena and Poseidon, the one heavily draped and the other naked. They were shown springing away from one another, each having produced a miracle by which their respective claims to Athens were judged. Athena brought forth the first olive tree, the fruit of which would become so vital a part of the Athenian economy. Poseidon struck the rock with his trident, causing a salt spring to gush forth, a reminder of his power over the sea that connected Athens with the rest of the world, and by which the city would command its maritime empire. Perhaps these tokens of their respective powers were shown between the two protagonists. If not, then perhaps it was the thunderbolt of Zeus that appeared between his quarrelling children and caused them to separate.

The outward thrust of Athena and Poseidon moving violently left and right was countered on either side by their incoming chariots. The divine contestants alighted from their vehicles, while these were still in motion, and before their charioteers had brought the

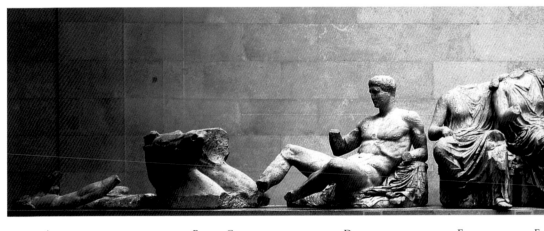

A B C D E F

horses fully under control. Indeed, the contest may not only have been about the merit of the miracle each god wrought, but was also a race to be first to deliver it. Such a race would echo the dramatic chariot charge shown in the frieze.

With the chariots of the west pediment went messenger gods as heralds. Hermes, whose trunk and feet are in the British Museum, heralded Athena's chariot, while Poseidon's was led by the goddess Iris, who personified the rainbow and the upper air breathed by the gods. Originally fitted with bronze wings, Iris was shown as if hovering above the ground, about to touch down from her flight. The sculptor has captured the spirit of the air that she both represented and exploited in order to soar above the earth. Her short tunic is made of the flimsiest of fabric, moulding itself to her youthful breasts, rounded belly and thighs or breaking away at the sides to flutter free in the breeze.

In Iris we witness the virtuosity of the sculptors of the Parthenon in turning cold stone into living flesh and then in converting human form into a universal element, in this case air. This alchemical power of transformation is also to be found in another of the surviving figures from the west pediment. To left and right of the chariots, lesser gods and heroes gathered as witnesses, or some would say judges, of the divine contest. These figures leaned, sat, squatted, knelt and finally lay down in order to accommodate the raking cornice above. From the extreme left-hand corner comes a lissom youth, naked and raising himself up on one arm. He is reminiscent of figures similarly placed on one of the pediments of the earlier temple of Zeus in the panhellenic sanctuary at Olympia in western Greece. There reclining gods personified two rivers of the region. The Parthenon's reclining figure must also represent a river, one of the streams that watered the plain of Attica, perhaps the Ilissos. Indeed, a river bank is represented beneath his supporting arm. Over it flows liquid drapery which, viewed from the rear, is indistinguishable from flowing water.

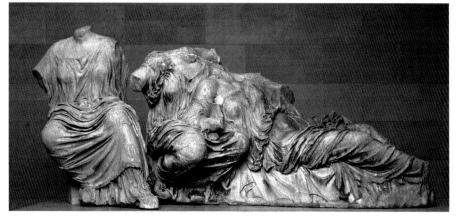

G

K L M

FIGURE 36 Sculptures from the east pediment in the British Museum.

METOPES

Above the architrave over the columns of the Parthenon runs a series of panels carved in high relief alternating with an architectural device known as a triglyph. The metopes, measuring 1.2 metres high and between 1.22 and 1.33 metres wide, were carved in very high relief and numbered ninety-two in all, fourteen on each short side of the temple and thirty-two on each long flank. Although the metopes on three sides of the building were defaced by the early Christian community of Athens, the subjects can still be determined. The east side features a battle of gods and giants recalling the assault on Mount Olympos by the monstrous sons of earth. This theme was carefully chosen to complement and contrast with the family of Olympian gods shown peacefully seated on the frieze over the east porch.

The metopes of the east side were answered by those of the west, where battle raged between Greeks and Amazons, the perversely female race of warriors. Several stories are connected with the Amazons, but the one illustrated here is likely to be that when the legendary Athenian king Theseus led a successful defence of the Athenian Acropolis against an Amazon invasion. Just as, therefore, the metopes on the east side with their gigantomachy set on Mount Olympos connected with the Olympian gods on the east frieze and with the birth of Athena on Olympos shown in the east pediment, so the Amazonomachy of the west metopes set on the Athenian Acropolis connected with the contest on the Acropolis of Athena and Poseidon, shown in the west pediment.

The theme of mythical battle was to be found also on the long north side of the temple where, so far as can be judged, the subject was the Trojan War. All bar one of the north metopes were defaced by the Christians, and many of these were destroyed altogether in the explosion of 1687. The metopes of the south side were spared iconoclasm and survived to be drawn by Jacques Carrey. Those to the left and right represented a mythical conflict between humans and Centaurs, while the central metopes represented a baffling assortment of subjects, few of which can be identified for certain (fig. 23). All fifteen metopes in the British Museum come from the south side and show a Centauromachy. The likely story is the wedding feast of Perithoos, king of the Lapiths, who inhabited Thessaly, a region of northern Greece. The Centaurs attended the wedding as guests but, inflamed by wine, attempted to rape the Lapith women and boys. The men defended their people and a battle ensued.

There is great variety in the quality of the design of the metopes. There is variety too in the manner of representing the Centaurs, who in some cases are endowed with a human face, while in others they wear a mask-like countenance akin to the dramatic masks of Greek tragedy. These discrepancies may have something to do with the fact that the metopes were executed relatively early in the construction of the temple, begun around 447 BC. By 438 BC the marble-tiled roof must have been in place to protect Pheidias' gold and ivory statue of the goddess Athena. In that year the statue is thought to have been

inaugurated at the Great Panathenaia. This festival was celebrated every year, but with especial splendour every fourth year. Unlike the pediments and the frieze, the metopes had to be in place and carved before the roof above was constructed. This, it seems, created an urgency in their carving which, in some instances, compromised design and execution. Collectively, nevertheless, they remain great feats of stone carving, where the relief is so deep and the figures often so undercut as to appear to hang free of the background and are connected to it only by narrow bridges of marble.

THE FRIEZE

At the same height as the metopes, about twelve metres above the temple floor, the frieze was located on the external walls of the long sides of the building and, on its short sides, it was placed above the porch columns (fig. 37). Such a continuous band of figured sculpture was unique in Doric temple architecture in mainland Greece and is a striking indication of the exceptional opulence of the Parthenon, especially when one considers how difficult it was to see the frieze, placed high up behind the colonnades.

The frieze measures a metre high and ran for a total of 160 metres. It was carved in low relief of around six or seven centimetres in depth. Its subject is the procession of the Panathenaic festival, which took place in honour of the goddess Athena at the height of summer. The procession was represented in two branches, each departing from the south-west corner of the temple (fig. 38). One branch, the shorter of the two, ran down the long south side until it turned the corner onto the east side. The other took in the west side of the building, before turning onto the long north side and, eventually, reaching the north-east corner, where it too turned onto the east.

Remarkably, while the pediments and metopes obey convention and take their subjects from mythology, the frieze breaks with tradition and shows an event from the religious life of the city in which Athenians, albeit idealized, could see themselves. The west frieze and about half of the long north and south friezes are composed of horsemen. The west shows them getting dressed, arranging bridles and reins or mounted and putting horses through their paces. The cavalcade proper is reserved for the north and south friezes with sixty horsemen apiece, arranged in ranks as many as eight deep. The presence of so many horsemen probably reflects Perikles' recent expansion of the state cavalry to a thousand-strong fighting force, an important new element in the Athenian military. Here, however, although many riders wear armour, virtually none possesses a weapon. The cavalry is gathered in a peaceful parade of horsemanship, the kind of thrilling experience that only recently had become a splendid new spectacle in the parade ground of the Athenian marketplace. Such an event could not have been a part of the Panathenaic procession itself, but may well have been staged as part of the festival.

FIGURE 37 Computer animation to show the location of the frieze on the building. The zone highlighted in blue symbolizes the northern branch of the procession and its turn on to the east side.

If it is hard to imagine the cavalcade as representing actual participants, nor is it possible to think of the chariot race ahead of the cavalcade as an actual part of the real-life procession. Rather, the chariot race was an event in the festival games, which also included competitions in music and athletics. The explosion of 1687 destroyed much of the middle part of the long walls, but from what survives, and with the help of Carrey's drawings, it is possible to reconstruct ten chariots to the south frieze and eleven to the north. In spite of the damage and loss, some glorious moments are preserved in which we almost hear the whirring of the wheels, the jangle of the harnesses and the pounding of hooves. Two figures ride in each car, the driver in a long ceremonial tunic and an armed warrior or *hoplite*. At a given marker, the *hoplite* was to leap down from the chariot and finish the race on foot.

Ahead of the chariots, groups of pedestrian figures walk in solemn procession, their slow pace in sharp contrast to the quick tempo of what has gone before. They comprise, in turn, bearded men (perhaps elder civic or religious officials), musicians, young men carrying water-jars, tray-bearers and youths leading sacrificial cattle or sheep. All these participants are male, like the riders in the cavalcade and the contestants of the chariot race. On turning the corners onto the east frieze, however, girls or young women appear for the first time.

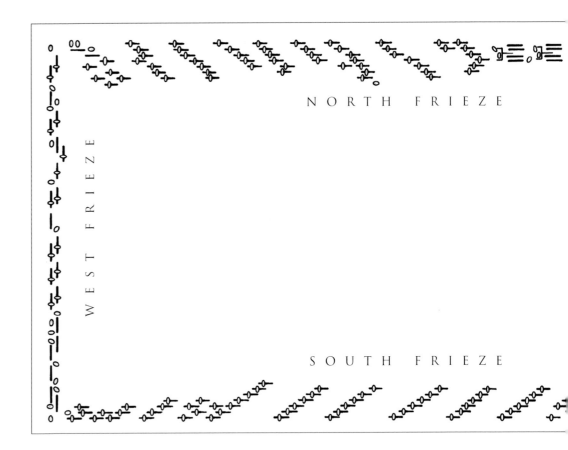

NORTH FRIEZE

WEST FRIEZE

SOUTH FRIEZE

Heavily draped and moving forward in slow time, they carry the paraphernalia of ritual sacrifice, jugs and bowls for pouring libations and at least one stand for burning incense.

The women, north and south, are led or met by male marshals, who act as transitional figures between the procession proper, and men who do not participate in it, but lean casually on sticks to engage in conversation. These leaning figures perhaps represent magistrates of the Athenian democratic government or they may be those eponymous heroes who gave their names to the ten tribes of Athens. Placed here they would provide a cosmological interval between the world of mortals in the procession and the divine world of the Olympian family, who appear next (fig. 39).

The gods are shown seated and therefore on a scale larger than that of the magistrates or heroes and that of figures in the procession. There are two groups arranged like a grandstand audience, one facing the southern division of the procession, the other looking towards the northern branch. Apart from their greater size, and although immortal and possessed of supernatural powers, nonetheless this pantheon is conceived very much as human. Each has his or her distinguishing attribute – a sunhat for Hermes, that runner of divine errands, a crutch under the arm of Hephaistos, lame god of smiths – and each

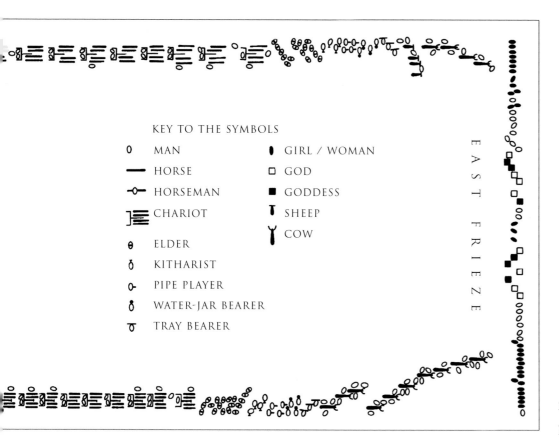

KEY TO THE SYMBOLS

0 MAN

— HORSE

-o- HORSEMAN

CHARIOT

θ ELDER

δ KITHARIST

o- PIPE PLAYER

δ WATER-JAR BEARER

σ TRAY BEARER

● GIRL / WOMAN

□ GOD

■ GODDESS

Ĭ SHEEP

Y COW

EAST FRIEZE

FIGURE 38 Symbolic plan of the procession shown in the frieze.

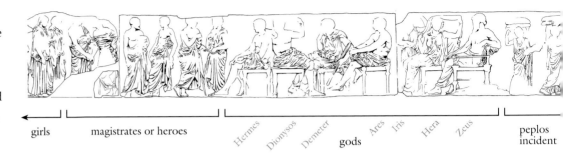

FIGURE 39 The two branches of the frieze procession converge on the east side but do not actually meet. At their head conversing magistrates or heroes lean on sticks, and then come the gods, seated and divided into two groups, one facing north and the other south. Between the gods a ritual is taking place involving the sacred robe for Athena.

girls magistrates or heroes Hermes Dionysos Demeter gods Ares Iris Hera Zeus peplos incident

is posed in a manner befitting a specific character. So, for example, Dionysos leans a drunken arm on the shoulder of Hermes, while Demeter rested the chin of her now missing head sadly on one hand in a gesture that betokens mourning for the loss of her daughter Persephone, carried off to be bride to Hades in the underworld. All powerful Zeus, meanwhile, leans his arm imperiously over the back of his throne.

Between the two groups of gods, and seemingly unobserved by them, was carved a curious scene of religious ritual. From left to right, two girls carrying cushioned stools on their heads approach a priestess, who faces them. She stands back to back with a priest who, together with a boy, is handling a folded blanket of cloth. There are many unanswered questions here: who are the girls? Why are they carrying stools? Who is the boy? Nonetheless, the essential message seems clear. The cloth is the *peplos*, the new robe for Athena, woven every year and presented to her as the culminating event of the Panathenaic festival and its procession.

The frieze of the Parthenon does not present a literal rendering of the Panathenaic procession. Rather, it embodies the festival in an artificial synthesis of events, which could not in reality have happened at the same time and place. Pomp, competition and sacrifice are brought together in an idealized rendering of the people of Athens, dressed up in their festival best and assembled on parade before their gods. These deathless beings are not portrayed as the zoomorphic monsters of other ancient religions. For all their supernatural powers, the gods of the Parthenon frieze, and indeed those of the pediments, are portrayed as larger-than-life humans. Whereas in the west and east pediments, however, it is certain that the gods are shown, respectively, on the Athenian Acropolis and on Olympos, in the frieze it is left vague as to whether they are watching the procession from the sacred citadel or from the holy mountain. Furthermore, if there is an uncertainty about the whereabouts of the gods, then so is there by implication about those who are paying them homage. In the timeless utopia of the Parthenon frieze, it cannot be said for certain whether heaven has come down to earth, or earth is going up to heaven. This is a nice ambiguity with which to flatter the people of Athens.

Athena Hephaistos Poseidon *gods* Apollo Artemis Aphrodite Eros magistrates or heroes marshals girls

Like the Funeral Speech of Perikles, the Parthenon frieze captures the spirit of ancient Athens at its best. It encapsulates people and place in one timeless moment in which human and animal, male and female, citizen and slave, young and old, mortal and divine pay honour and, through its acceptance, are honoured in turn. Deity graciously receives the sacrificial beast, which itself must go willingly to the altar. Idealistic optimism, however, is not the only message of the frieze. In 431 BC Perikles sounded a defiant note 'in midst of other woe'. Athens had just embarked on a disastrous war with Sparta, which would see Perikles himself dead two years later from the plague that war brought to his city. As in every epitaph, there is a melancholy about the frieze, which prompts reflection upon the frailty of the human condition and the uncertainty of human fortune. Living flesh rendered in stone sculpture is life rescued from its earthly corruption. Certainly, this was the message of countless sculptured Greek grave stelae, where the deceased, often with his or her family, are represented in the perpetual bloom of youth. As noted at the beginning of this essay, the nineteenth-century romantic poet John Keats in his *Ode on a Grecian Urn* captured the reflective mood of the frieze. Let us, however, give the last word to the ancient Greek poet Mimnermos, who lived in the sixth century BC:

We are as leaves in jewelled springtime growing
That open to the sunlight's quickening rays
So joy we in our span of youth, unknowing
If God shall bring us good or evil days.
Two Fates beside thee stand; the one has sorrow,
Dull age's fruit; that other gives the boon
Of death, for youth's fair flower has no tomorrow,
And lives but a sunlit afternoon

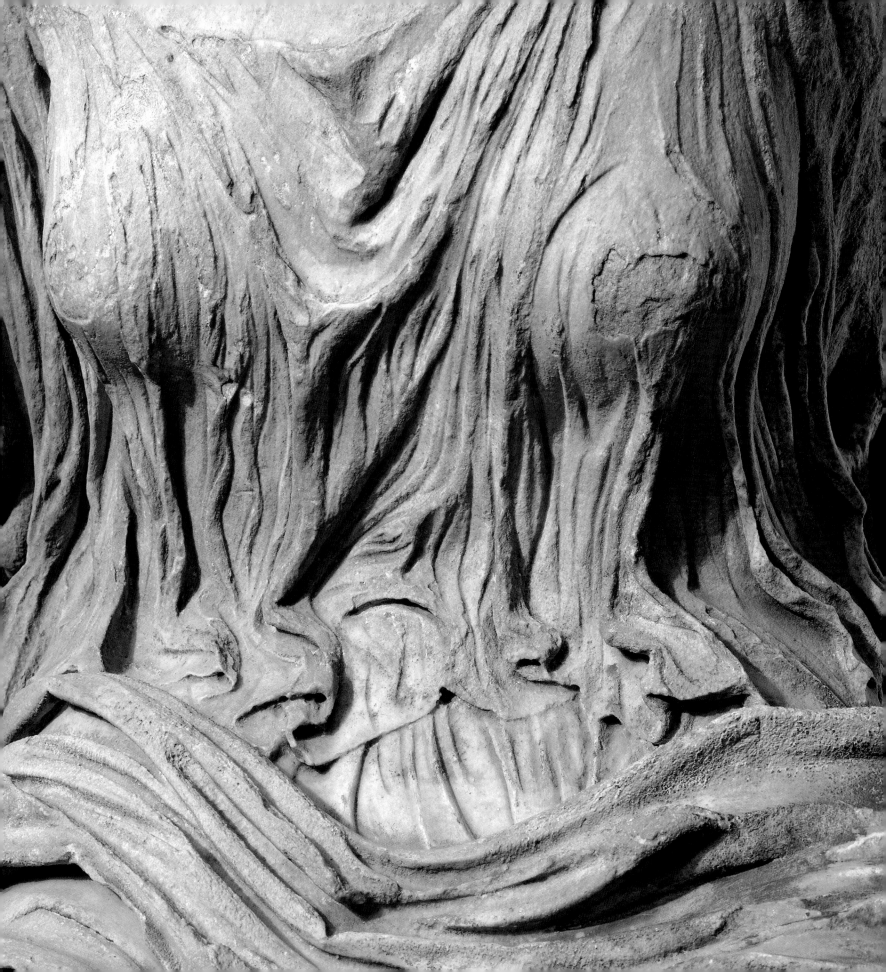

THE PEDIMENTS

Pediments are the triangular gable ends of a Greek temple, which were often filled with sculpture. Pausanias, writing in the second century AD, reports that the east pediment of the Parthenon represented the birth of Athena. Drawings made in 1674, probably by the artist Jacques Carrey (see fig. 34 on p. 37), show the figures from the two corners that survived in his day. Already missing were the colossal sculptures that occupied the centre of the pediment. They included figures of Athena herself, her father Zeus and half-brother Hephaistos, the god of smiths. Athena was born fully grown and armed from the head of Zeus, split open by a blow from Hephaistos' axe. The time of Athena's birth was marked in the corners of the east pediment by, on the left, the sun-god Helios rising in his horse-drawn chariot at dawn and, on the right, the chariot of the moon-goddess, Selene, sinking beneath the horizon.

Pausanias says that the west pediment of the Parthenon showed the contest of Athena and Poseidon for the land of Attica. The composition of figures, now very fragmentary, can be seen in drawings made again in 1674 by Jacques Carrey (see fig. 35 on p. 38). In the centre were colossal figures of Athena and Poseidon, who arrived by chariot. Athena's chariot was driven by Nike, goddess of victory, and heralded by the messenger god, Hermes. Poseidon's chariot was driven by his wife Amphitrite and accompanied by a female messenger, Iris. On either side were various heroes from Athens' legendary past. In front of these witnesses Athena and Poseidon worked their respective miracles, on which the contest was to be decided. Poseidon caused a salt spring to gush from the rock, but Athena won by creating Athens' first olive tree.

EAST PEDIMENT K *left*
A waterfall of drapery cascades over the breasts of this seated goddess and falls onto her abdomen. There it meets the river-like folds of another garment flowing over her lap.

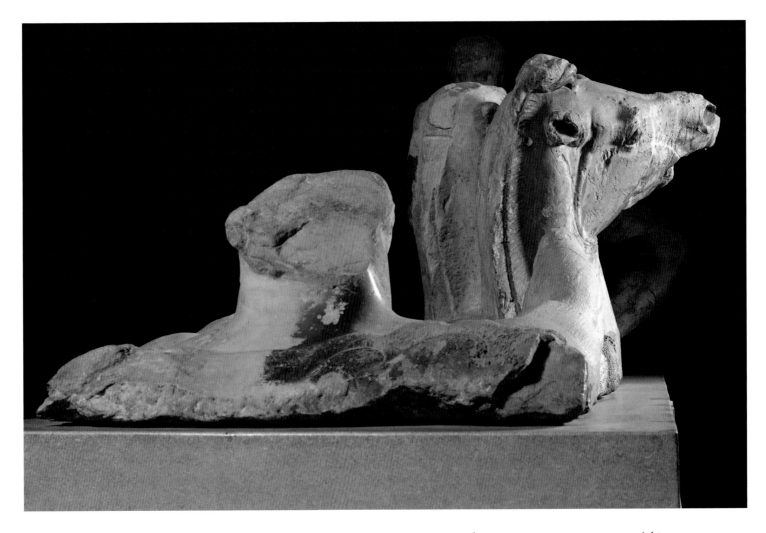

EAST PEDIMENT A, B AND C *above*

The god of the sun, Helios, was shown driving his horse-drawn chariot out of the sea at dawn. Here are seen his shoulders, neck and extended right arm. The heads of two of his four horses are also shown. Helios' own head is broken away.

EAST PEDIMENT *right*

An oblique view of sculptures in the east pediment shows how the composition was crowded with figures, their height adjusted to the raking cornice of the architectural triangle that framed them.

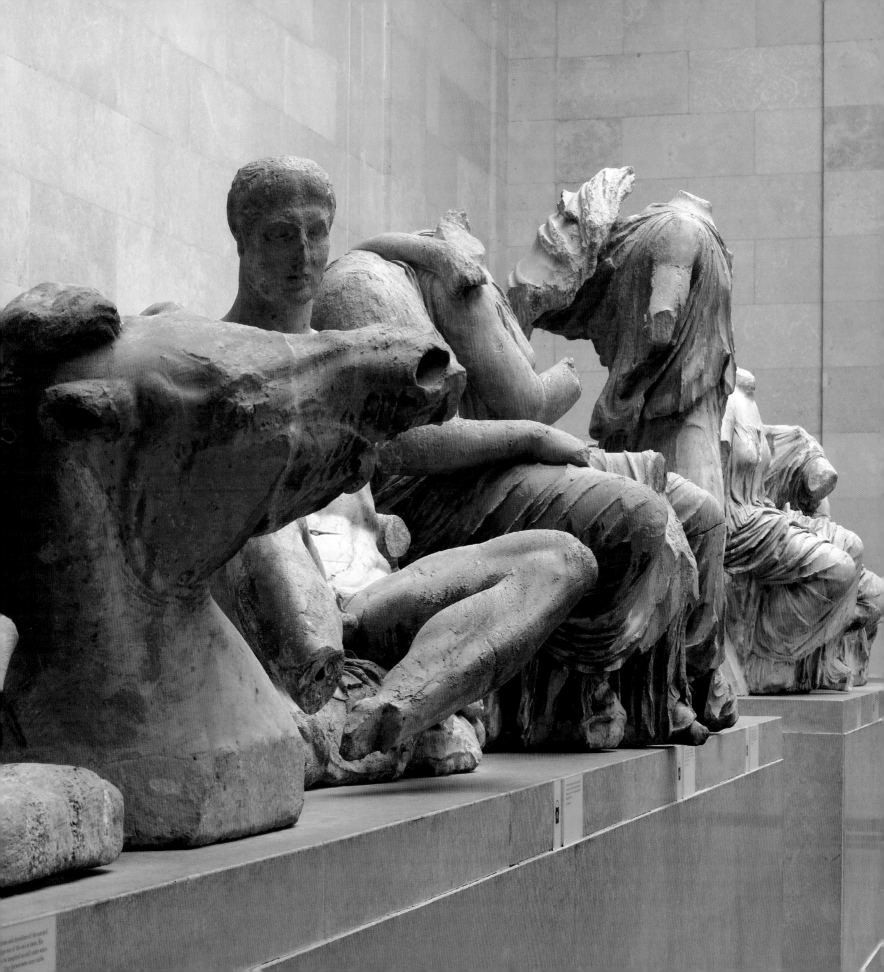

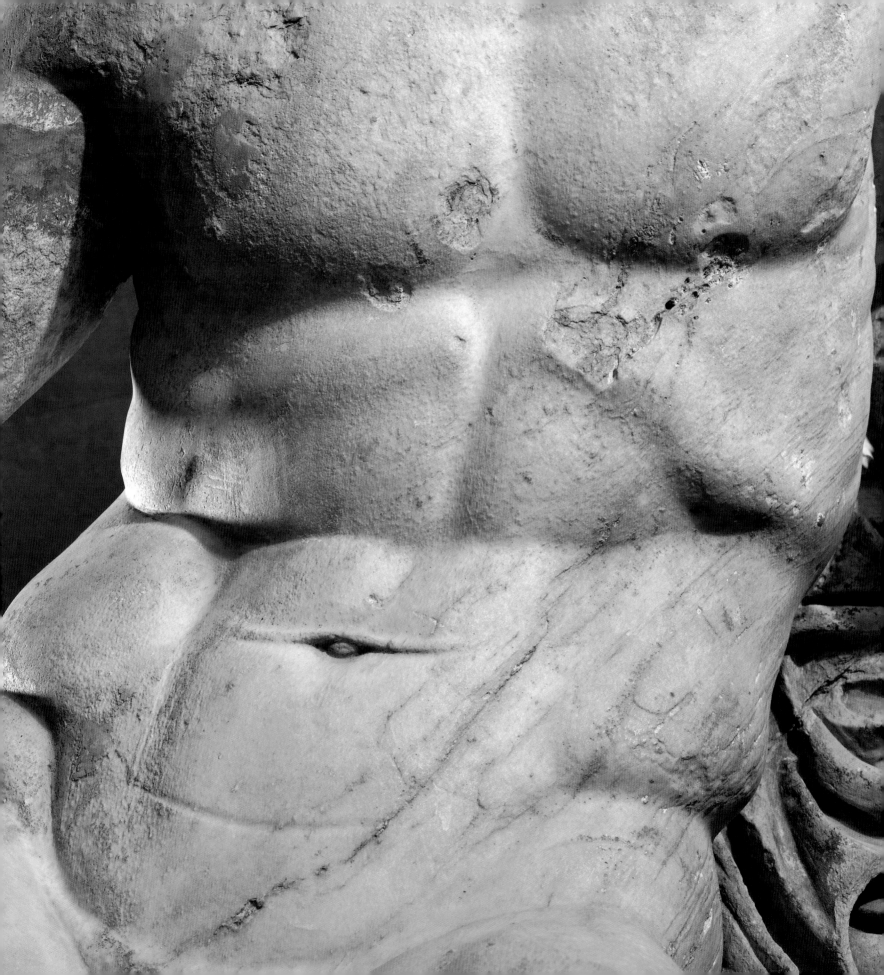

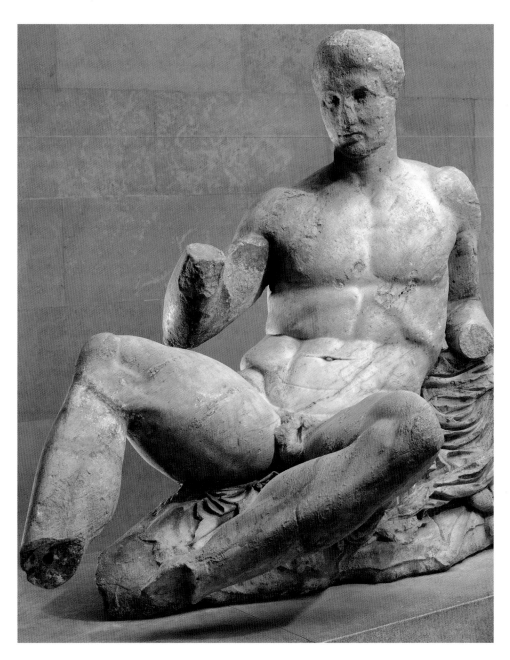

EAST PEDIMENT D *above and left*
The god of wine, Dionysos, reclines
naked on a rock cushioned with the
pelt of a panther. He probably held a
drinking cup in his right hand. The
hand is missing, but the figure is
remarkable for being the only one
of all the pediment sculptures to retain
its head. The torso is closely observed.
Note, for example, how the abdomen
is flattened by the action of the stomach
falling into the pelvis. This display of
male beauty is charged with divine
sexuality.

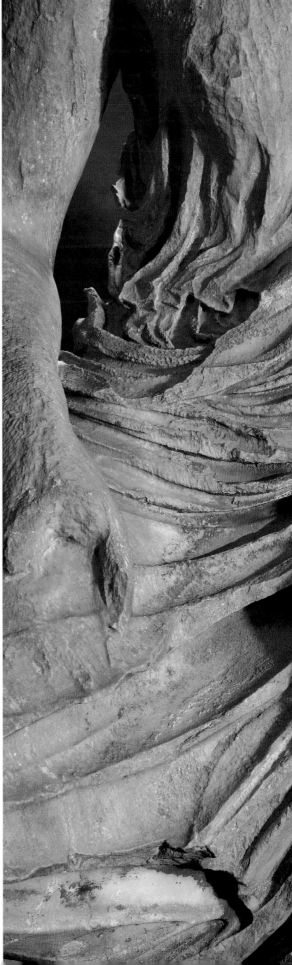

EAST PEDIMENT E AND F *above*
Two goddesses are seated on boxes, prob-
ably conceived as being made of wood.
When freshly carved, they were most
likely gilded. Drapery falling on either
side frames the boxes and contrasts with
the neat folds of the cushioning blankets.

EAST PEDIMENT E AND F *right*
Flowing draperies are alive with energy
expressive of the excitement provoked by
the birth of Athena in the centre of the
pediment. The right-hand figure turns
towards the miraculous birth, her arms
raised in surprise.

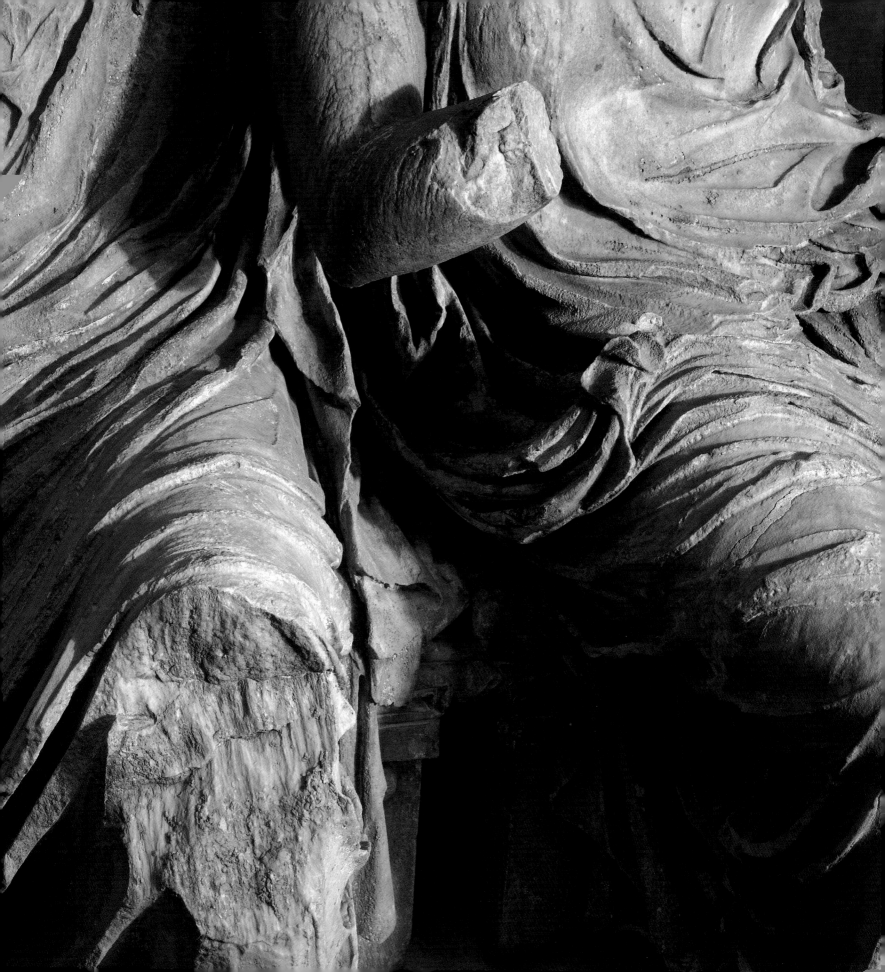

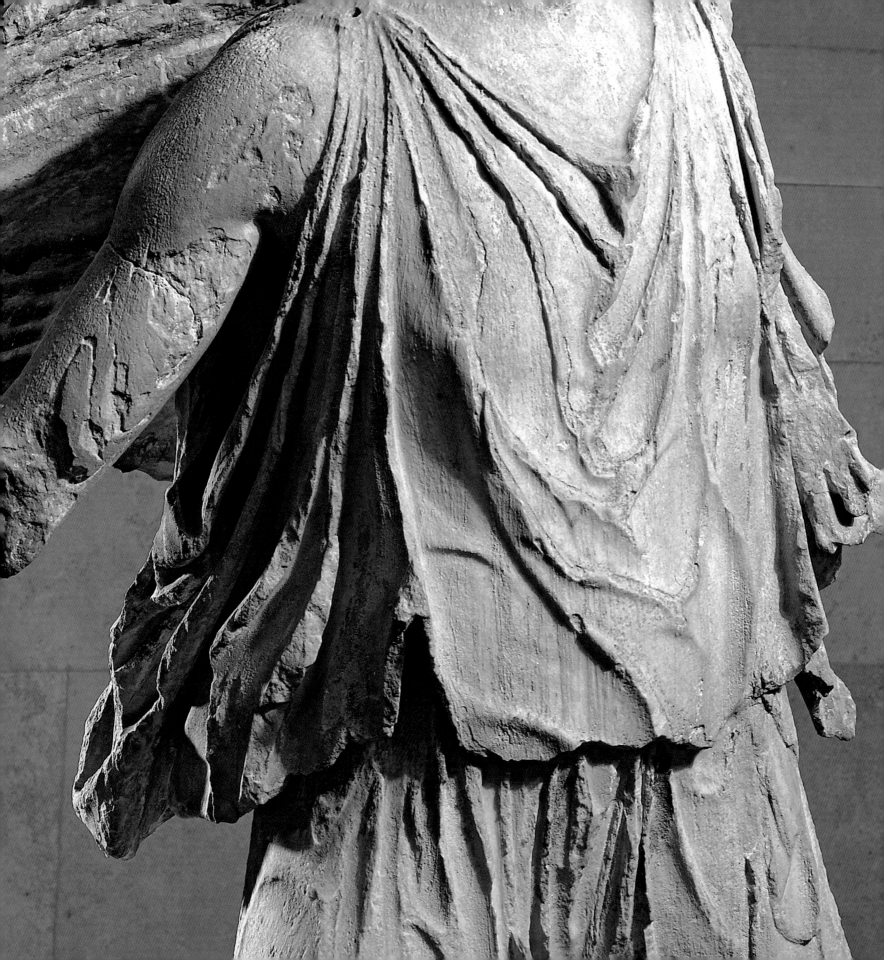

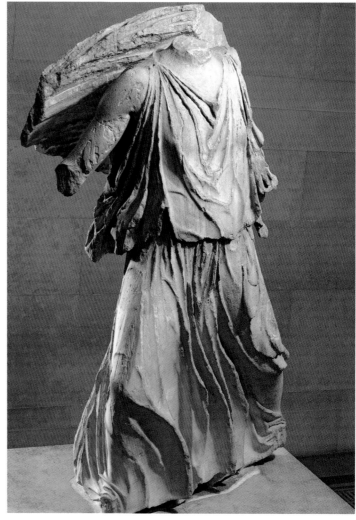

EAST PEDIMENT G *left and above*
A girl dashes away from the centre of the pediment where she has just witnessed the miraculous birth of the goddess Athena. As she lurches to the left, the drapery between her legs swings to the right. Shocked surprise is expressed through this vivid movement of her dress or *peplos*, a woollen garment woven as one rectangle of cloth. It is folded around her body with pins at the shoulders to keep it in place. This is the same type of garment as that woven every year to be dedicated to the goddess Athena at the Panathenaic festival. It is shown as a simple blanket of cloth in the central scene of the east frieze. The girl also wears a cloak, a fragment of which flies behind her missing head.

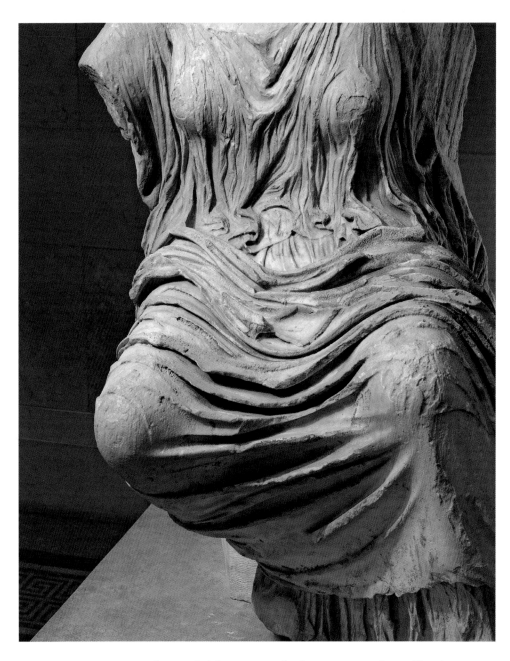

EAST PEDIMENT K *above and right*
Disturbed by the commotion of Athena's
birth at the centre of the pediment, a
seated goddess is on the point of rising.
She tucks her bent right leg and foot

under her to act as a lever. The drapery
between her knees is stretched taut
and is rendered tight and smooth over
her projecting right knee. This physical
tension reflects mental excitement.

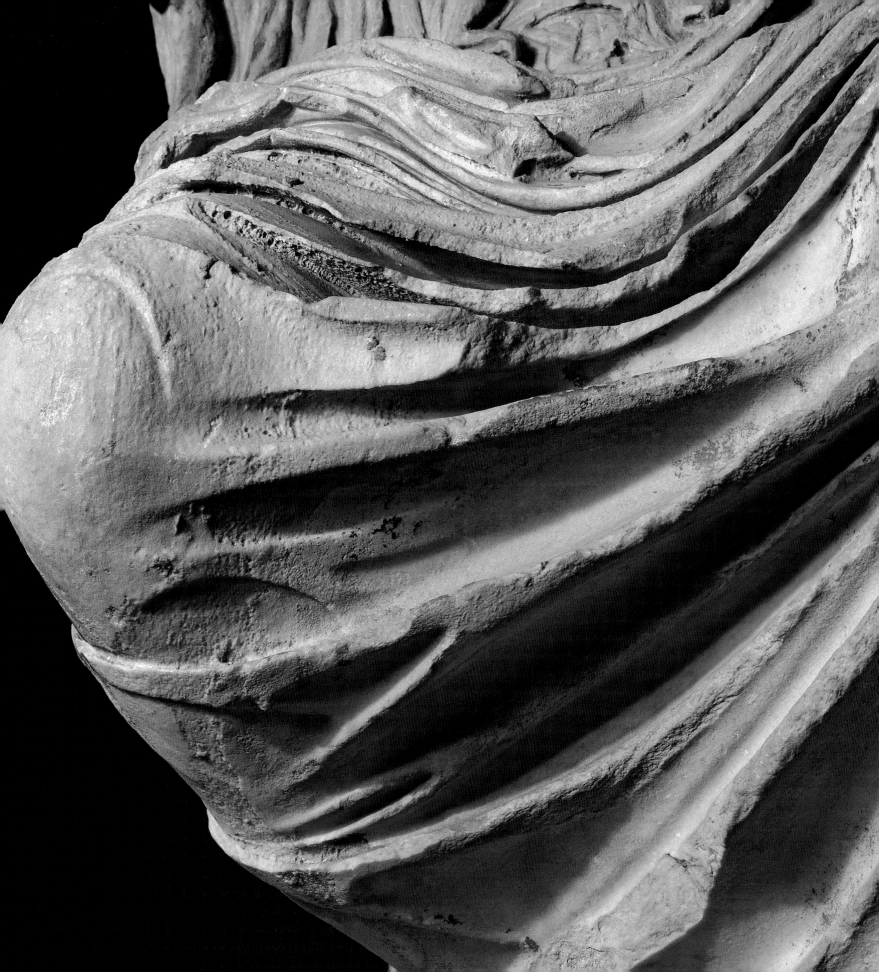

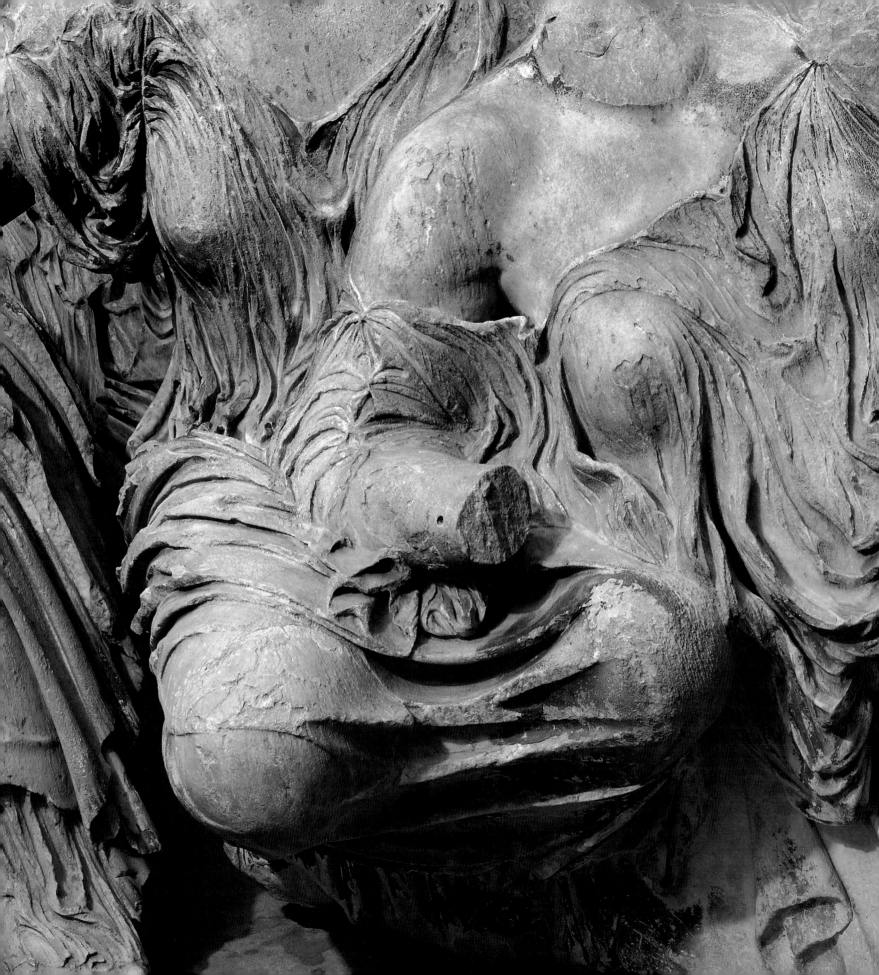

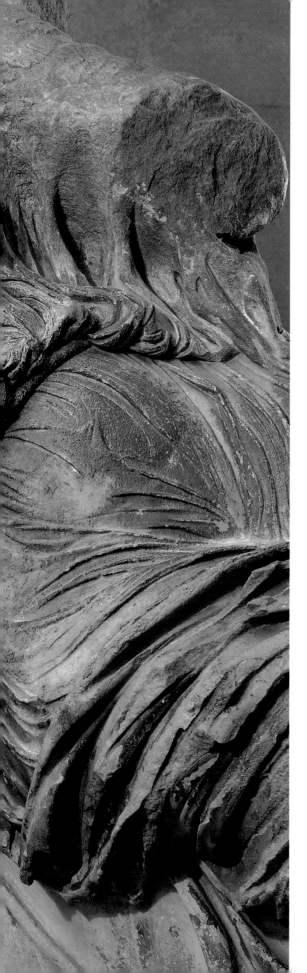

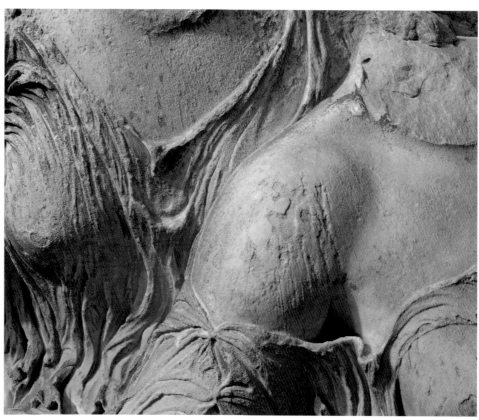

EAST PEDIMENT L AND M *left and above*
Two goddesses are carved from a single
block of stone, the one reclining luxuri-
ously on the lap of the other. Their com-
plex, wet-fold draperies swirl and swim
over their feminine forms, moulding
themselves to the rounded shapes of
breast, knee, abdomen and shoulder.
With a sleeve slipping off the shoulder,
the reclining figure, whose see-through
drapery is almost more revealing than it
would be if she were actually naked,
is charged with divine female sexuality.
It is not known who these sculptures
represent. The reclining figure is perhaps
Aphrodite, goddess of love, cradled in
her lap of her mother, Dione. Stretched
out on a fabric-covered rock, she nicely
balances the reclining figure of Dionysos
from the left-hand side of the pediment.

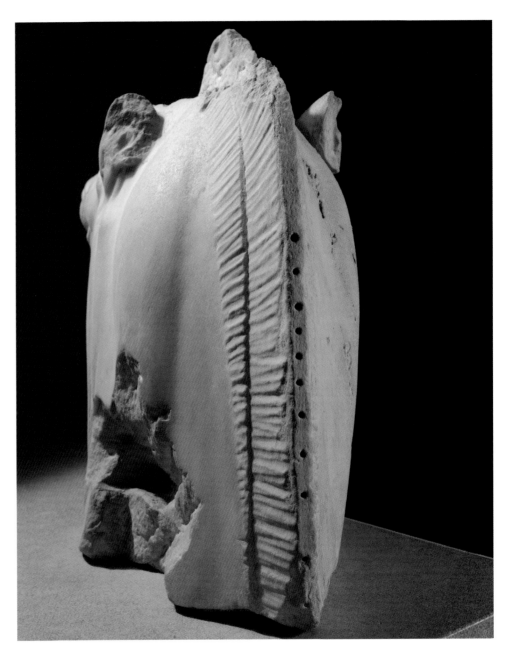

WEST PEDIMENT A *pp. 62–5*
From the corner of the pediment a
lissom youth portrays a river-god
raising himself onto a bank. Drapery
flows like water over his left arm
and disappears behind him, where
it is all the more water-like.

EAST PEDIMENT O *above and right*
The head of the horse of Selene is one of
four that were shown pulling the chariot
of the moon-goddess across the darkened
sky. This head is an exquisite study of a
horse nearing the end of its labour. The
signs of fatigue are shown in the gaping

mouth, flaring nostrils, bulging eye,
pinned-back ear and the skin, which is
stretched spare and taut over the flat bone
of the cheek. The mane is elaborately
cropped into a double row of bristle, and
the front was drilled to be decorated with
miniature finials, probably made of metal.

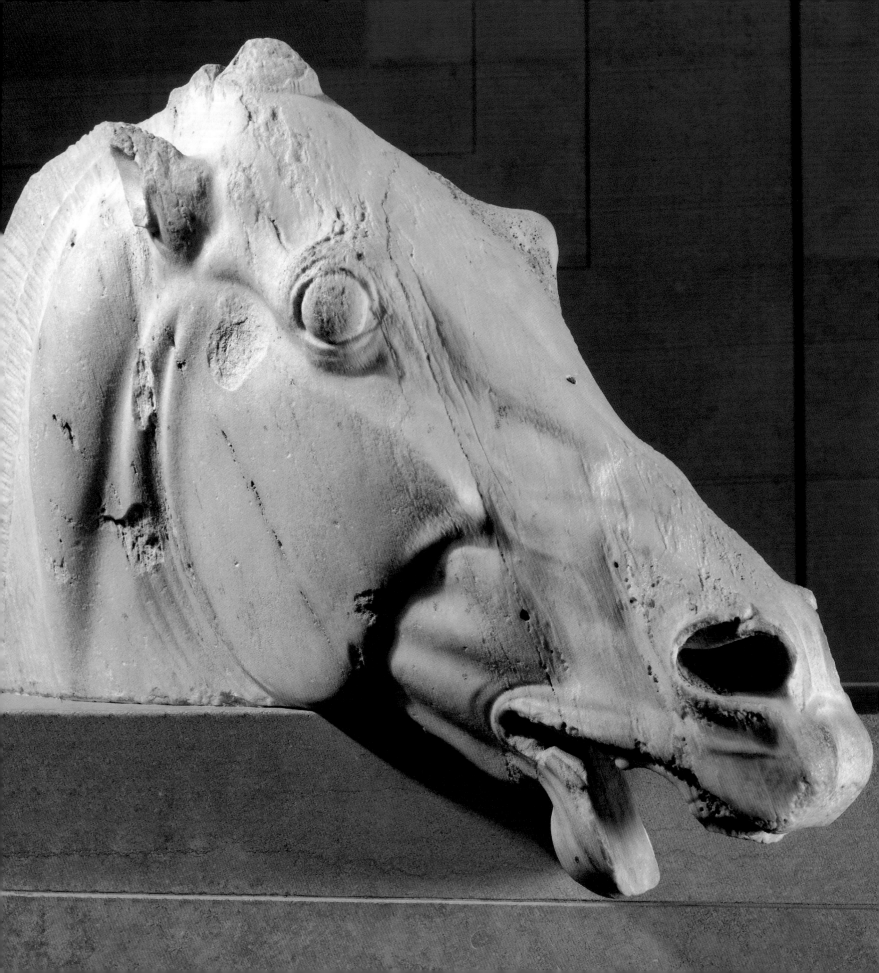

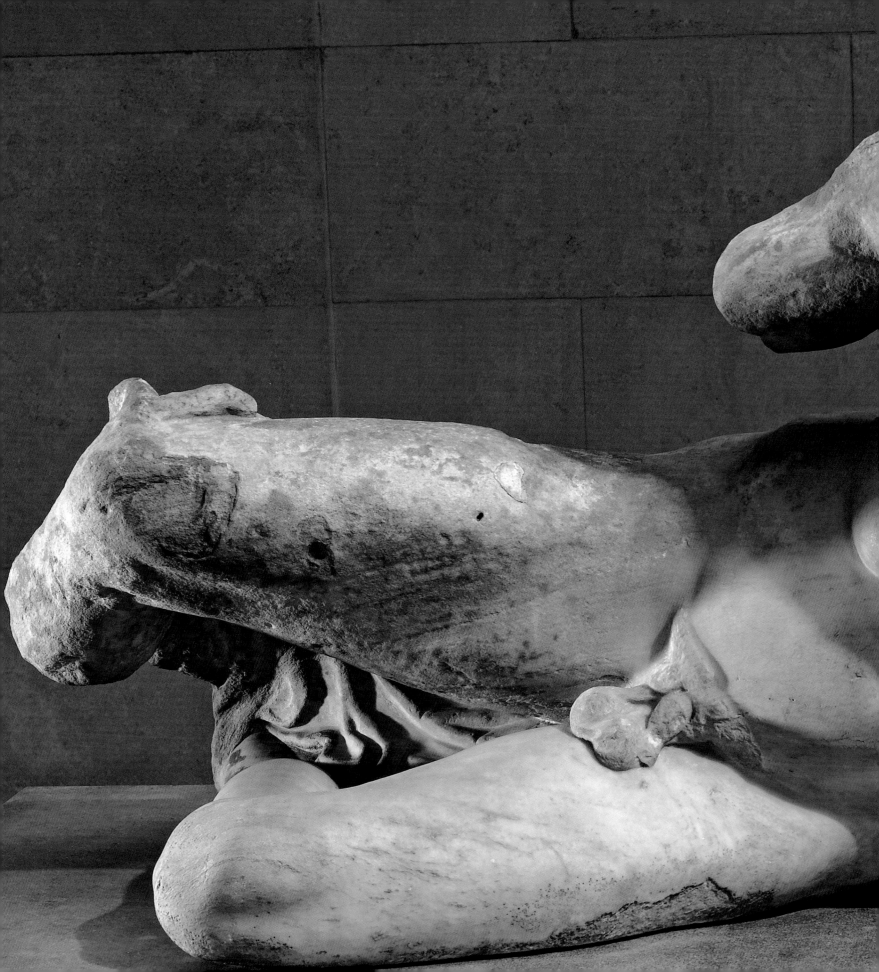

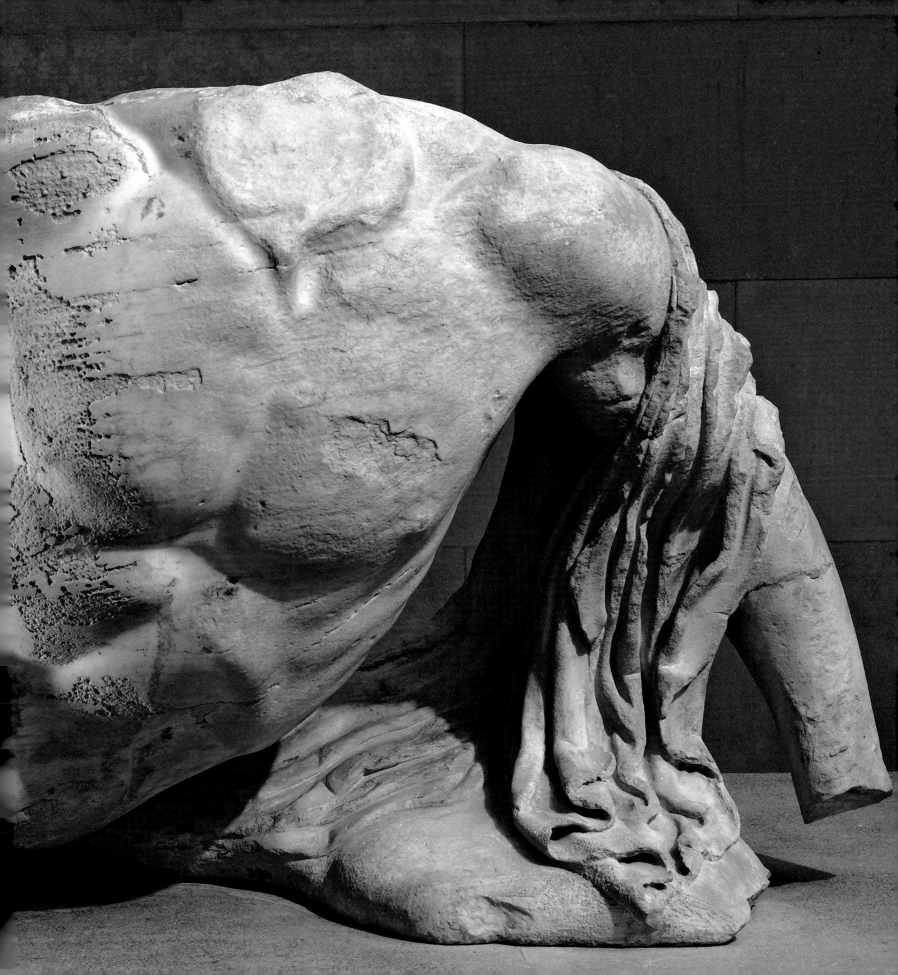

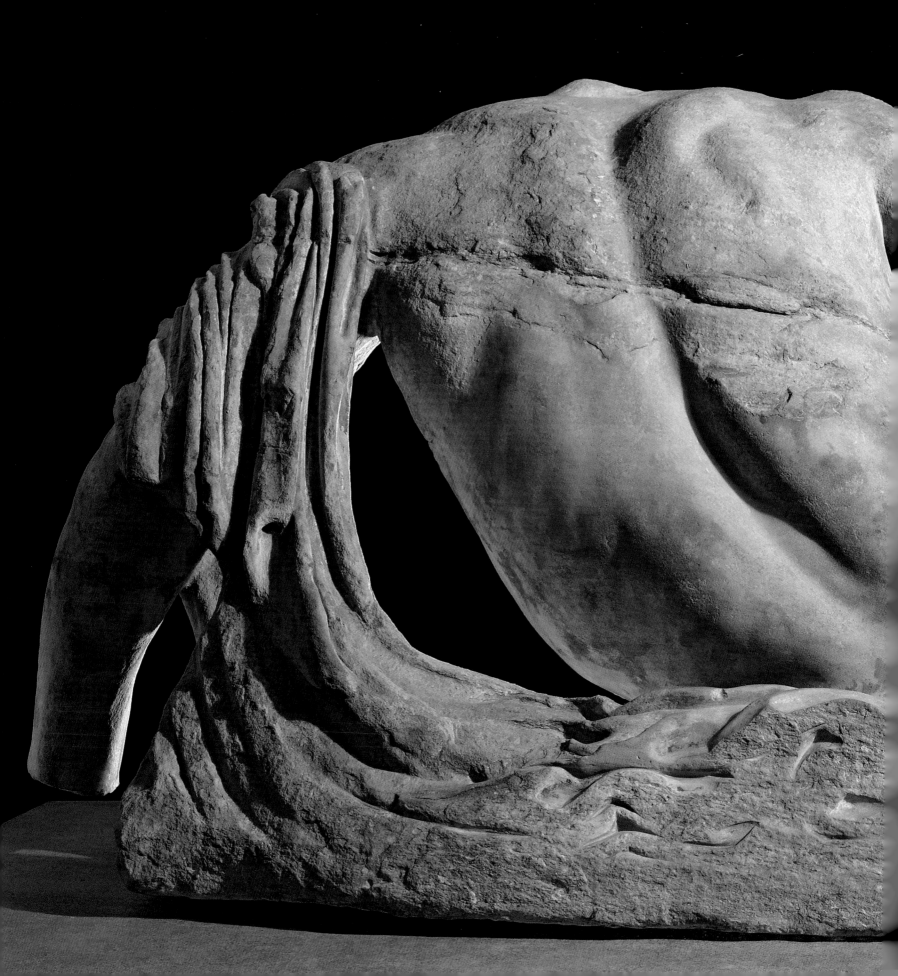

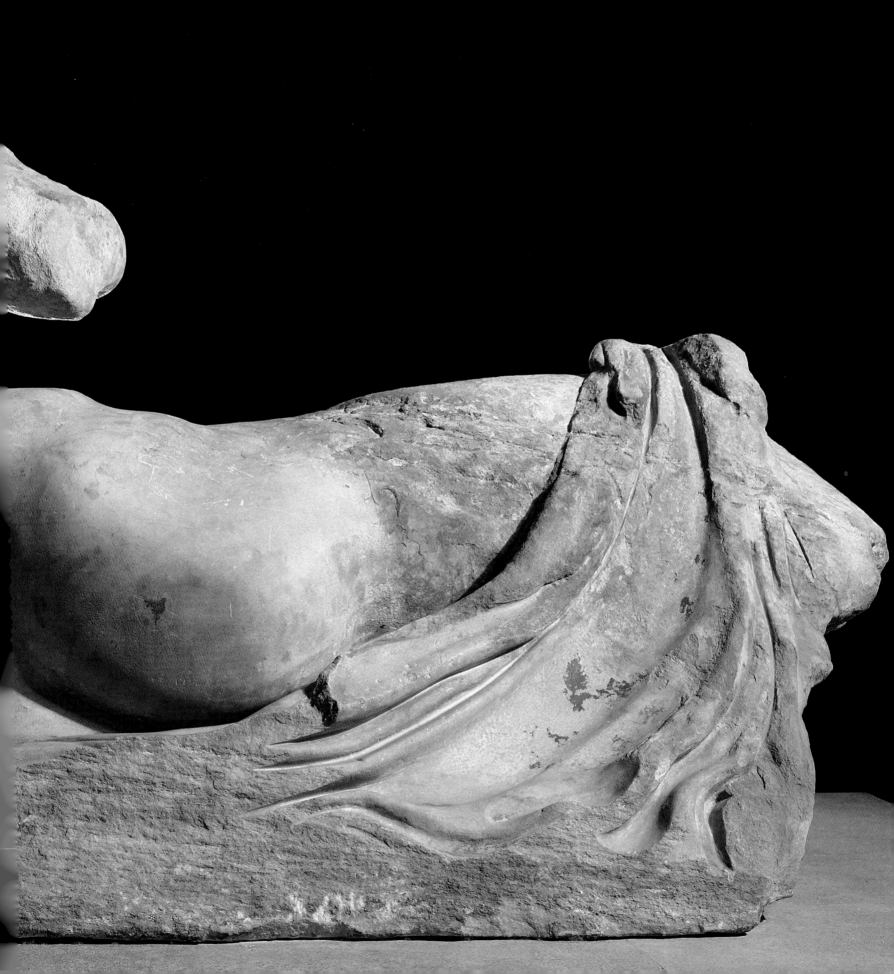

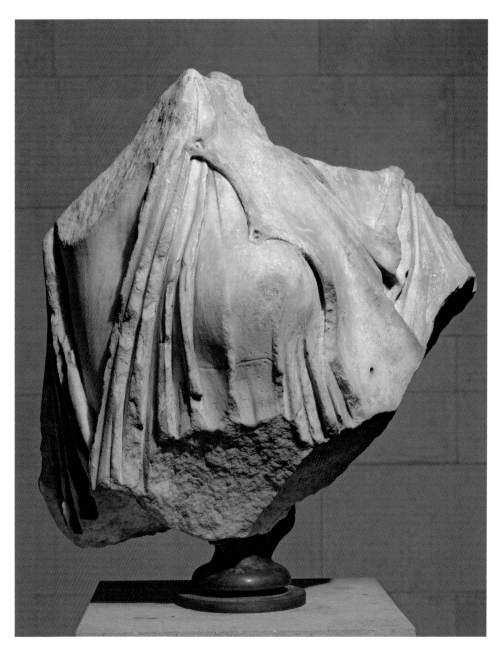

WEST PEDIMENT L *above*

This and a joining fragment of the helmeted head are all that survives of the once colossal figure of the goddess Athena. A girlish breast, lifted with the action of raising the missing right arm, shows through the folds of her tunic.

WEST PEDIMENT N *right*

Like the river god in the previous pages, this figure of Iris is a miracle of stone turned into flesh and cloth. The sculptor has created more than human form by conjuring the universal element of air in this representation of a girl in flight.

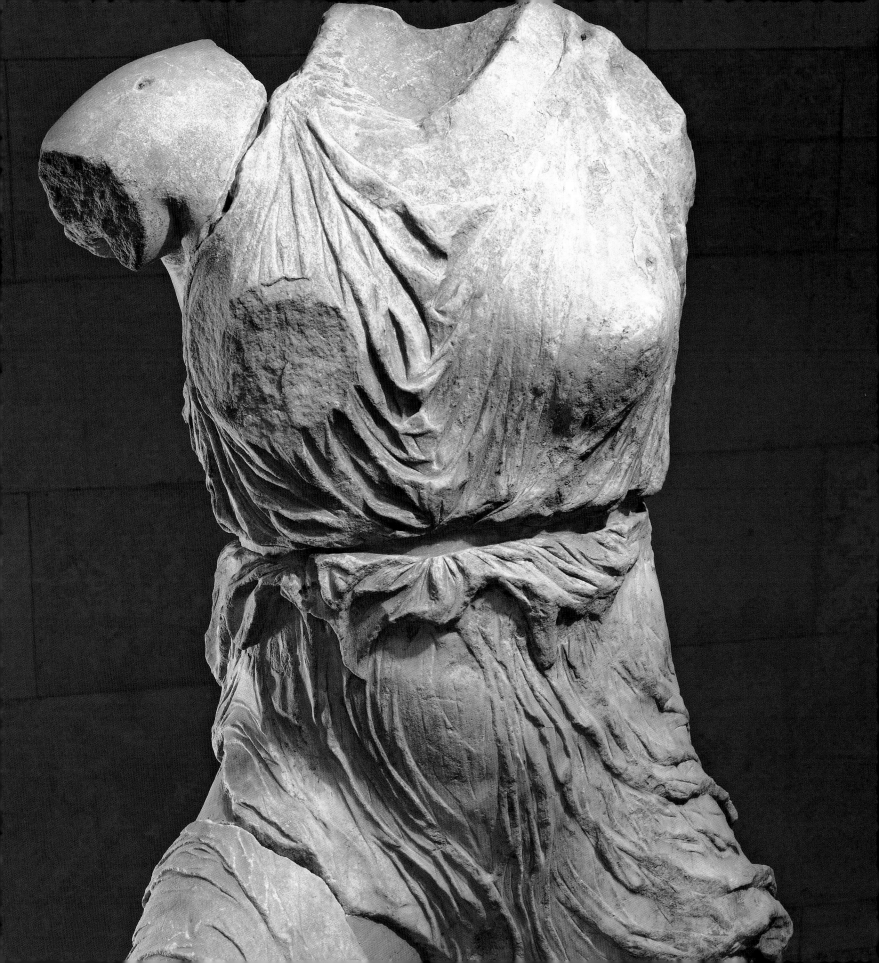

THE METOPES

THE METOPES OF THE PARTHENON WERE DESIGNED TO BE PART OF A FRIEZE PLACED ABOVE THE architrave resting on the columns. All ninety-two metopes were carved in high relief with scenes from Greek mythology: on the west side, combat between Greeks and Amazons; on the north, scenes from the sack of Troy; on the east a battle of gods and giants; a major theme of the metopes on the south side was a fight between Centaurs and human Lapiths, who were supposed to live in northern Greece. The scene of the battle was probably the wedding of Perithoos, the Lapith king. The Centaurs, part man part horse, were invited to the feast but became drunk, and a fight broke out as they tried to carry off the Lapith women. All the metopes in the British Museum come from the south side of the building.

There are only ever two figures in the frame. Centaur and Lapith are usually shown locked in mortal combat. Great ingenuity is exhibited in varying the manner of the fight. Often it is a wrestling match, but sometimes weapons are used. The Centaur, perversely against the laws of hospitality, may wield one of the vessels from the party as a club. For the most part the outcome of each fight is undecided, but in metope 28 a Lapith lies lifeless along the ground-line of the picture and invites our mortal pity. In some metopes we witness not the fight but its cause. Metope 29, for example, shows a Centaur making off with a Lapith 'filly', who struggles to escape.

Some variation in the style of carving the figures in the metopes and, indeed, some unevenness of competence in design and execution may indicate that these were the earliest sculptures, carved in something of a hurry, so that the roof could go on the building before it was dedicated in 438 BC.

SOUTH METOPE 26 *left*
A human Lapith fends off an attacking Centaur with his foot. We feel the pressure of toes bent back and the strain of leg muscles.

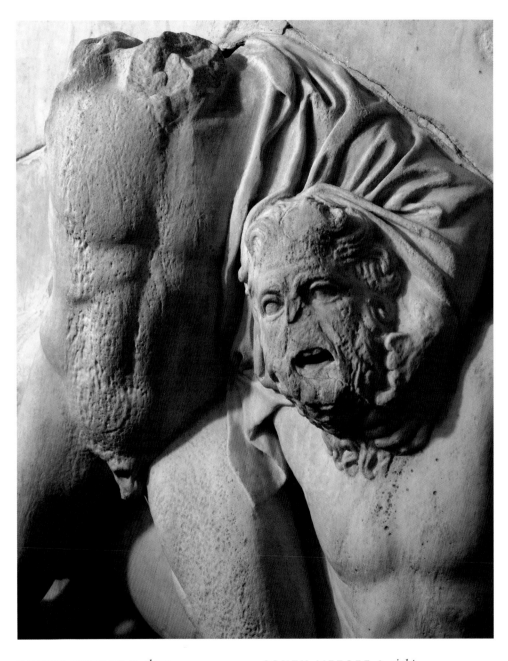

SOUTH METOPE 2 *above*

A Lapith wrestles his opponent to the ground, gripping him by the throat and beard. The Centaur's mouth gapes open as he gasps for breath. The Lapith's headlock is a hold observed from real-life wrestling in the gymnasium.

SOUTH METOPE 3 *right*

Wearing cloak and ankle boots, a Lapith springs onto the back of a Centaur. As elsewhere in the metopes, the Lapith's penis was made separately and dowelled into place.

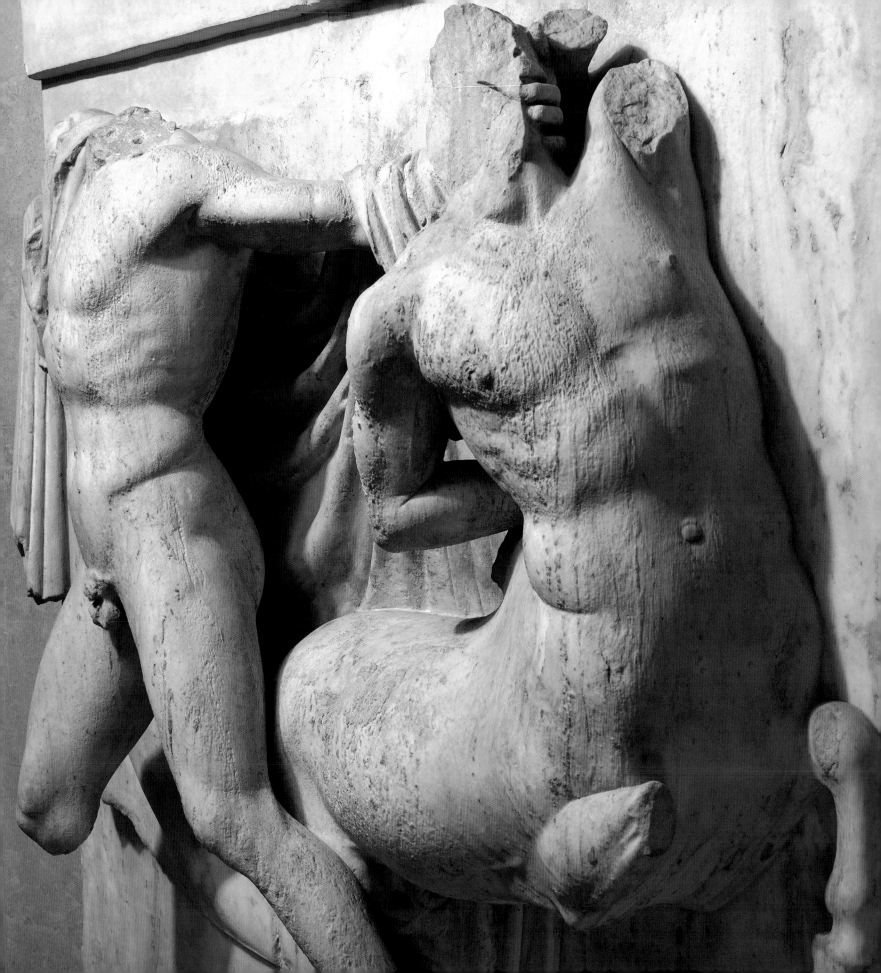

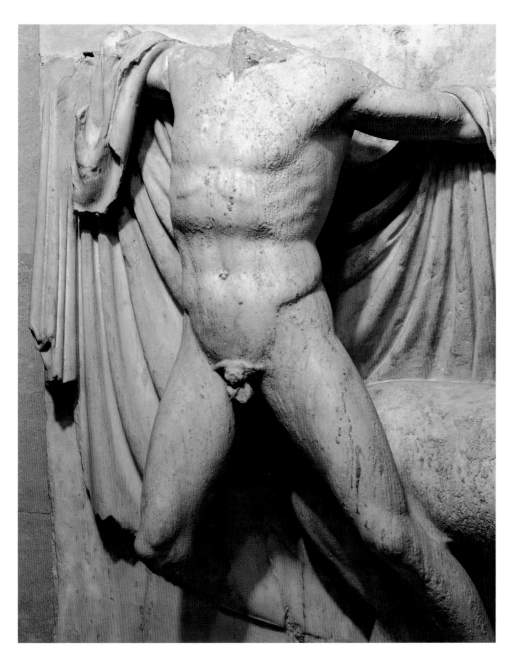

SOUTH METOPE 27 *left and above*
A Centaur pressing a wound in his back
tries to gallop away but is held at the
neck by a Lapith, who draws himself up
to deliver the fatal blow. Viewed from the
side, the Lapith is undercut so deeply as
to appear to hang off the metope,
suspended in the air. Viewed from
the front, the human figure is set
off against his cloak, which fans out
behind him like a stage curtain.

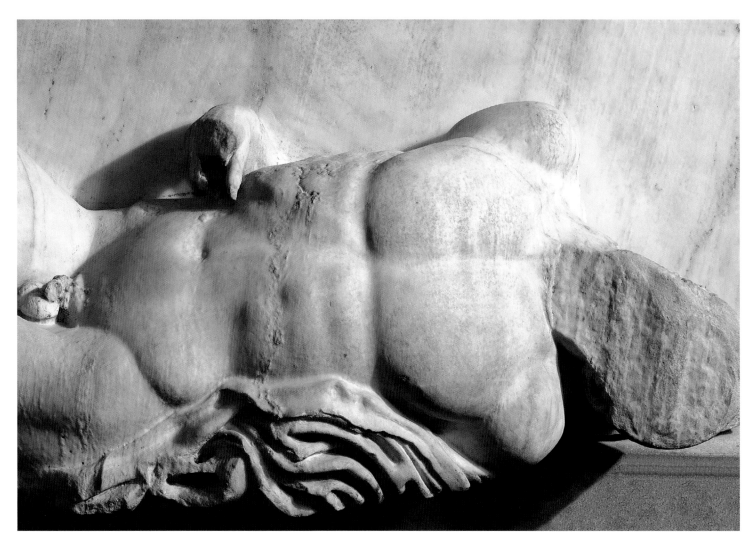

SOUTH METOPE 28 *above and right*

The whole composition of this metope is
perfectly balanced to contrast the savage
horror of the Centaur's triumph with
the pitiful plight of the dying Lapith.
A youth lies unconscious on the ground.
Life flows from his limbs as his head,
the face split away, rolls to one side.
Over him the Centaur rears in triumph,
punching the air with the left hand,
from which hangs the skin of a panther.
The Centaur's other hand brandished a
wine-mixing bowl, normally a token of
hospitality but here perversely turned
into a weapon with which to bludgeon a
host. The panther's tail and paw fly into
the open space behind the Centaur, as his
own flame-like tail rises to meet them.

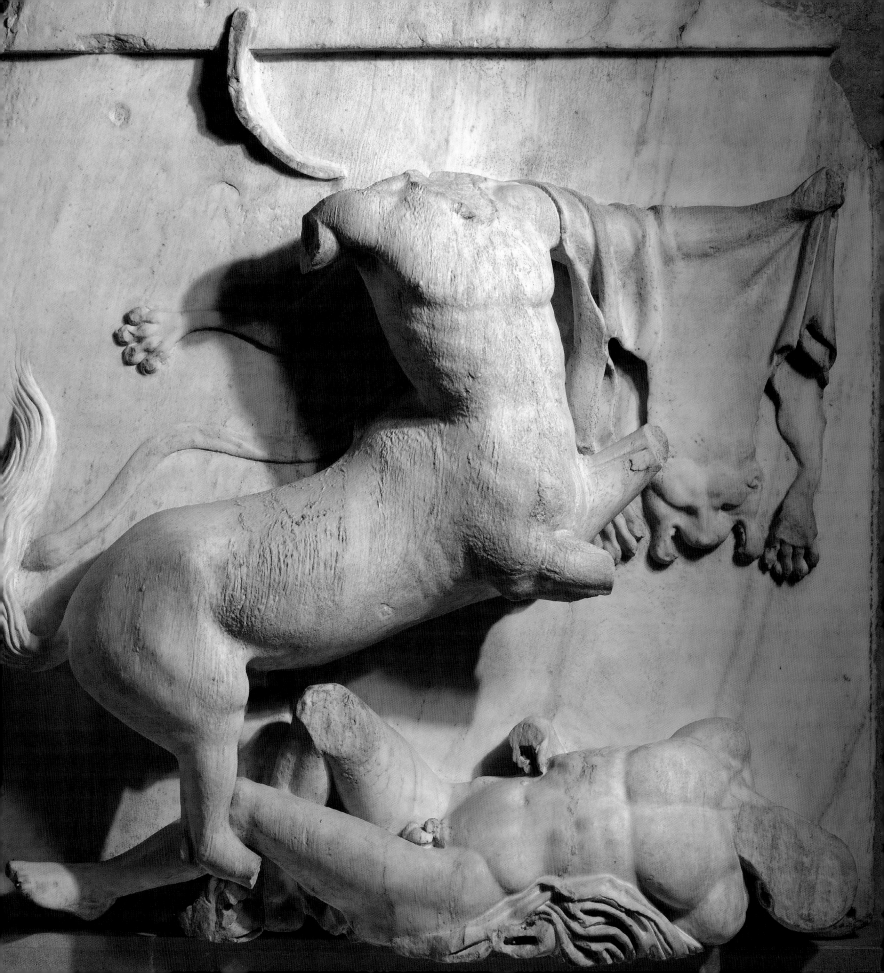

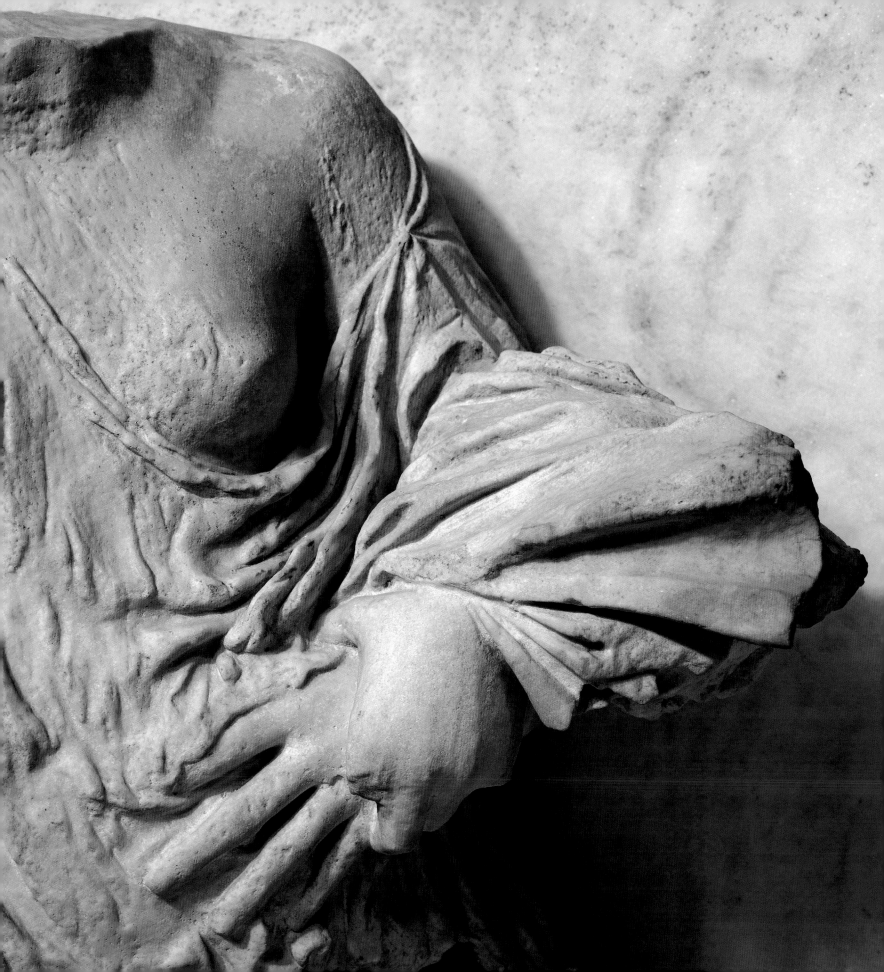

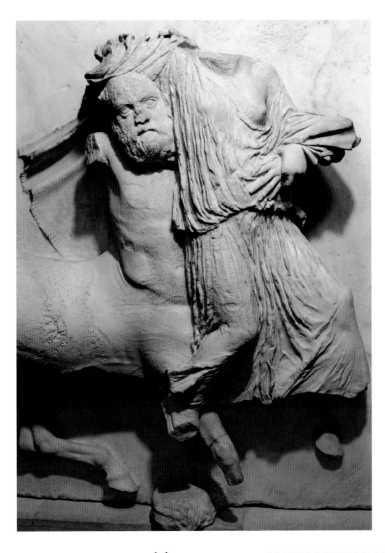

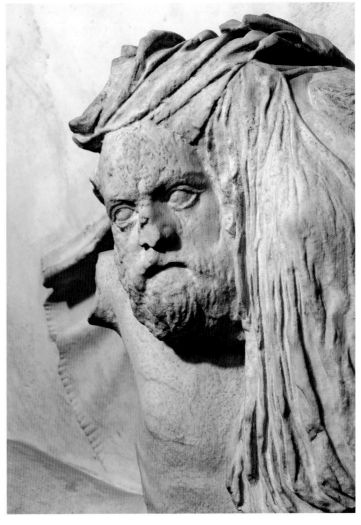

SOUTH METOPE 29 *left*

As a hand struggles to unlock her captor's grip, a young girl's tender breast is exposed to view. She wears the *chiton*, a tunic woven of fine linen, pinned on the shoulder to form loose sleeves. A fragment of a second garment, a heavier woollen mantle, pours over her arm and disappears behind her back before re-emerging from her right side, where it flies free.

SOUTH METOPE 29 *above left and right*

In contrast with the tragic mask of some Centaur faces, here the beast has the bald and bearded head of a satyr. As he rides gleefully away with his prize, the Centaur looks out of the picture, the iris and pupils of his eyes visible on the surface of the marble, where once they were painted.

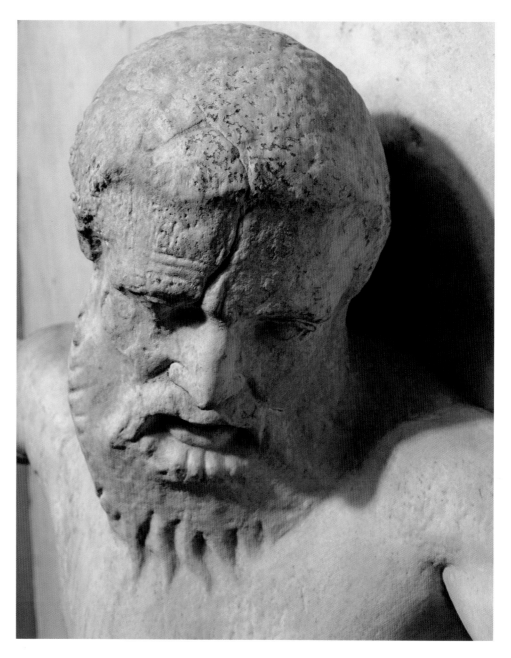

SOUTH METOPE 30 *above and right*
Combatants deliver and receive blows in a
tangle of human and animal limbs. The
tense body of the crouching, distressed
Lapith is a perfect study in youthful male
anatomy. We see the firm, lean outline
of the pectoral muscles, a well-formed
shoulder and bicep, the play of shadows
across corrugated skin stretched tight over
the rib cage, the swelling abdomen and
the muscle separating waist from rounded
thigh. By contrast with the grimace of the
Lapith, the Centaur's face, with its hoary
beard, seems calm and almost pitying.

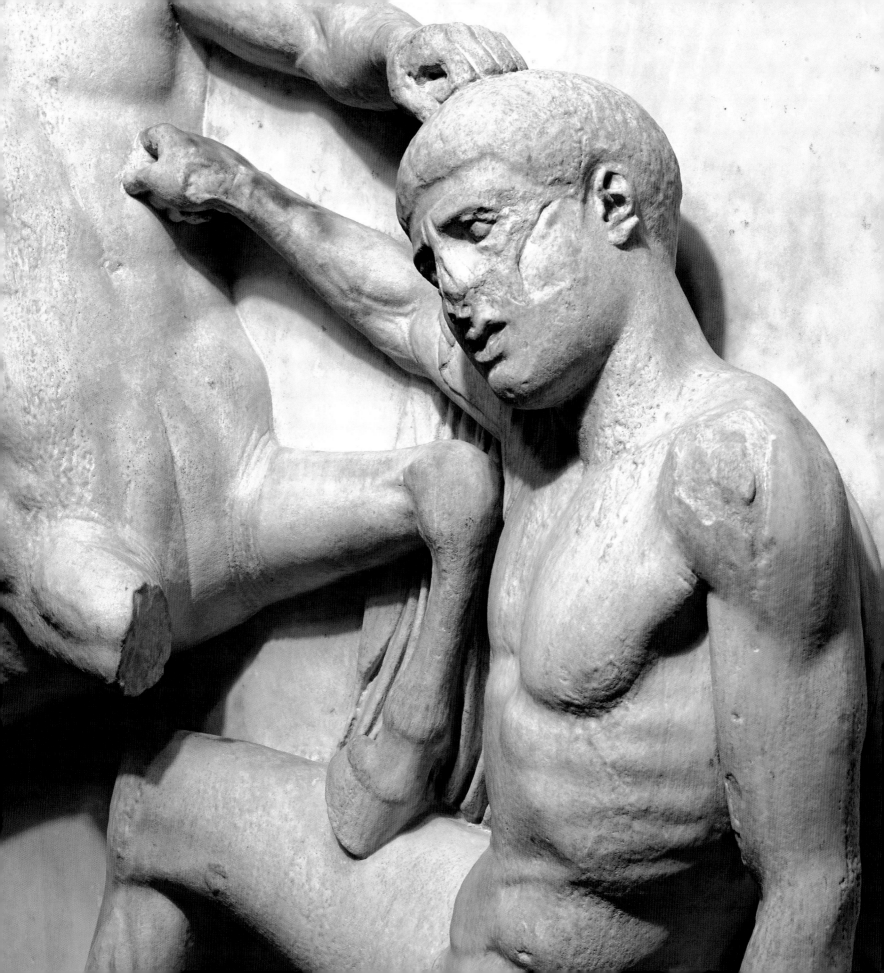

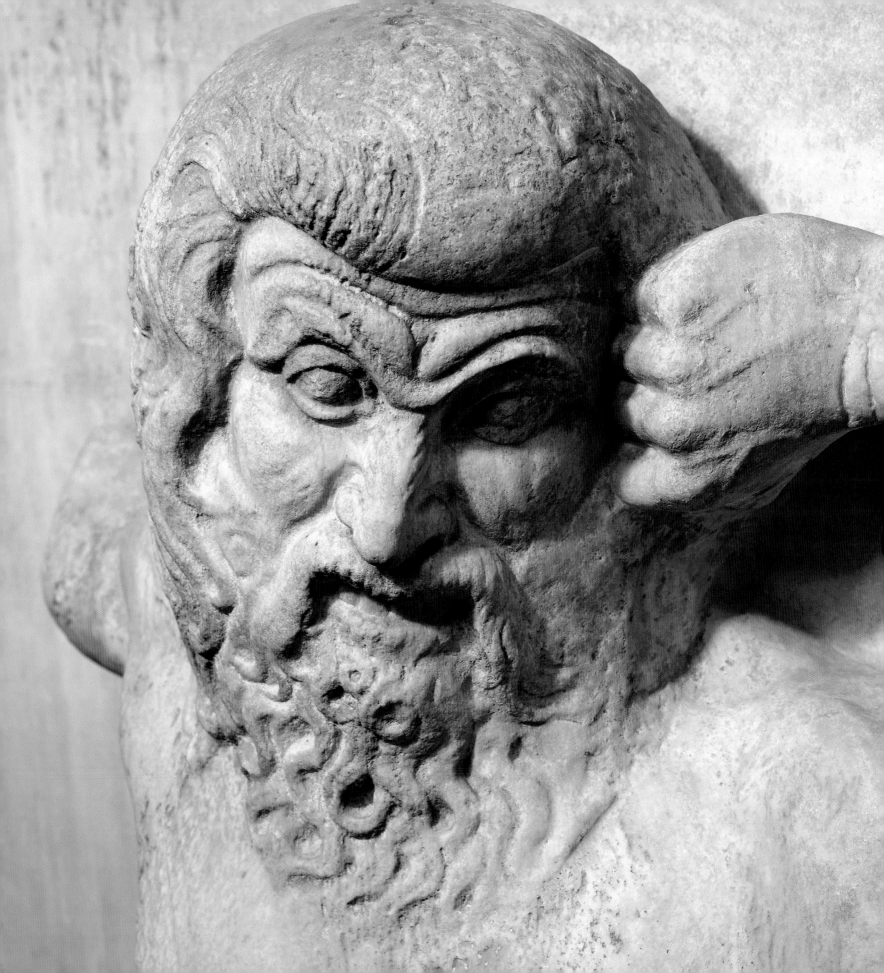

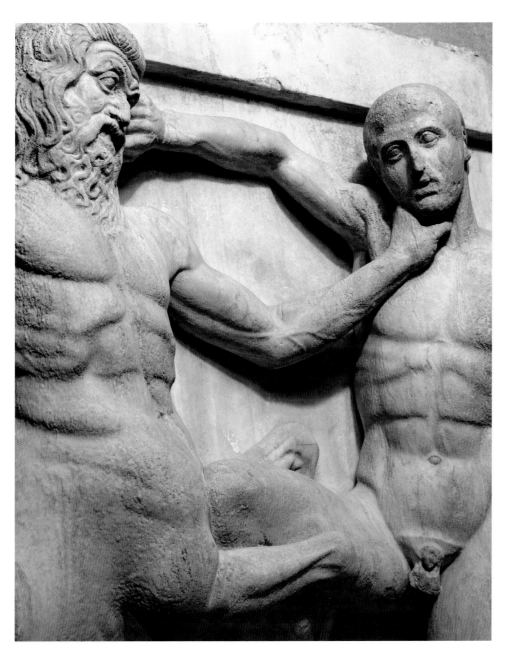

SOUTH METOPE 31 *left*

The Centaur's face is a grimacing mask, resembling the tragic masks of the Greek theatre. Its features include a heavily furrowed brow, deep-set eyes, wrinkled nose and teeth bared in pain and rage.

SOUTH METOPE 31 *above*

Centaur and human Lapith are locked in mortal combat. The one takes his opponent by the throat, while the other snatches at the hair of the monstrous head.

THE FRIEZE

THE PARTHENON FRIEZE RAN AS A CONTINUOUS BAND OF LOW-RELIEF CARVING AROUND ALL FOUR sides of the temple. It showed a procession (see fig. 38 on p. 43), which began on the west side of the building and was then divided into two branches, running along the long north and south sides. On the east side, the leaders of the procession converged towards the gods, seated in two groups, one facing the northern division and the other facing the southern.

The procession was that of the Panathenaic festival, celebrated in high summer to commemorate the birthday of Athena. Every fourth year the festival was celebrated with particular splendour as the Great Panathenaia. The procession carried a specially woven robe, or *peplos*, to the Acropolis, where it was dedicated to the goddess.

The frieze represents various groups taking part in the procession. The west frieze faced the entrance to the Acropolis and showed horsemen preparing to mount or moving off. The cavalcade continues on the north side, where riders occupied twenty-one of the forty-seven blocks that made up the frieze on that side. Ahead of them came racing chariots and then groups of pedestrians: elders, musicians, pitcher-bearers, tray-bearers and attendants leading sacrificial victims. The procession followed a similar pattern on the south side. The north and south frieze continued on the east side with girls carrying cult vessels, including jugs and bowls for pouring libations. Towards the middle, the procession approaches groups of standing men – maybe officials or tribal heroes – and an audience of seated gods, who are shown on a larger scale than the mortals. In the centre of the east frieze the priestess of Athena appears with two girls carrying stools on their heads. The *peplos* itself is shown being folded or unfolded by a long-robed priest and a child.

SOUTH FRIEZE III *right*
In very shallow relief the sculptors of the frieze create delightfully living pictures, such as this athletic torso of a youthful rider, one of sixty who were shown in the south cavalcade.

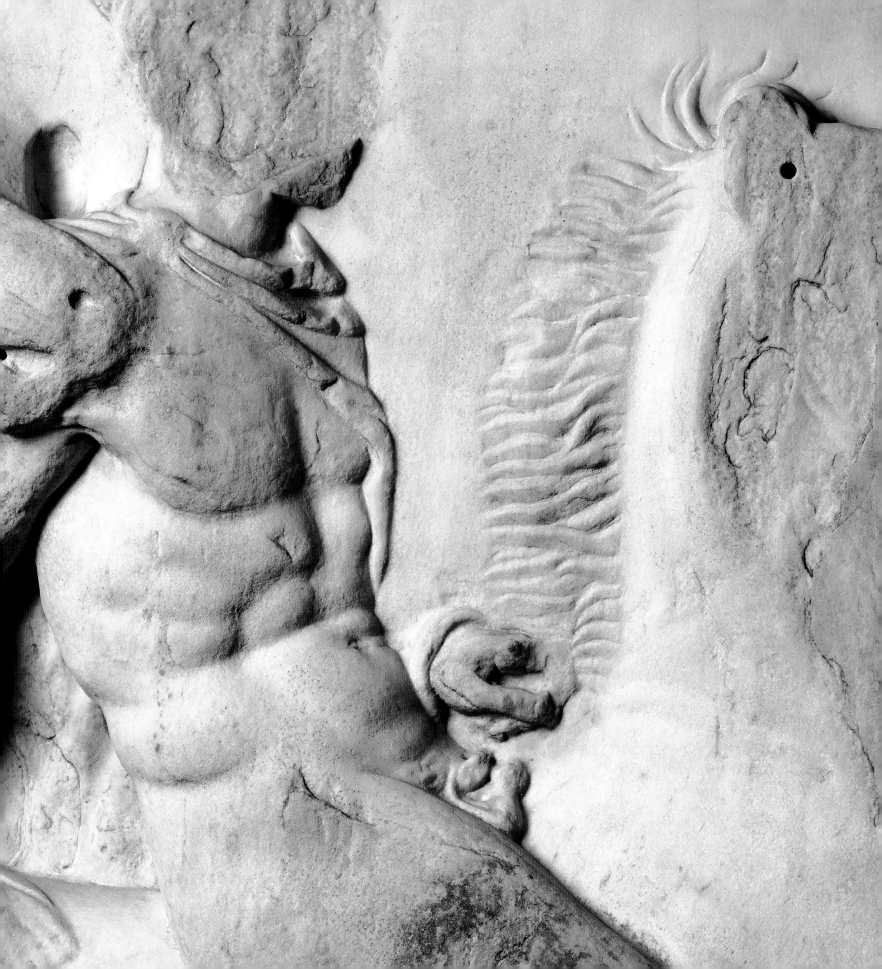

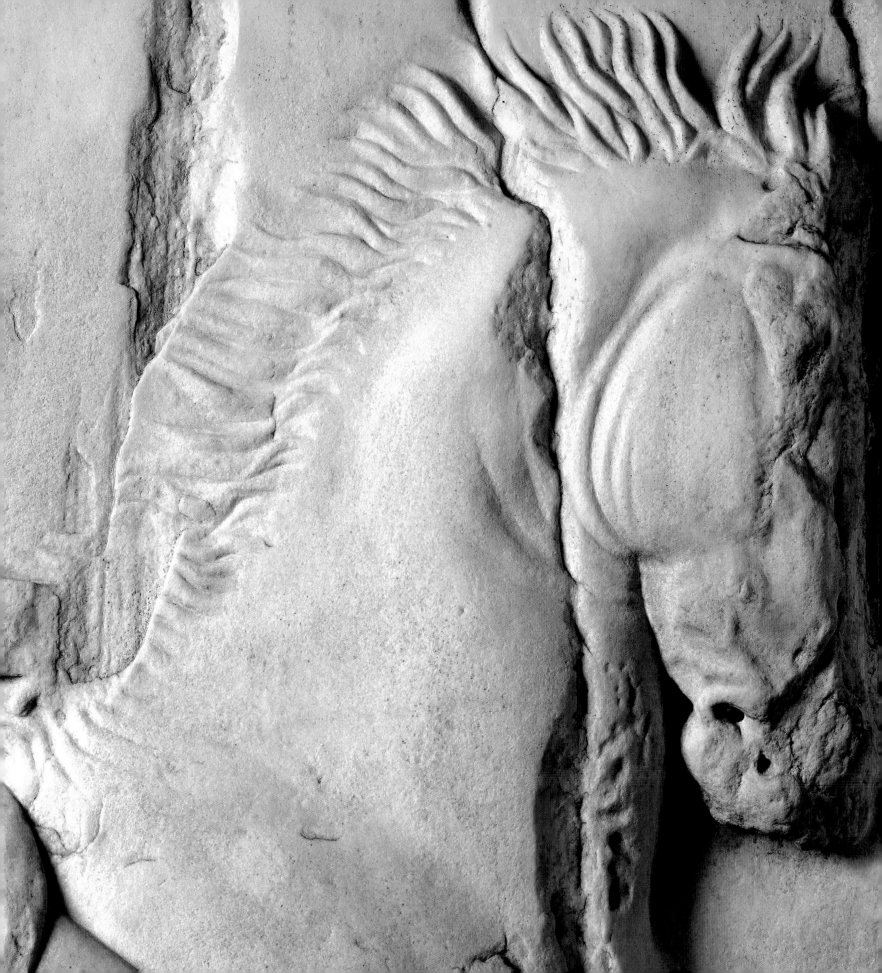

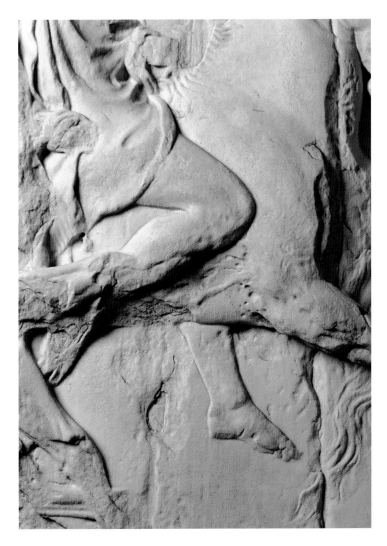

SOUTH FRIEZE III *left*
Individual sculptors treat the manes
of the horses differently from others.
The neck of this horse seems aflame
with flickering fire.

SOUTH FRIEZE III *above left*
The horsemen of the Parthenon frieze
ride without saddle or stirrups.

SOUTH FRIEZE III *above right*
A bare foot hangs free, the curling
toes tenderly observed.

SOUTH FRIEZE X *above*

The fingers of a lifelike hand curl to hold
a horse's rein, which will have been
added as a metal attachment, now lost.

SOUTH FRIEZE IX *right*

The manes of these two horses stand
up like stiff bristle. They must have been
finished with detail added in paint.

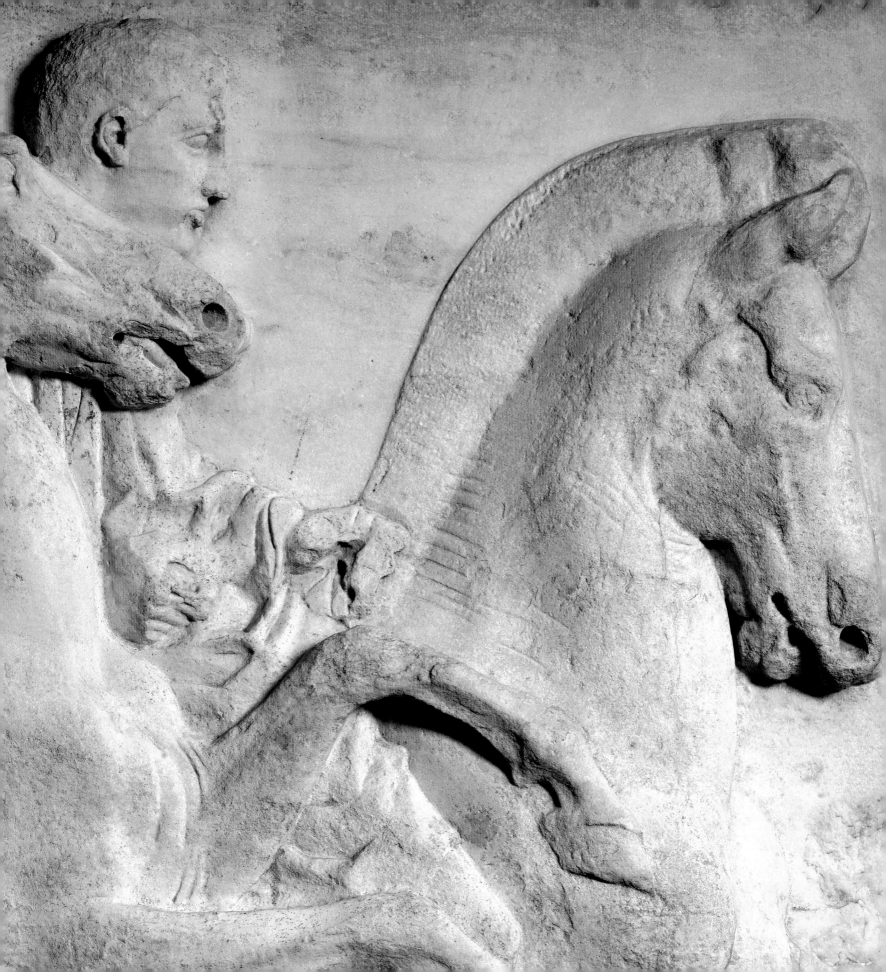

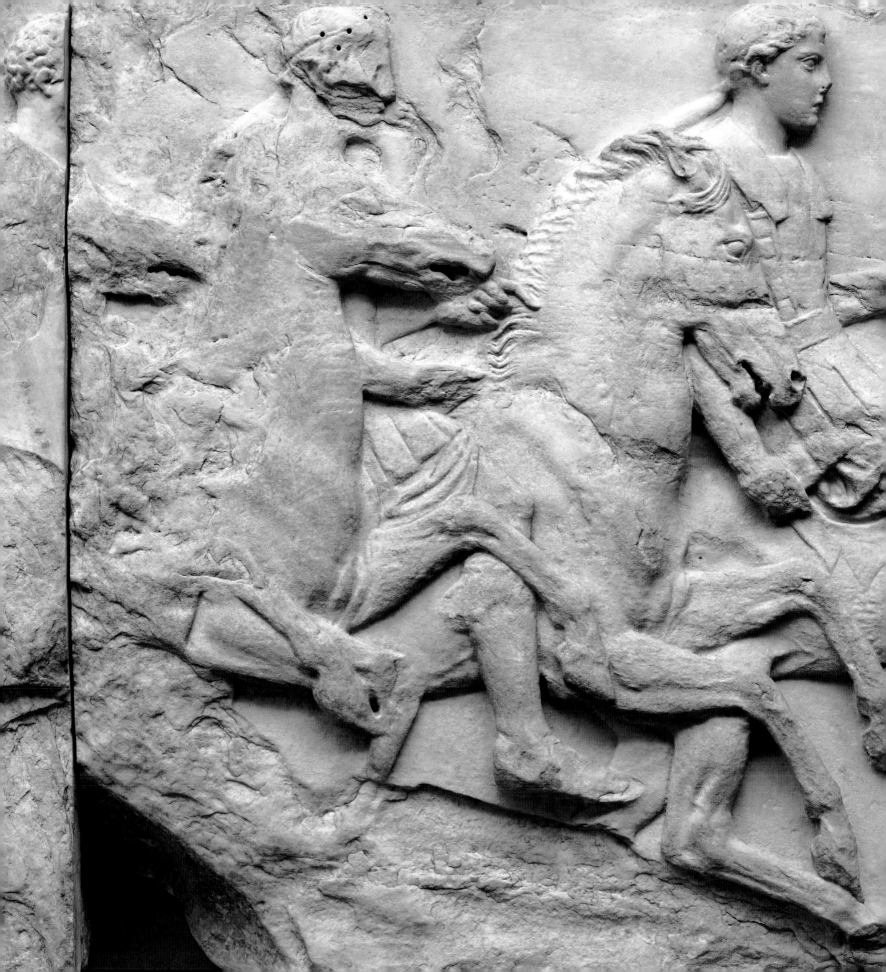

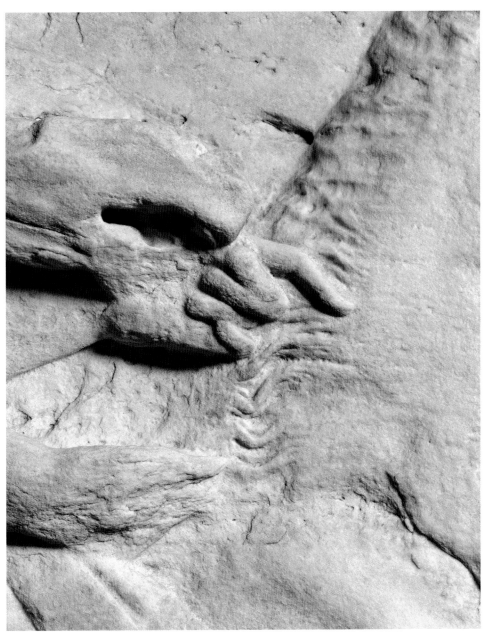

SOUTH FRIEZE XIII *left and above*
The south frieze arranges its sixty riders into ten groups of six, each with its own manner of dress or armour. Here an animal-skin hat, with tail behind, is worn with body armour over a short tunic and with long riding boots. Although dressed the same, subtle differences are introduced to the way each rider manages his horse. The detail shows the distinctive arrangement of the fingers of a rein-holding hand.

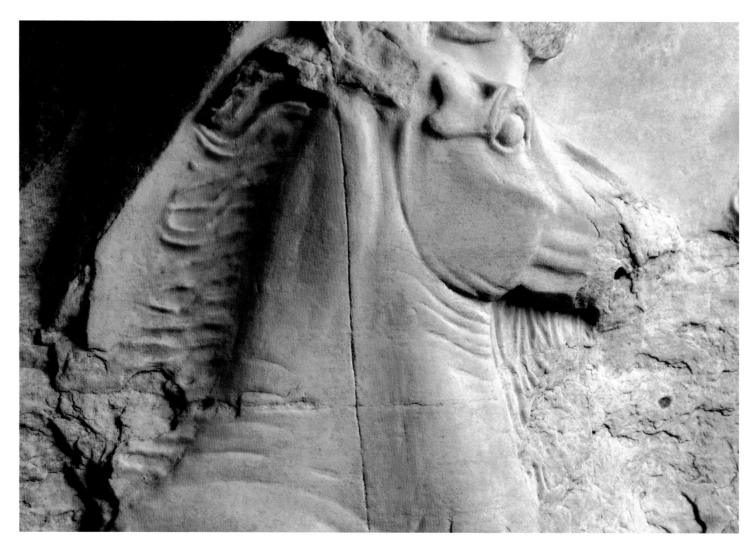

SOUTH FRIEZE XV *above*

This spirited head of a horse with its bulging eye and pronounced cheekbone is reminiscent of the head of the horse of Selene from the east pediment (see p. 61).

SOUTH FRIEZE XIII *right*

A rider wears a corselet of leather or, perhaps, of stiffened linen. From the belt hangs a series of flaps (*pteryges*) to protect the midriff, while at the same time allowing movement.

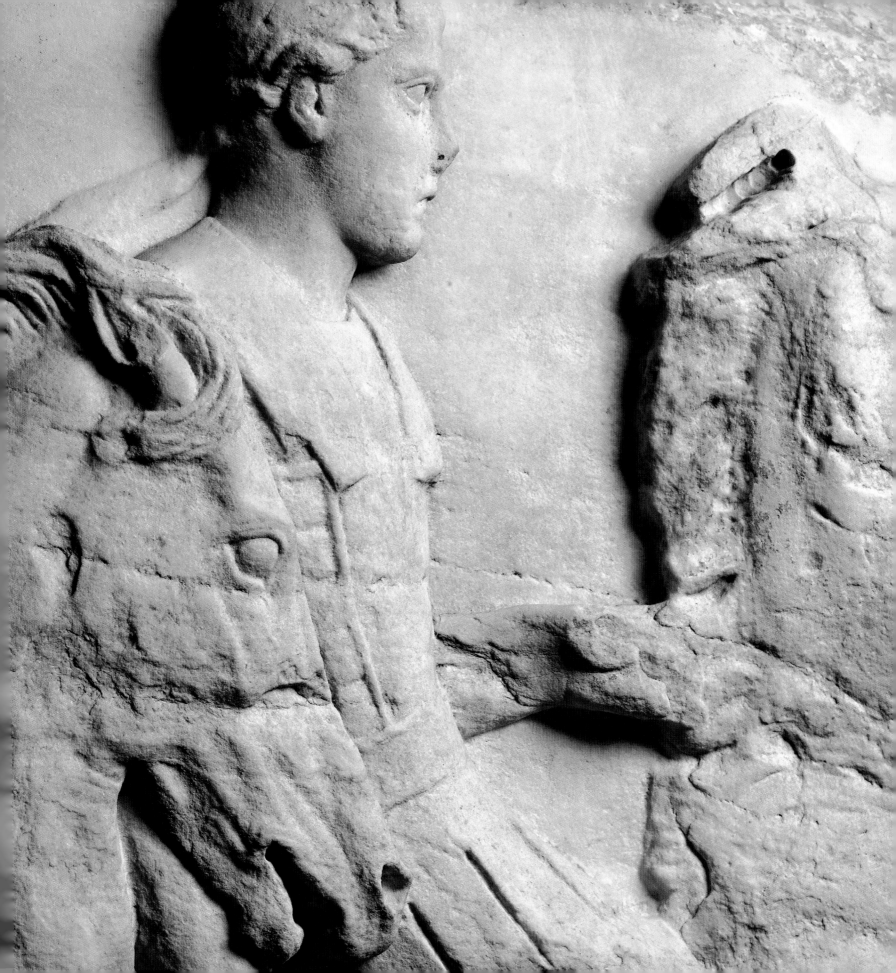

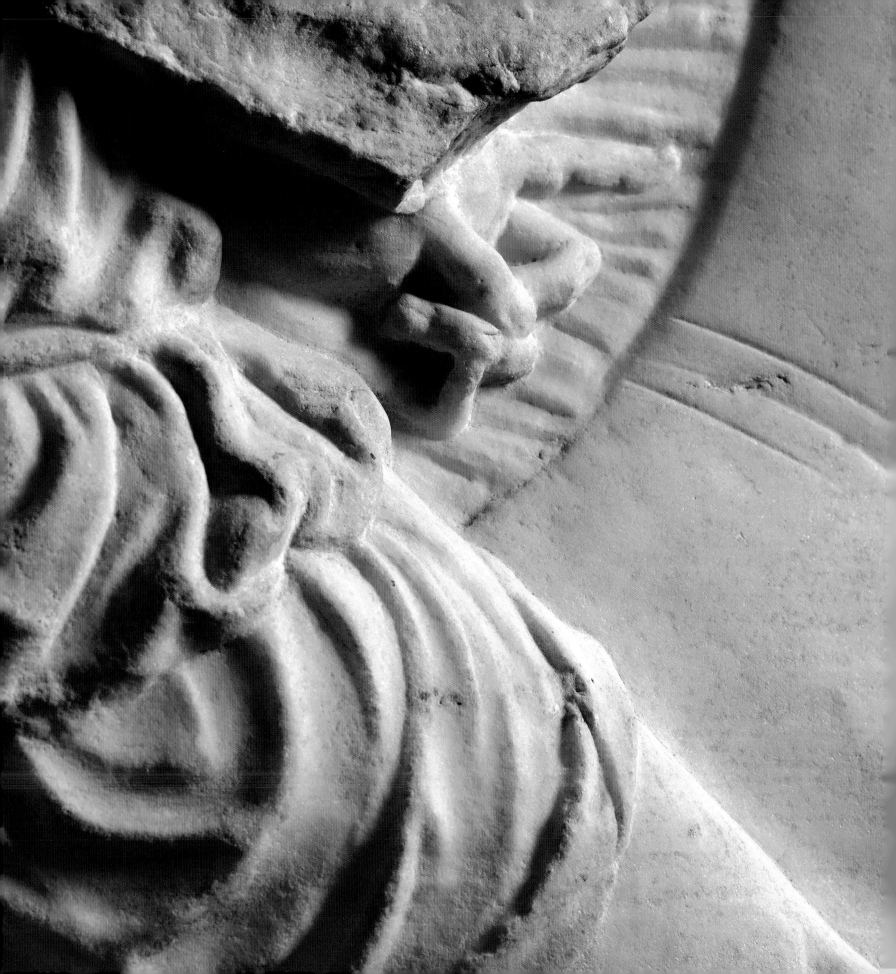

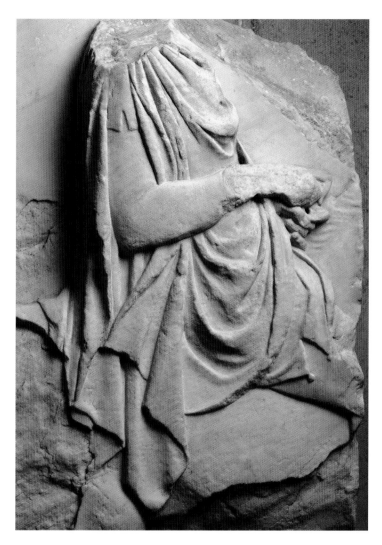

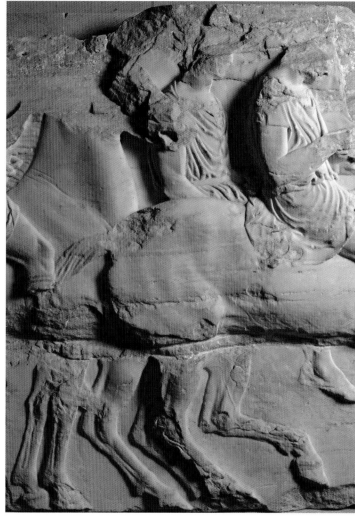

SOUTH FRIEZE XXIII *left*
An index finger is extended, while other fingers curl to hold a now missing rein. Here we witness the complex layering of different surfaces to build up a picture in the shallow relief of the marble.

SOUTH FRIEZE XIX *above left*
A short cloak, pinned on one shoulder, is worn over a skimpy tunic. A drill hole in the hand indicates where the rein, once added in metal but now lost, was attached.

SOUTH FRIEZE XXIII *above right*
At the head of the cavalcade riders trot to a halt, reining in their horses in anticipation of the chariot that stands ahead.

SOUTH FRIEZE XXVI *right and above*
The chariot race is introduced with
a stationary vehicle. Each chariot
accommodated two figures, the driver
and a footsoldier. On reaching a marker
in the real-life race, the footsoldier would
leap out of the vehicle and finish on foot.
Here he stands with the weight resting
on one foot, wearing a tunic, belted twice
at the waist, and a cloak falling behind.

His right arm and hand hang free,
the fingers expressively arranged.
His left arm supports a round shield,
the hand-grip once attached by a large
drill hole. On the other side of the
horses, a marshal extends his arm in
a commanding gesture. A detail of the
marshal's hand reveals the care that
went into carving the fingers and the
joint of hand to wrist.

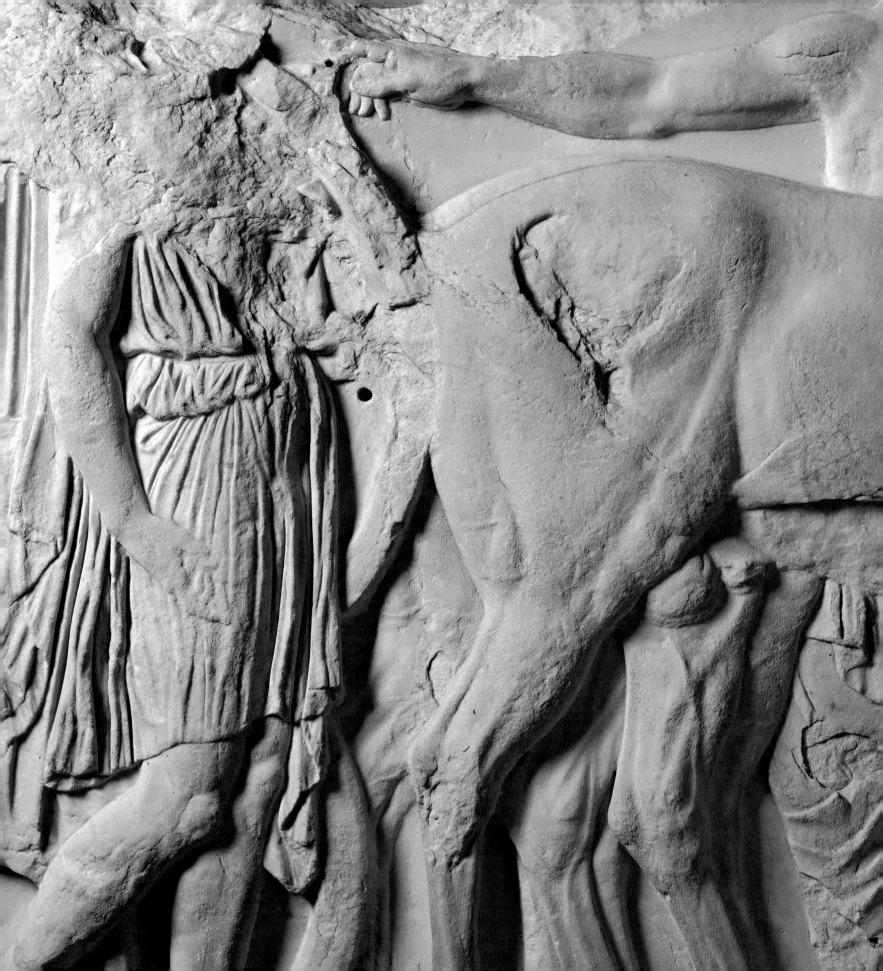

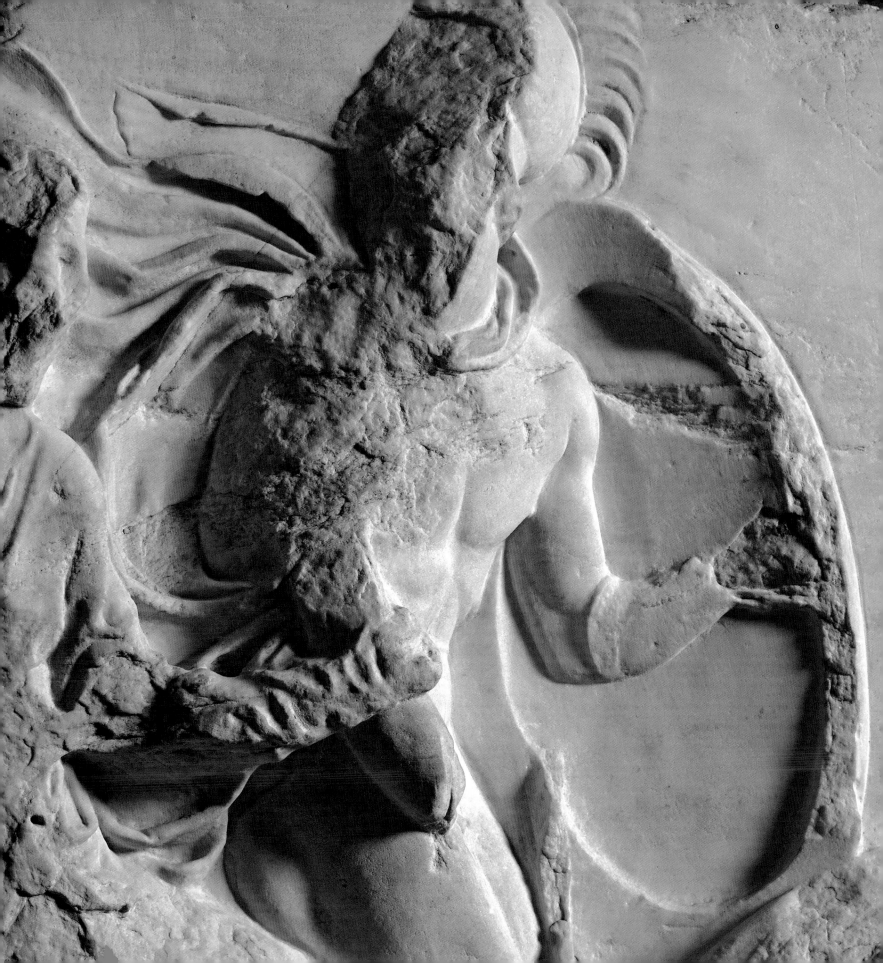

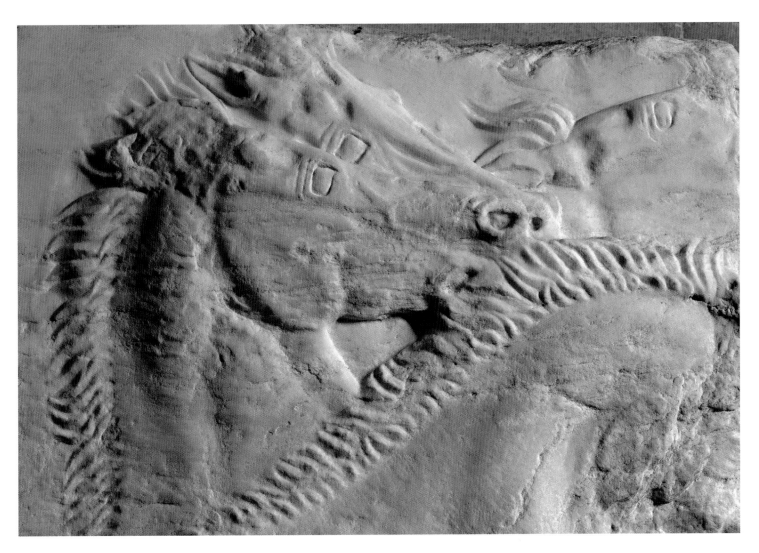

SOUTH FRIEZE XXXI *left*

Naked but for a cloak that flies behind him, a footsoldier rides a chariot at full pelt. His helmet sports a horse-hair crest that turns in the wind to echo the flying cloak. His left arm supports the round shield carried by footsoldiers or *hoplites*. Less well preserved is the figure of the charioteer, whose outstretched arm holds the reins.

SOUTH FRIEZE XXXI *above*

The flickering manes of the horses deliberately echo the flying helmet-crest and cloak of the footsoldier: the heads of four horses are miraculously carved into shallow relief. Although their heads are convincingly modelled, the eyes of the horses are curiously sketched in. Perhaps the carver was relying on added paint to finish them.

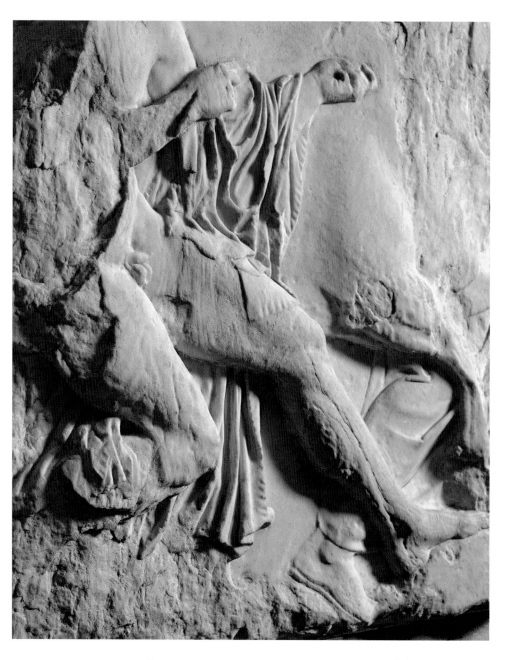

SOUTH FRIEZE XLIII *above*

Ahead of the chariots came figures
proceeding on foot. In the cattle-drove
of the south frieze a drama unfolds as a
cow bolts and has to be restrained by a
handler, who jams his left foot against a
rock and strains on the halter.

SOUTH FRIEZE XLIV *right*

The commotion behind upsets one
of the cows in front, which raises its
head, as if to bellow in protest.

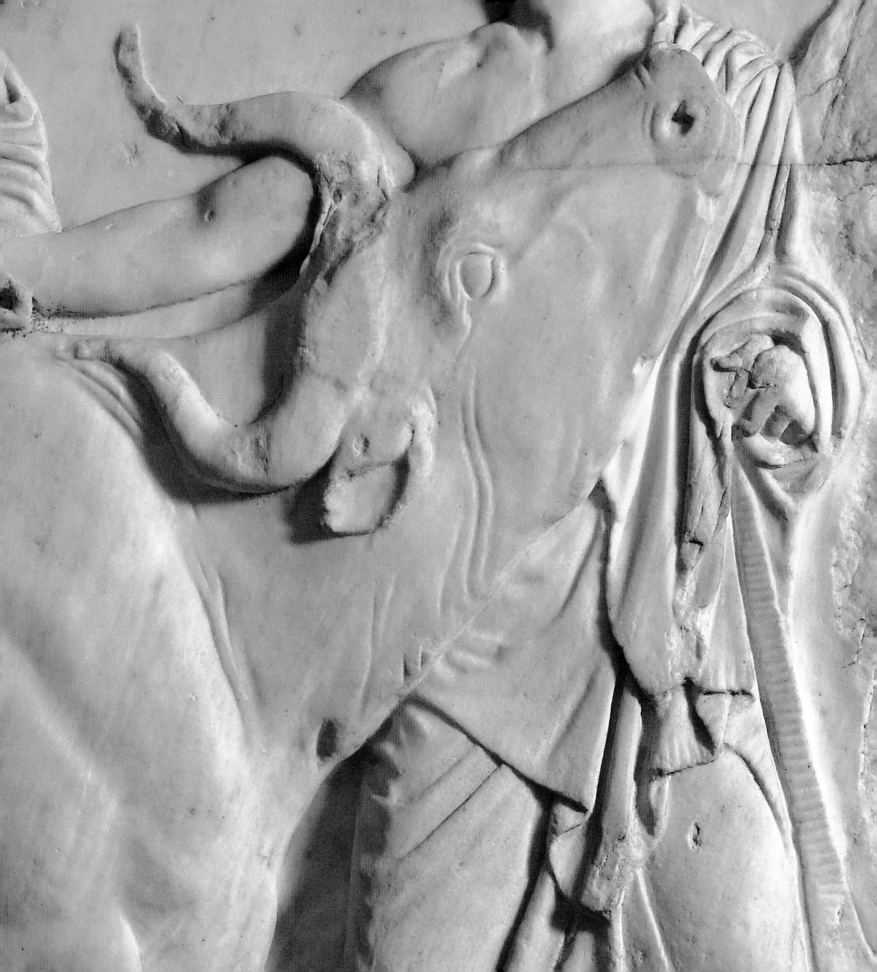

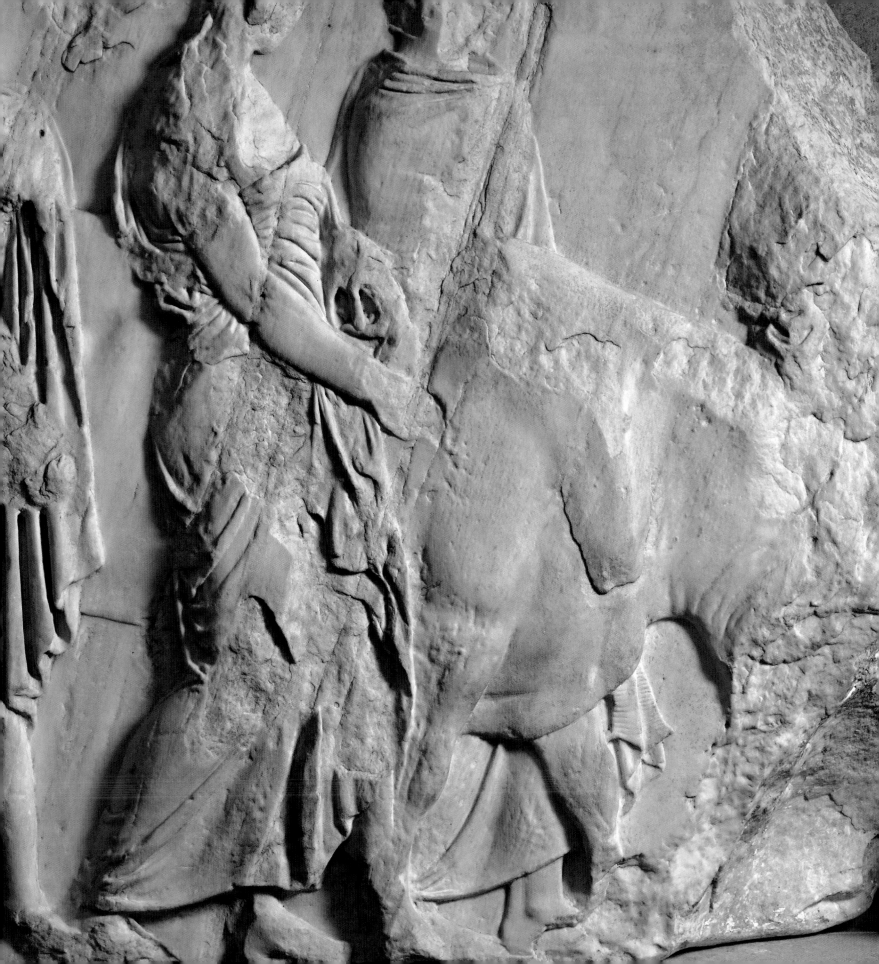

SOUTH FRIEZE XLV *left*

Calm is restored with a beast which
sniffs the ground but does not resist its
handlers. There is a pleasing rhythm in
the weaving together of man and beast,
contrasting complex drapery with plain
animal hide.

SOUTH FRIEZE XLV *above*

The selvedge of a handler's cloak is
clearly indicated, together with the
tassel by which the cloth was attached
to the loom.

SOUTH FRIEZE XLVI *above*

As in the cavalcade, so in the procession of sacrificial victims, hands with the fingers expressively arranged contribute to the pictorial realism of the frieze.

SOUTH FRIEZE XLVI *right*

This head of a cow, with its crumpled, seemingly disconsolate mouth, is a sympathetic portrait of an animal which, although not human, was nonetheless a member of the household and, as such, deserving of respect.

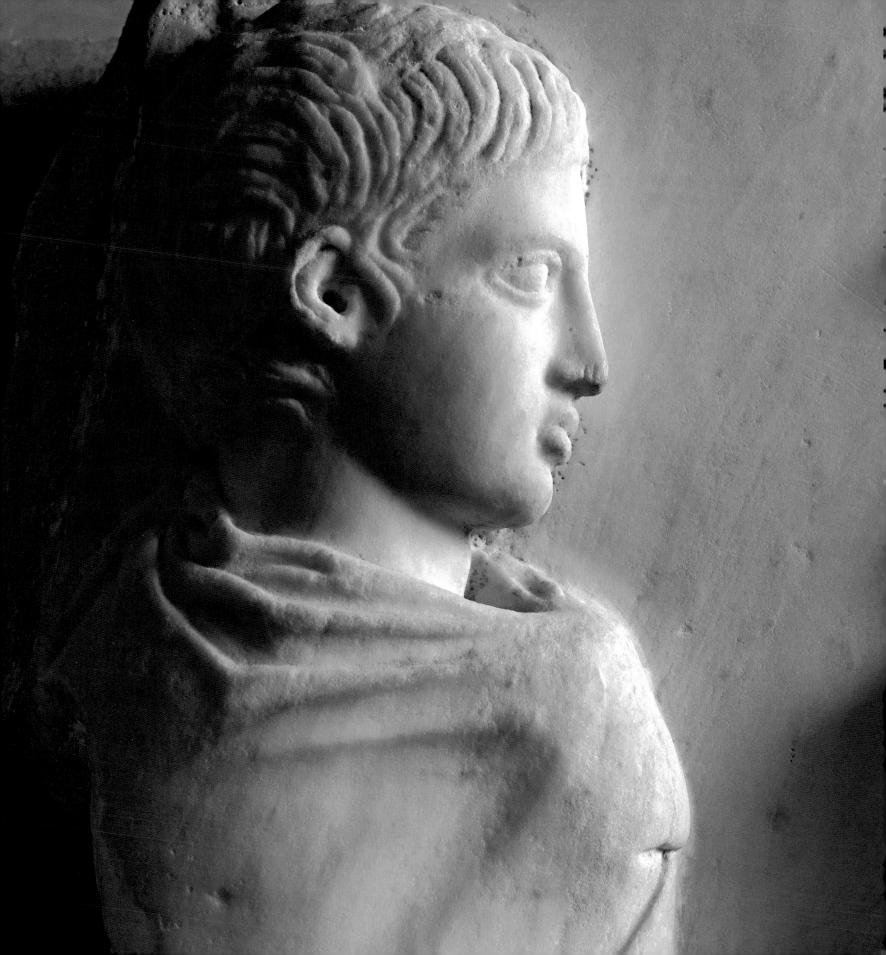

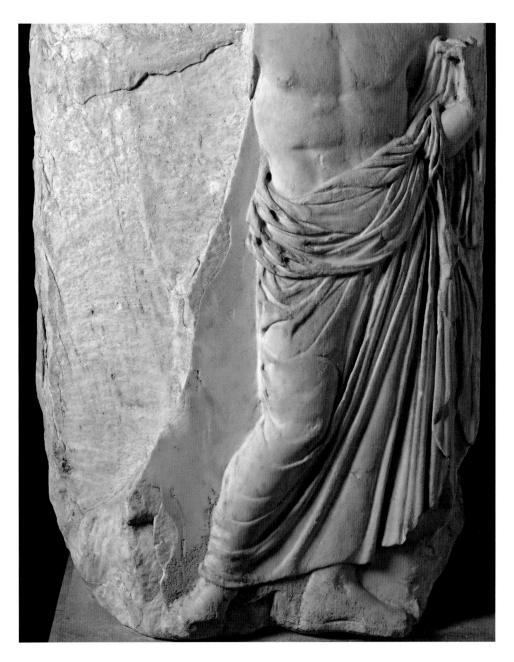

SOUTH FRIEZE XLVII *left*

The pouting lips and distant gaze
of this young cow-handler contribute
to the sober, almost sulky expression
of adolescent youth represented in
the frieze.

EAST FRIEZE I *above*

At the turn of the south onto the east
frieze stands a marshal whose purpose
is to guide the procession and our eye
around the corner. Now lost, his right
arm extended with the index finger of the
hand cocked to beckon the celebrants.

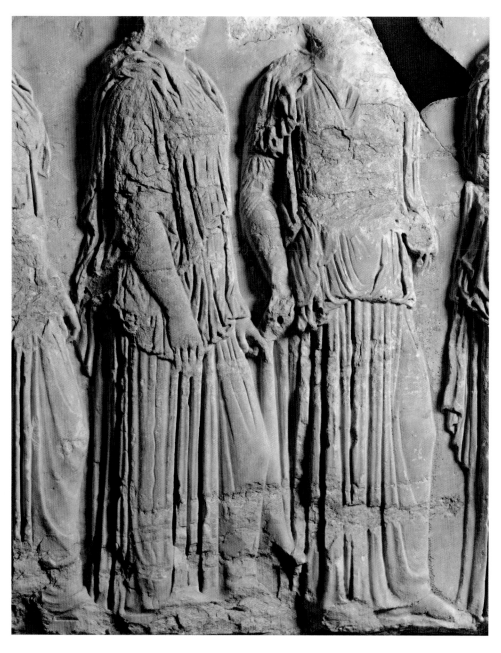

EAST FRIEZE III *above*

While the west, north and south friezes
are exclusively populated by male figures,
the east frieze features a procession of
girls, walking in slow time and heavily
draped. Still as columns, the vertical folds
of their tunics fall in parallel lines.

EAST FRIEZE III *right*

Wrapped in a heavy cloak or *himation*,
a male figure at the head of the procession
leans forward to converse with a marshal
whose gesturing hand appears on the left.

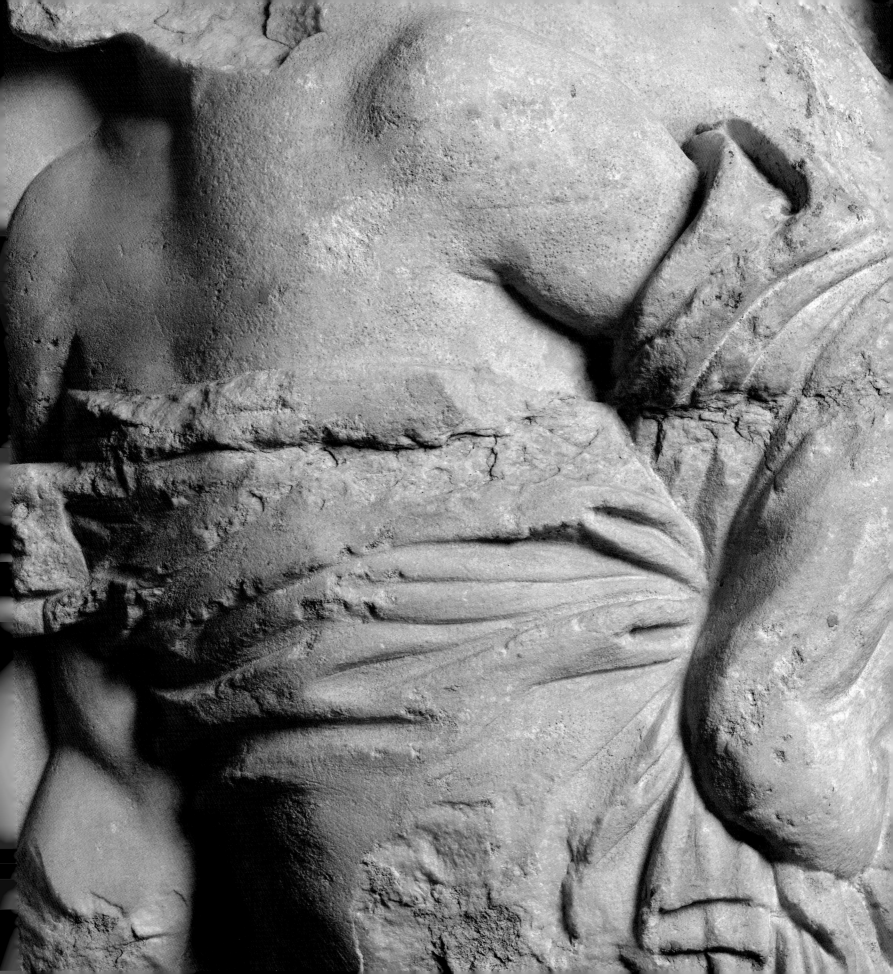

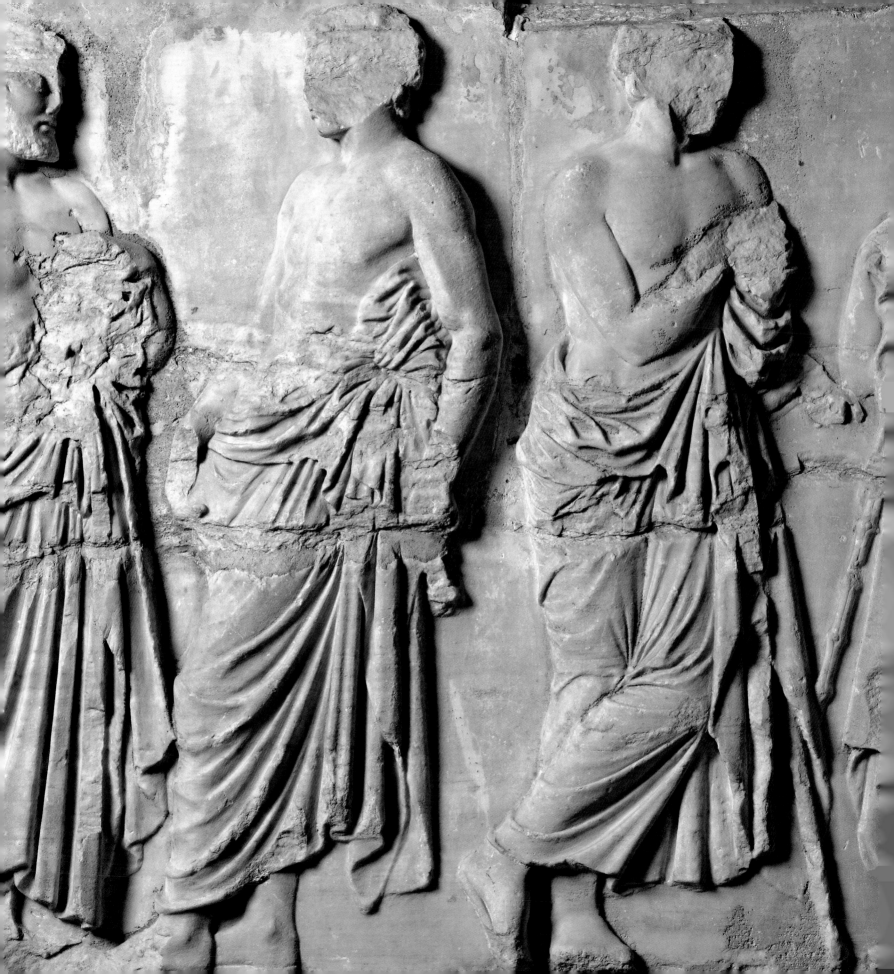

EAST FRIEZE IV *left*

Between the walking or standing
processional figures and the sitting
gods is a group of male figures,
who lean on sticks. They are perhaps
distinguished officials or, possibly more
than mere mortals, they may be heroes.

EAST FRIEZE III *above*

A marshal at the head of the
procession of girls gesticulates
as he converses with a companion.

EAST FRIEZE IV *right and above*
Although seated and shown larger
than the human figures in the frieze,
the gods behave like humans and
each has his own personality, which
is connected with his identity and
role in the pantheon. In the picture
on the right, Hermes sits looking
out from his seat on the edge of the
group of gods, watching and waiting
for the approaching procession.

A sunhat rests on his knee. He is the
messenger god, as well as the leader of
souls into the underworld. Leaning
on his shoulder is Dionysos, god of
wine and sensory excess. The picture
above shows Ares, god of war, with
both feet off the ground. He cradles
his right knee in clasped hands, in a
manner observed straight from life.
His left foot rests on his spear, visible
beneath the ankle.

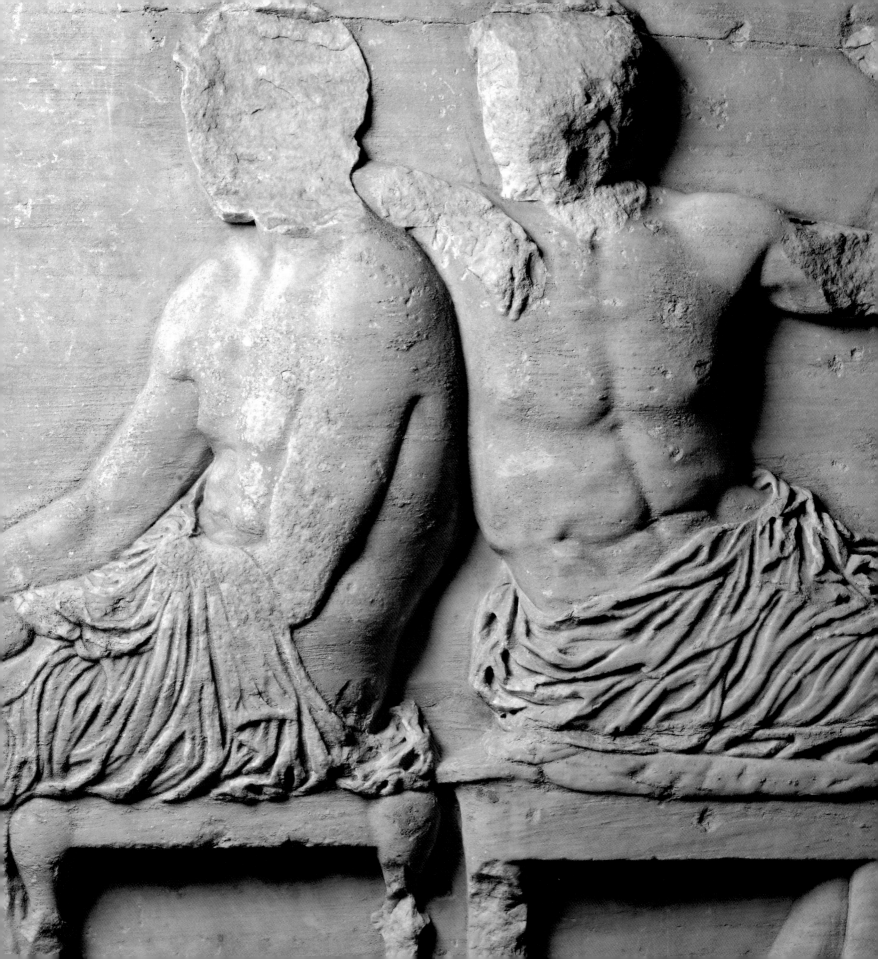

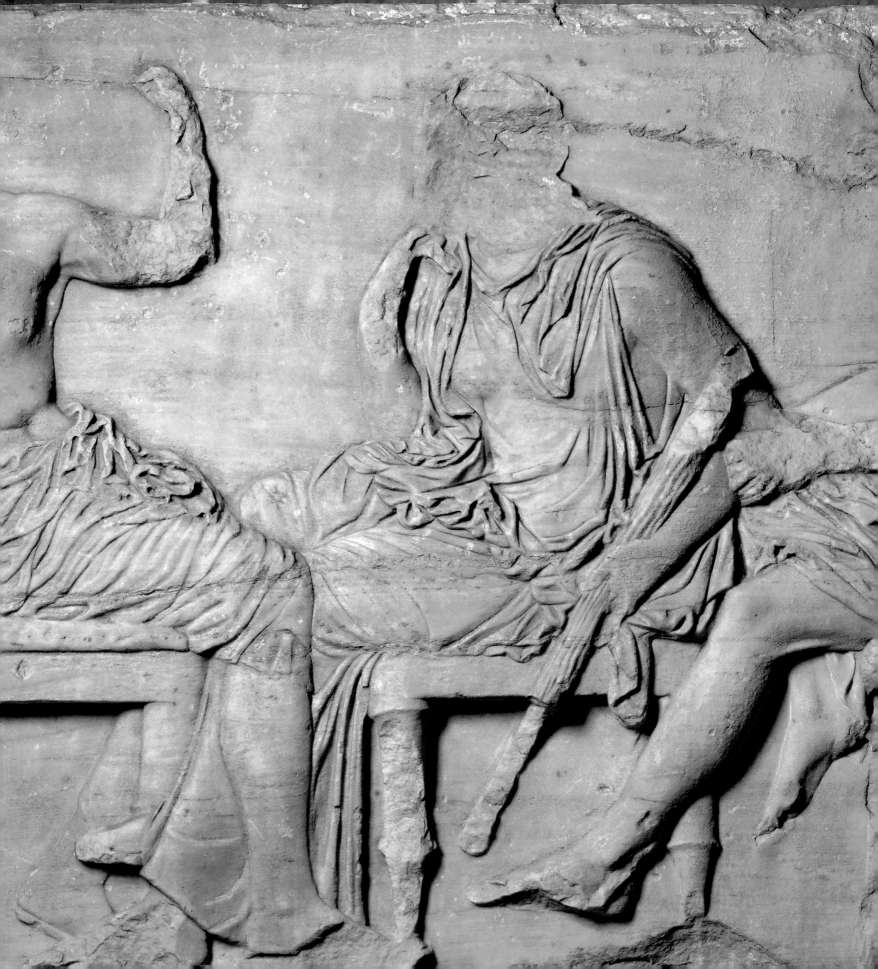

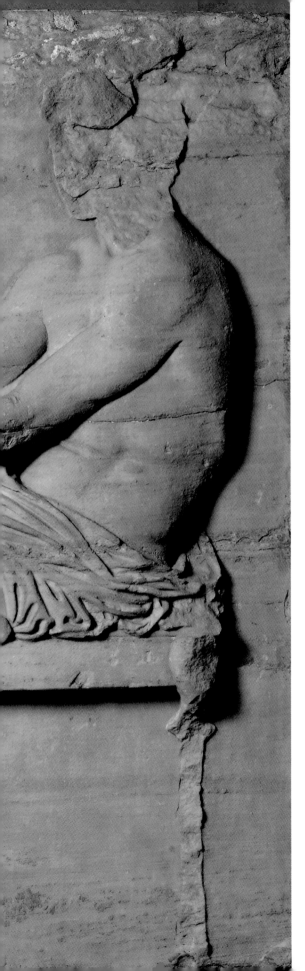

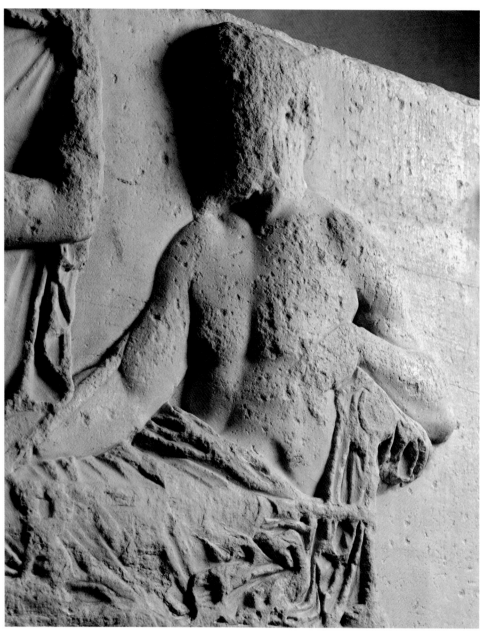

EAST FRIEZE IV *left*

Matronly Demeter, goddess of the earth's fertility, supports the chin of her now missing head. This gesture of mourning refers to the loss of her daughter Persephone, carried off by Hades to reign with him in the underworld.

EAST FRIEZE V *above*

Zeus is father of the gods and is distinguished as such by his reclining over the back of a throne, while the other gods are seated on stools. The armrest of his throne is supported on the left by a miniature Sphinx.

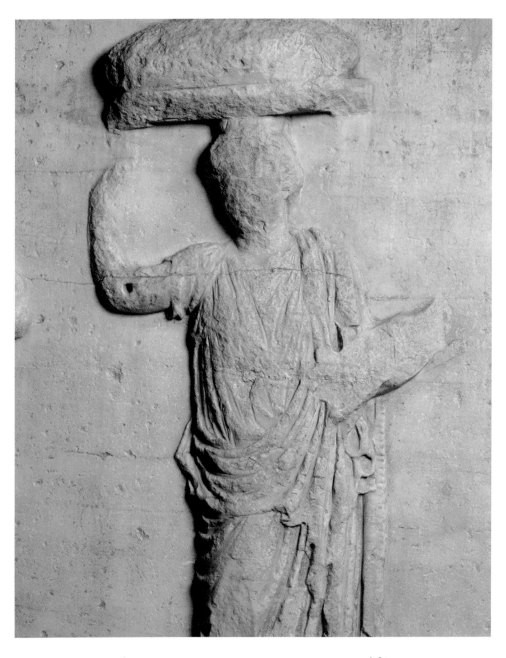

EAST FRIEZE V *above*

Between two groups of seated gods is a mysterious gathering of figures shown engaged in some religious ritual. A girl supports a cushioned stool on her head while in her left hand she carries a footstool.

EAST FRIEZE V *right*

Hera is the goddess of marriage and here performs the wedding ritual of unveiling herself to her husband. Zeus, Hera's consort and father of the gods, is enthroned to the right.

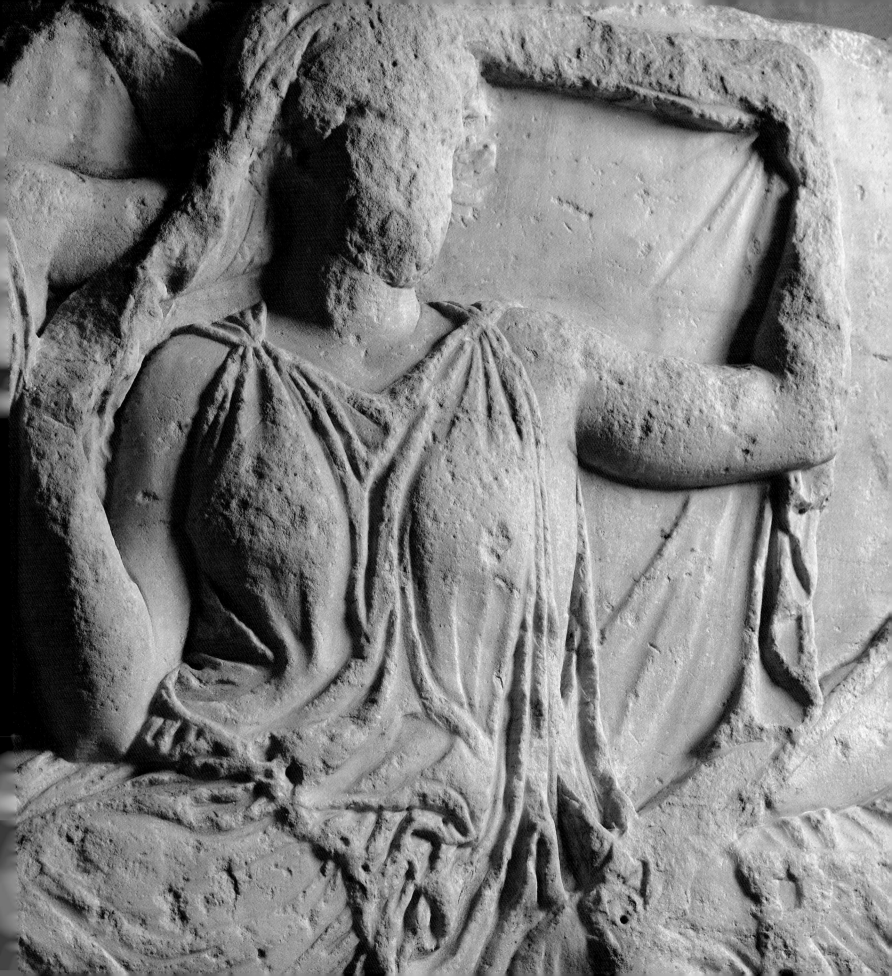

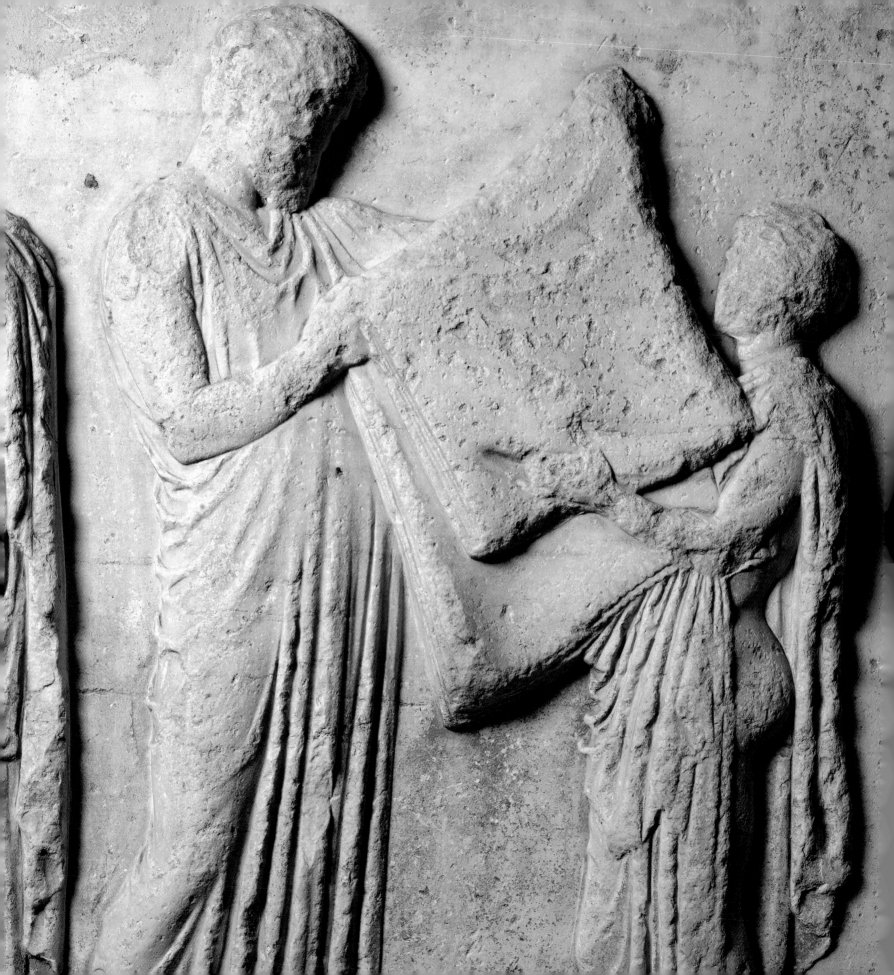

EAST FRIEZE V *left*

A bearded man wearing the long robe of a priest performing sacrifice is pictured with a child folding or unfolding between them a blanket of cloth. This is the sacred *peplos*, woven afresh every year, and dedicated to the goddess Athena on the occasion of her birthday, celebrated at the Panathenaic festival.

EAST FRIEZE V *above left*

The sex of the child is disputed. Some would see here a girl, perhaps one of those charged with the ritual weaving of the *peplos*. Others identify a prepubescent boy of a kind with both parents living who sometimes features in Greek religion.

EAST FRIEZE V *above right*

The sacred *peplos* was an object full of meaning for an Athenian audience. It was picture-woven with images depicting the legendary battle between gods and giants, when once and for all the Olympian deities established their rational order in the universe. The same subject was shown in the metopes above the east colonnade of the Parthenon.

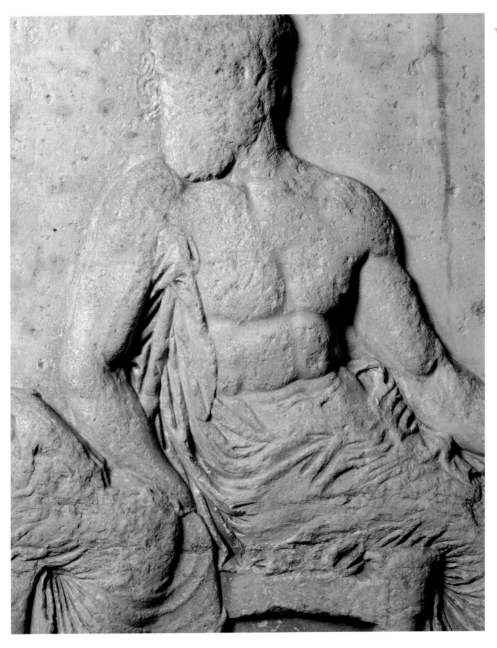

EAST FRIEZE V *above*

Hephaistos, the god of smiths, is paired with Athena, his half-sister and fellow god of craftsmen. Hurled out of Olympos by Zeus, and later allowed to return, he supports his right side – injured in his fall from paradise – with a crutch.

EAST FRIEZE V *right*

Athena sits with the snake-fringed aegis, a protective poncho-like garment, resting in her lap. Her right hand held a spear, which was affixed by drill holes along her right side and arm.

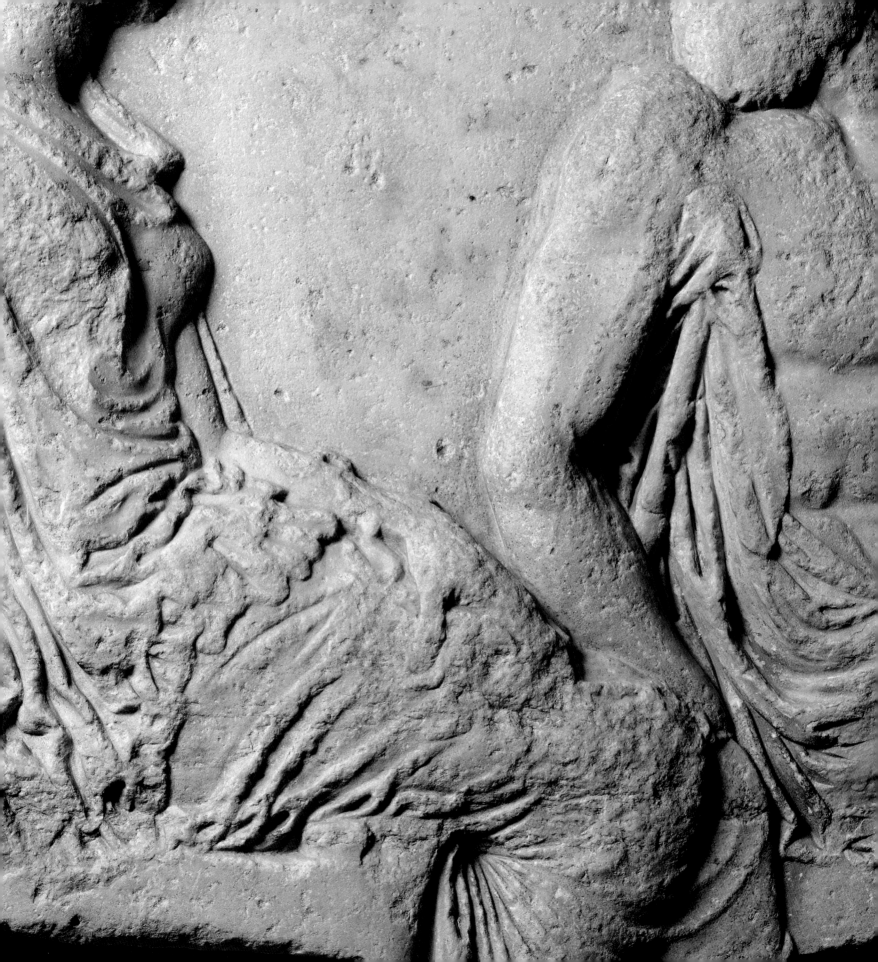

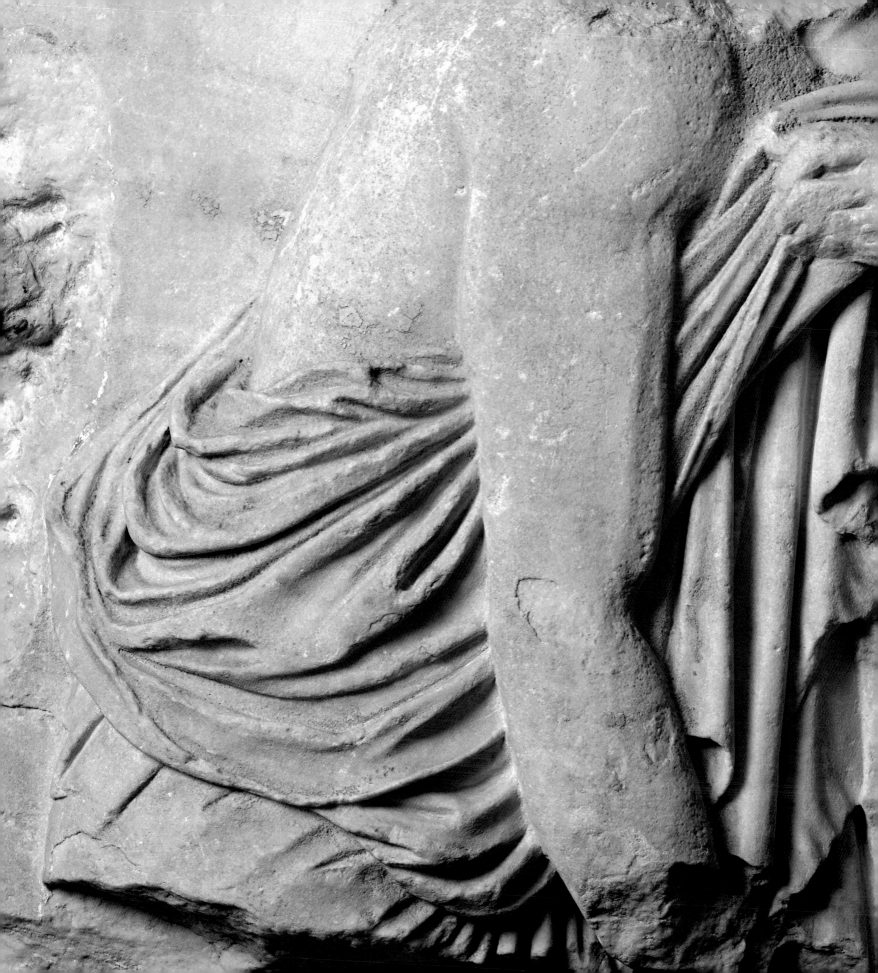

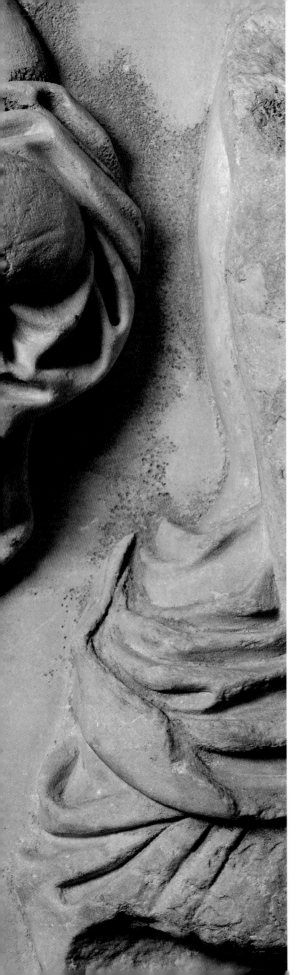

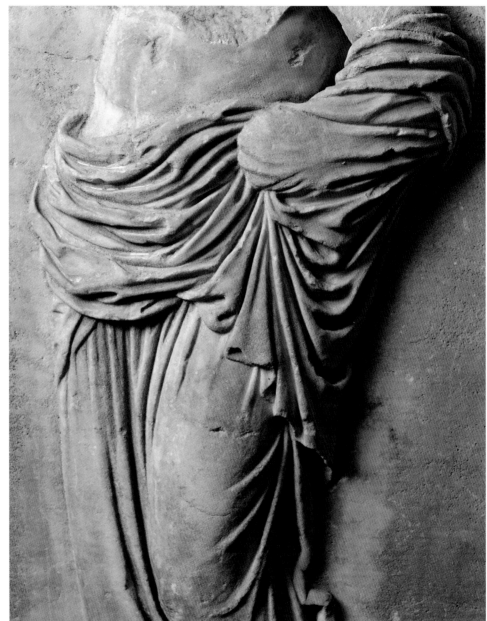

EAST FRIEZE VI *left*

To balance the group of officials or Athenian heroes shown on the south side of the gods, a further group was carved on the north side. These figures lean, supported by sticks.

EAST FRIEZE VI *above*

The distinctive style of carving drapery in the frieze often creates, especially in the east frieze, a mesmerizing series of deeply cut folds in which the play of light and shade shimmers with an almost magical intensity.

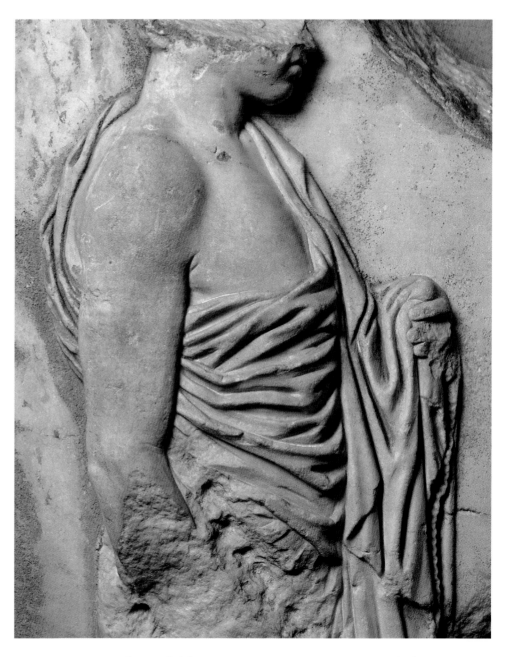

EAST FRIEZE VI *above and right*
A young man serving as a marshal
stands facing the oncoming procession.
He wears a heavy cloak, the *himation*,
arranged in the deep and complex folds
that are a distinctive feature of figures in
the east frieze.

EAST FRIEZE VIII *overleaf*
Young women walk in single file, each
carrying a ritual vessel. They are heavily
draped and this, together with the slow
tempo of their procession, is in contrast
to the energetic scenes involving men
that occur in the cavalcades.

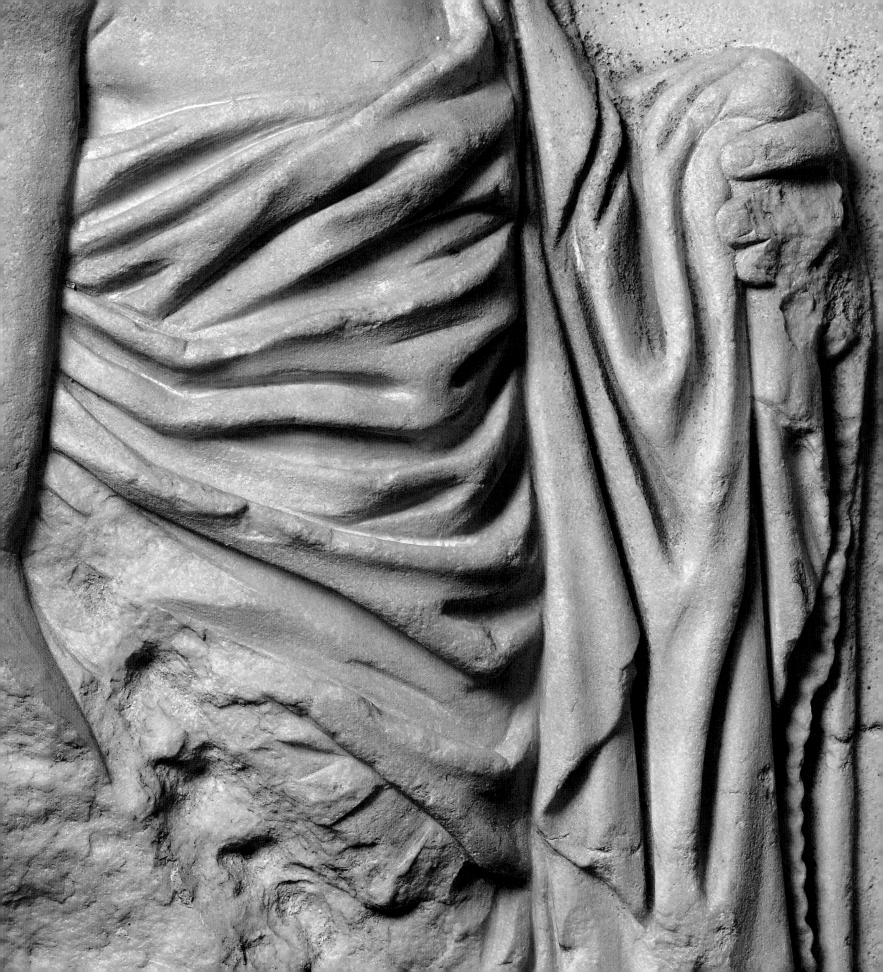

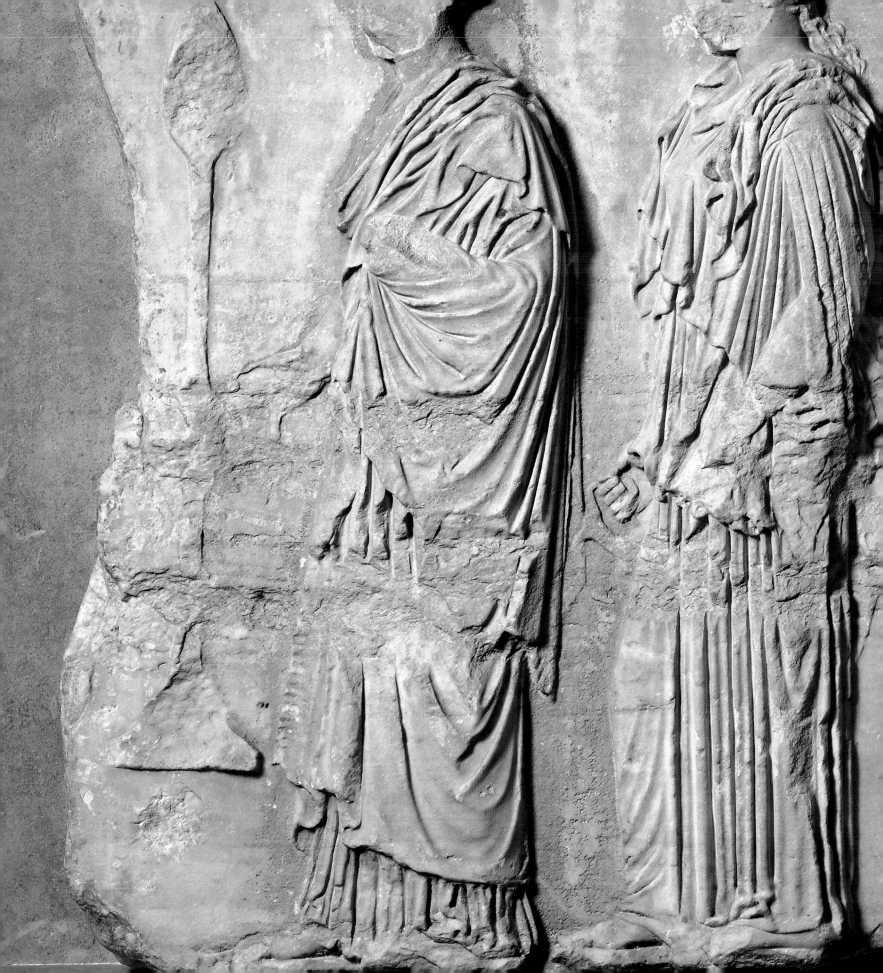

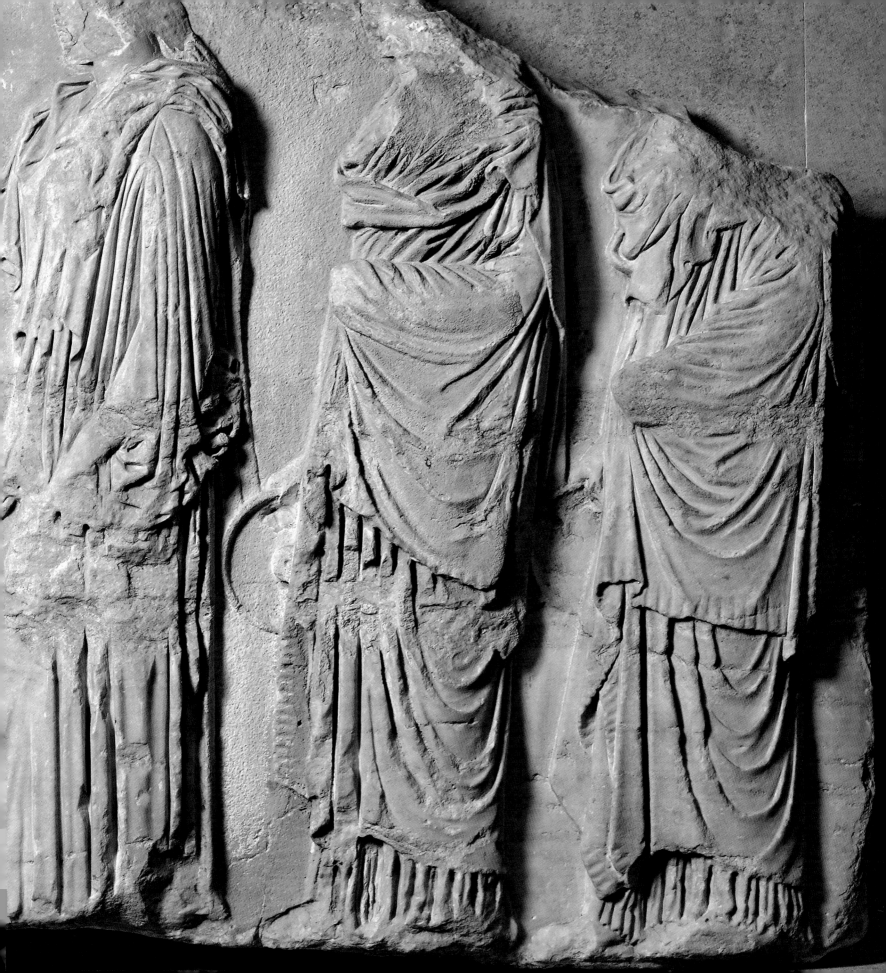

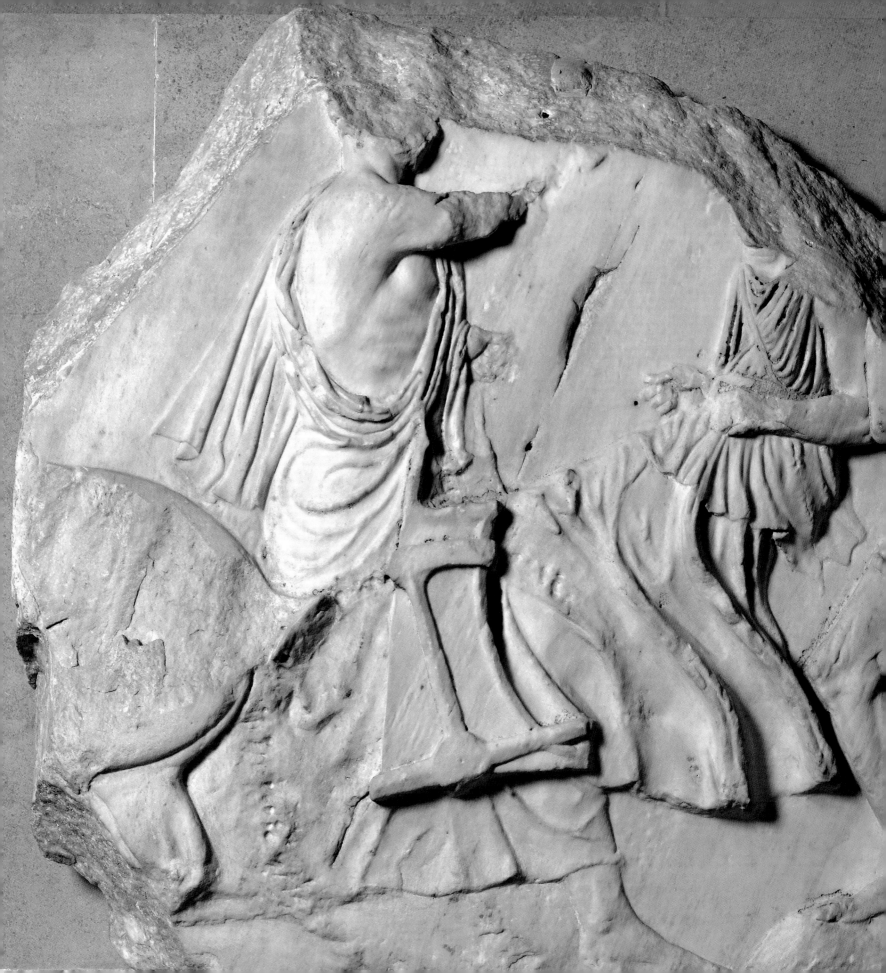

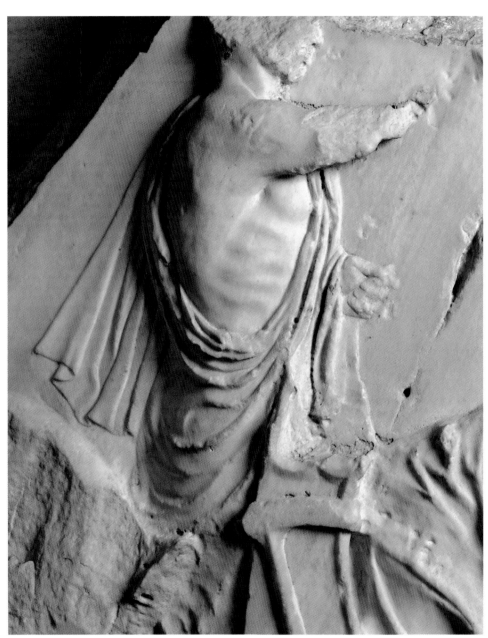

NORTH FRIEZE XII *left and above*

As in the south frieze, so in the north, ahead of the chariots went a pedestrian procession. Here the lead chariot in the race applies the brakes, anticipating the figures that were shown walking ahead. The charioteer in long flowing robe leans right back in the car, his hands connected to the horses by reins attached in metal by a drill hole. A footsoldier has leapt from the vehicle and looks back to avoid being run over. On the far side a marshal runs back, holding up his right hand in a gesture of command.

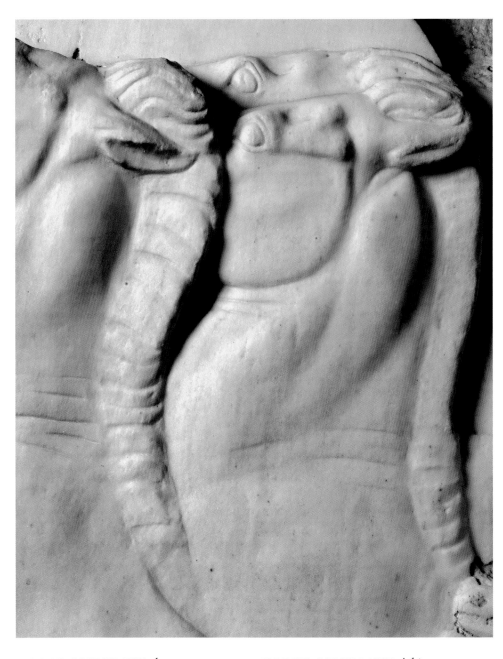

NORTH FRIEZE XXIV *above*
The heads of the chariot horses
are carved one behind another
in a remarkable simulation of
receding depth.

NORTH FRIEZE XXIV *right*
In shallow relief, not more than 5–7 cm
deep, each element of the chariot race is
carefully articulated so as to create the
illusion of receding depth. Nearest the
viewer is the chariot wheel and furthest
away is the figure of a marshal.

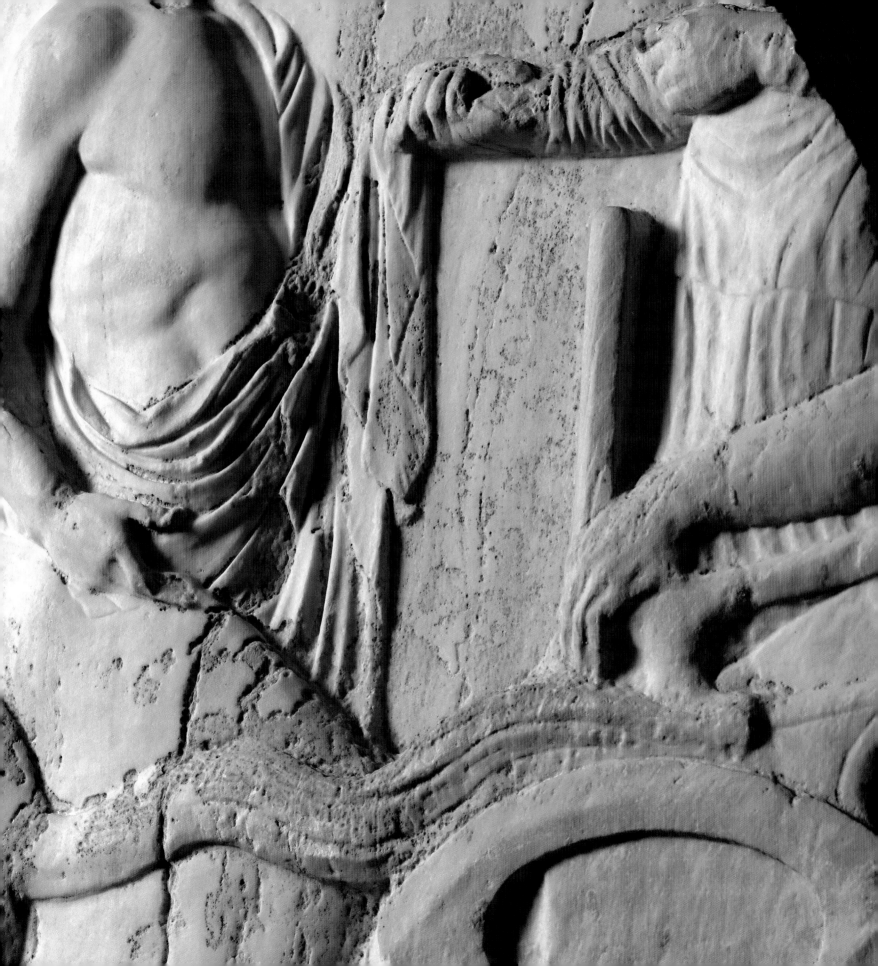

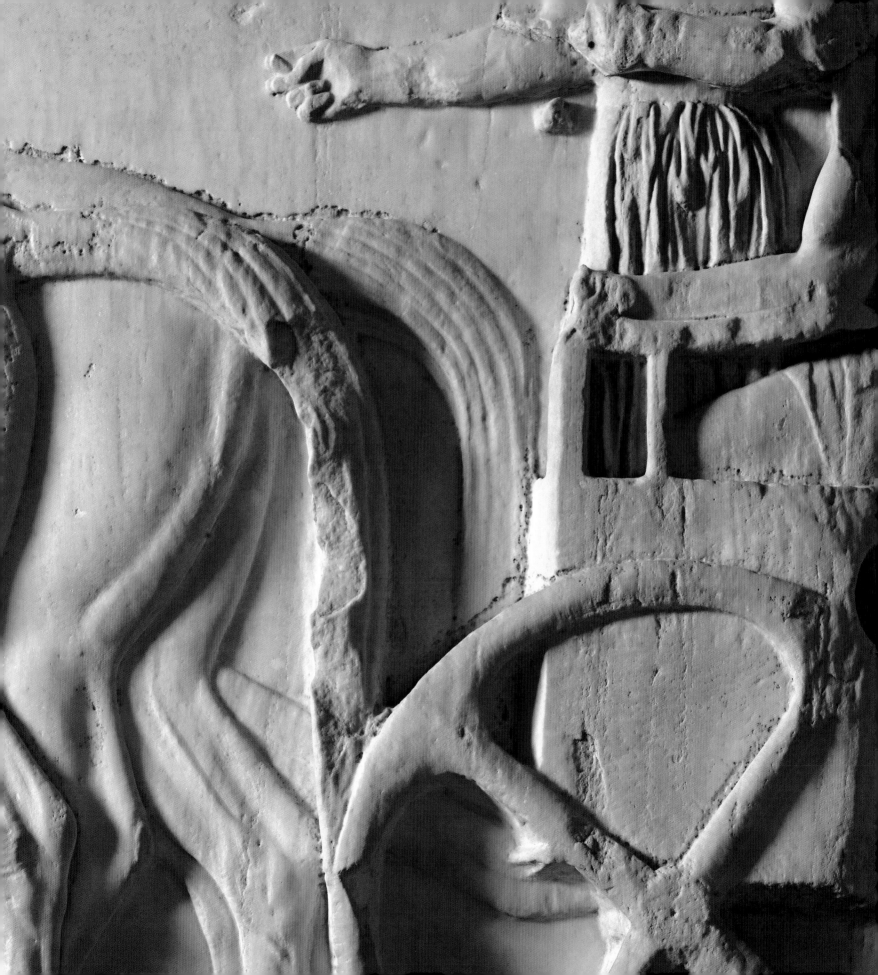

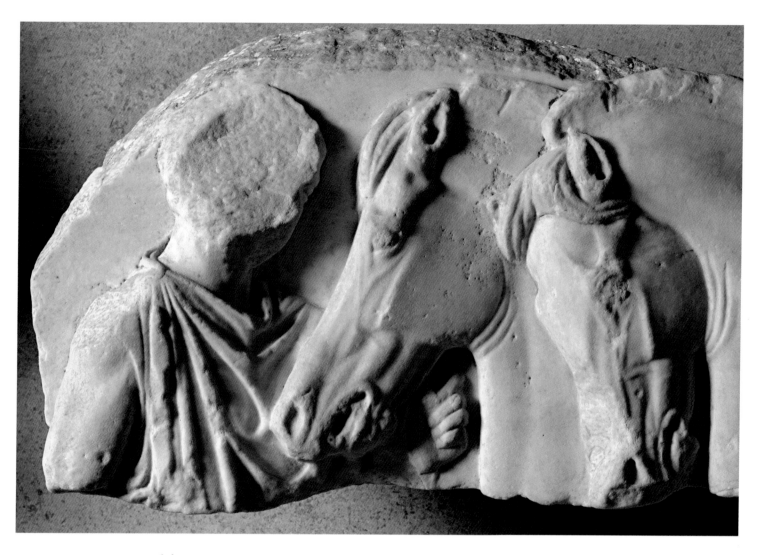

NORTH FRIEZE XXVIII *left*

The chariot race begins with a stationary vehicle about to pull away. The driver stands ready holding the reins, while his companion the footsoldier grips the handrail of the car to haul himself in. The horses lift and arch their tails in excited anticipation of the signal for departure.

NORTH FRIEZE XXVII *above*

A groom holds the harness of one of the team of horses, restraining its excitement and eagerness to be off.

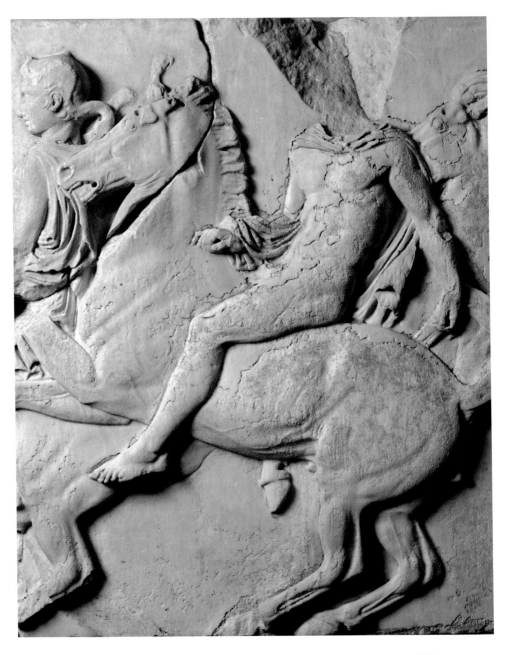

NORTH FRIEZE XLI *above*

The horsemen of the cavalcade are
divided into ranks, each rank fronted
by a distinctive rider (see the diagram
on pp. 42–3). This near-naked horseman
turning his torso round to face the viewer
marks the beginning of his rank.

NORTH FRIEZE XXXVII *right*

By contrast with the cavalcade of the
south frieze, there is more variety in
that of the north, both in the way that
the ranks of horsemen are composed
and in their dress.

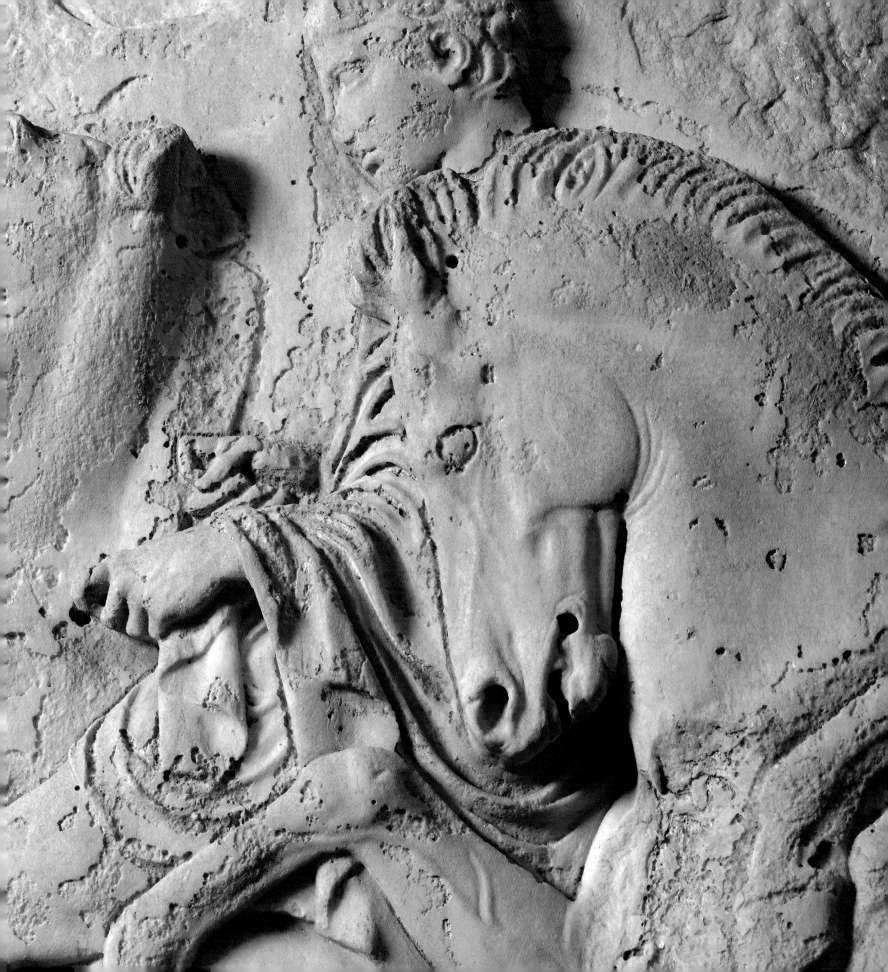

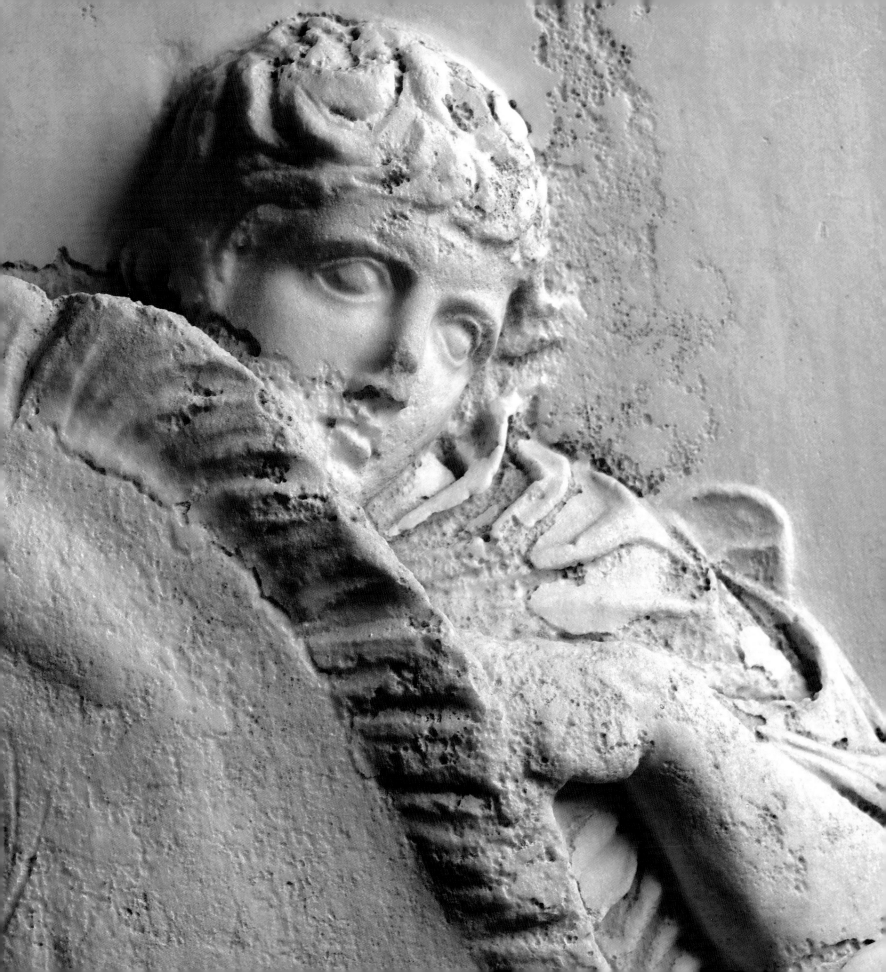

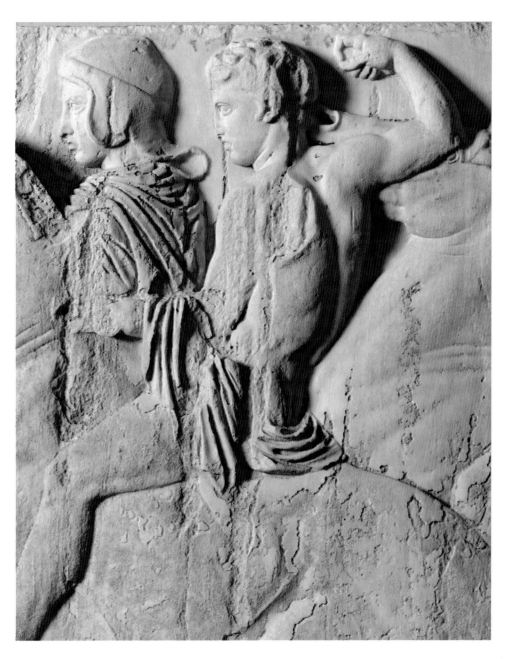

NORTH FRIEZE XLI *left*
A horseman looks back to check on
progress behind. His gaze, however, seems
to be directed beyond the action of the
moment and to focus instead upon some
non-specific and eternal time and place.

NORTH FRIEZE XLIII *above*
A distinctively near-naked figure
fronts his rank. He raises his whip
hand and as he does so exposes his
bare back.

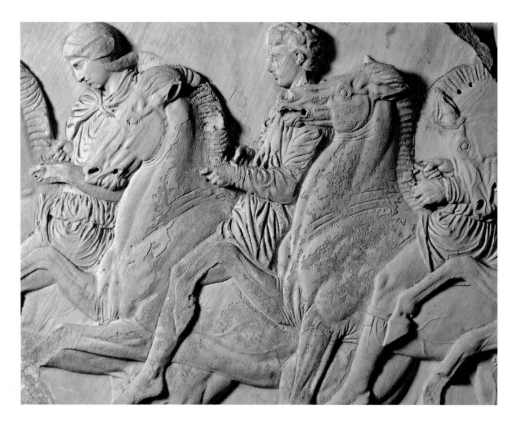

NORTH FRIEZE XLIV *above*

Sometimes the gaze of the horsemen
is straight ahead, while at others it is
down or back. This controlled variety
of positioning the heads of the horsemen
creates a rhythm in counterpoint with
the same variety in the rise and fall of
the heads of the horses.

NORTH FRIEZE XLIV *right*

A horseman drops his gaze to look
down in seeming quiet reflection.
He wears a hat of animal skin with
ear flaps and a neck piece.

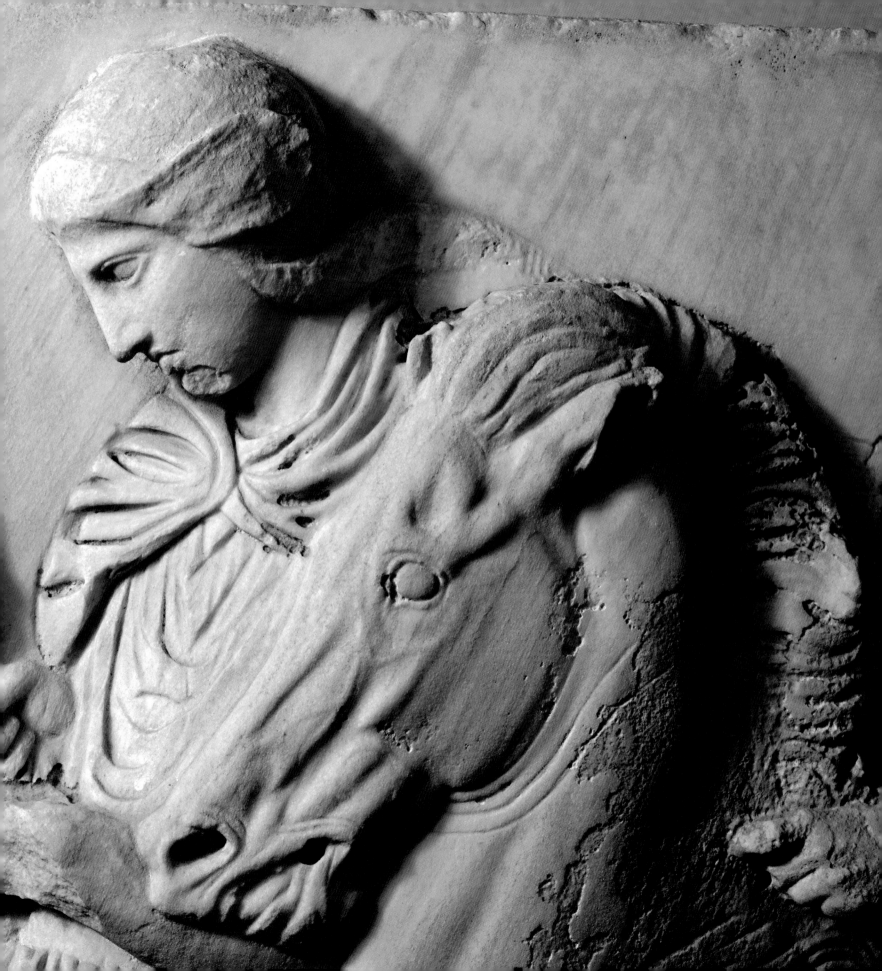

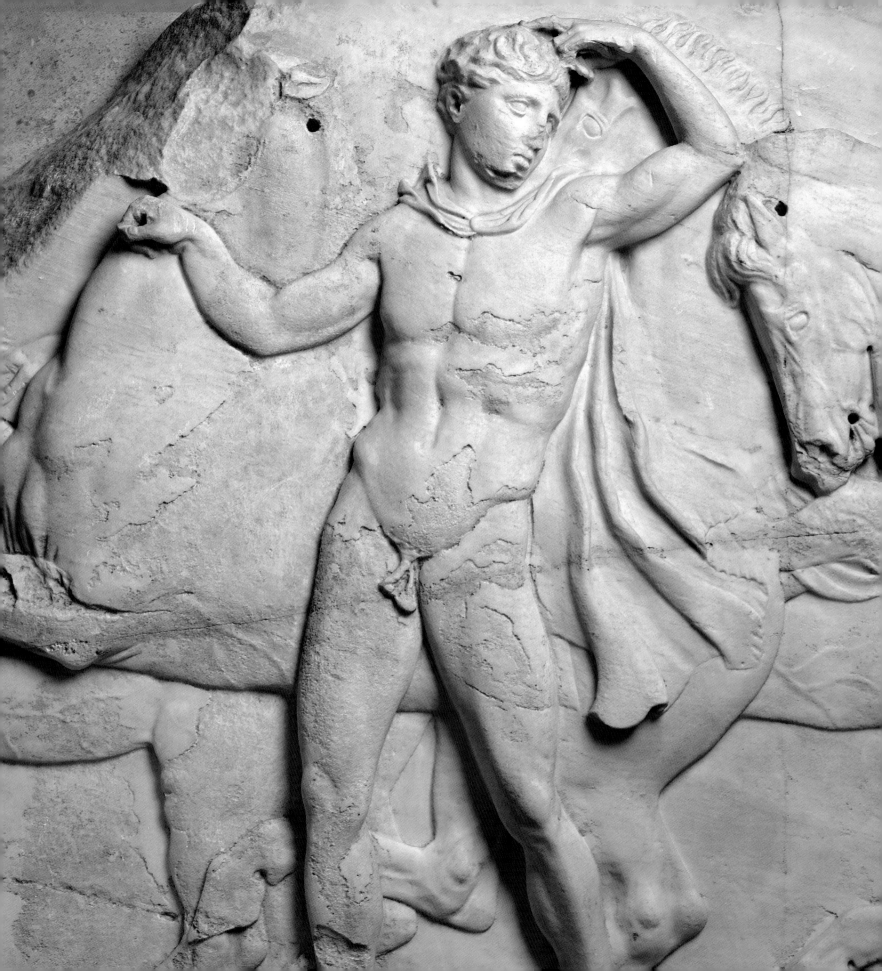

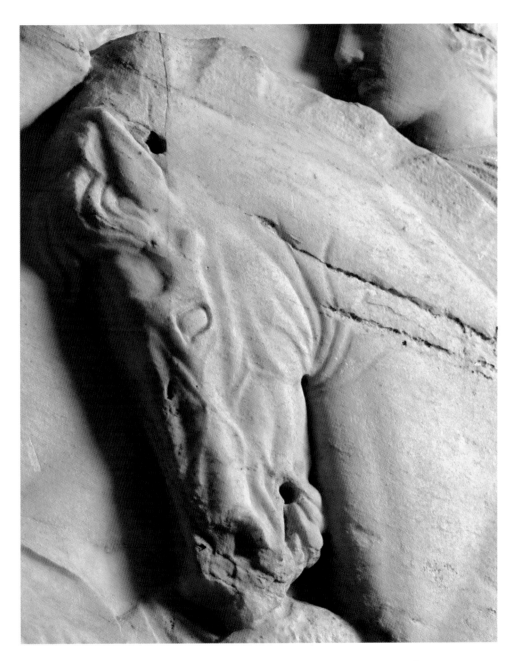

NORTH FRIEZE XLVII *left*

Full of nervous energy, the body of this youth seems tense with excitement as he looks back. His right hand holds the bridle of the rearing animal, while his left hand touches his head with the index finger extended as a signal.

NORTH FRIEZE XLVII *above*

The Parthenon frieze is sympathetic not only in its representation of idealized human beings but also in its carefully observed treatment of animals. Muscles, veins and forelock are all skilfully rendered in this portrait of a noble beast.

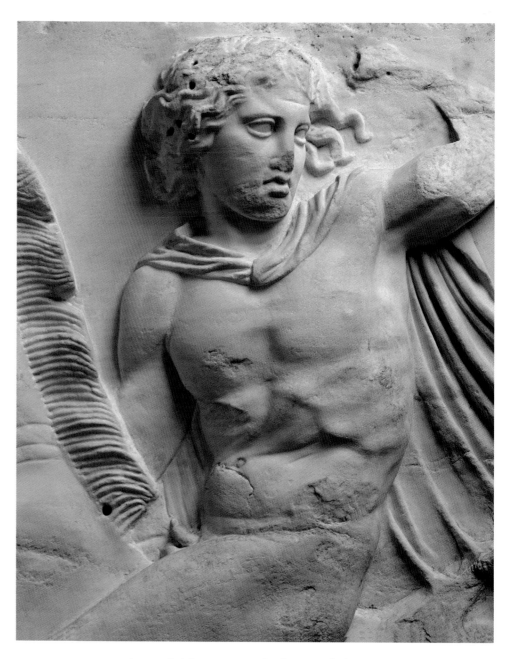

WEST FRIEZE II *above and right*

A beautiful youth with flowing locks and cloak turns round to check on his fellow rider behind. As he does so, he raises his left hand, now lost, to touch his head with the index finger in a gesture identical with that of the standing rider of the scene on p. 138. Drill holes in the hair were for attaching a metal crown, now lost.

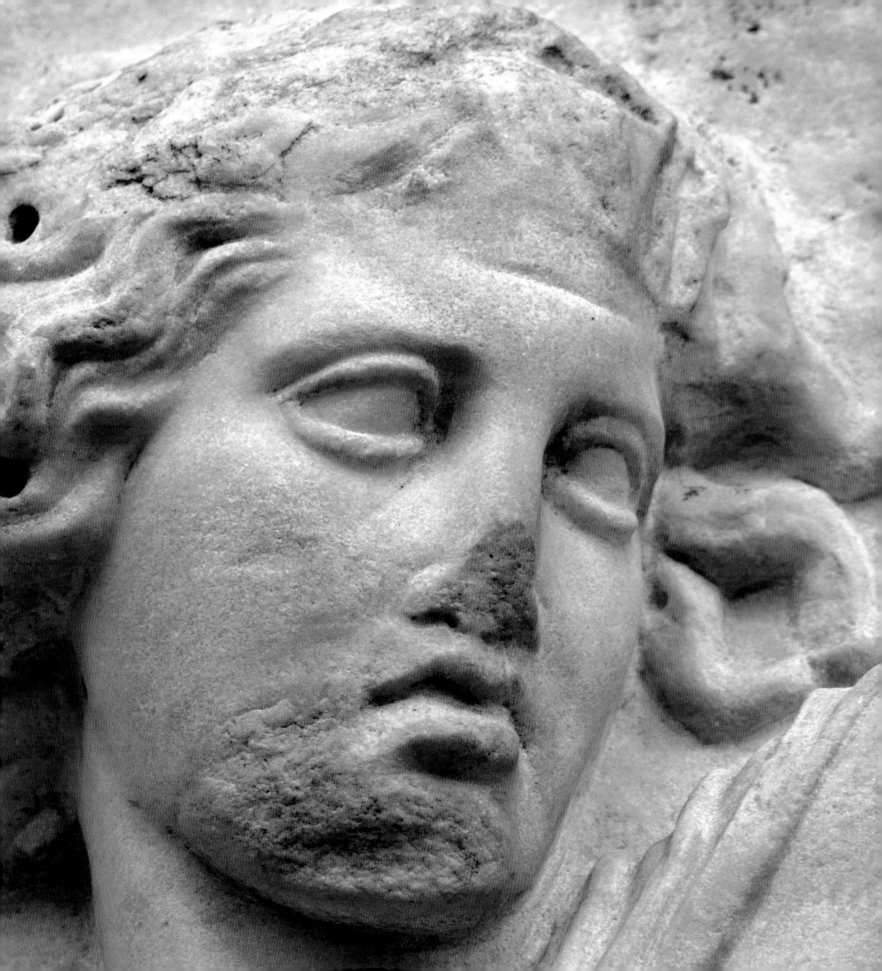

FURTHER READING

For the nineteenth-century reception of the Parthenon sculptures, see:

A.H. Smith, 'Lord Elgin and his collection', *Journal of Hellenic Studies* 36 (1916), pp. 163–372.

J. Rothenberg, *'Descensus ad Terram': the Acquisition and Reception of the Elgin Marbles*, New York and London 1977.

I. Jenkins, *Archaeologists and Aesthetes in the Sculpture Galleries of the British Museum 1800–1939*, London 1992.

For the Parthenon and its history, see:

Essays collected together in P. Tournikiotis (ed.), *The Parthenon and its Impact in Modern Times*, Athens 1994.

M. Beard, *The Parthenon*, London 2002.

J. Neils (ed.), *The Parthenon from Antiquity to the Present*, Cambridge 2005.

For the conservation history of the building and its sculptures, see:

Essays collected together in R. Economakis (ed.), *Acropolis Restoration: the CCAM Interventions*, London 1994.

I. Jenkins, *Cleaning and Controversy: the Parthenon Sculptures 1811–1839*, British Museum Occasional Paper 146, London 2001.

For N. Balanos, see Ch. Bouras, 'Restoration Work on the Parthenon and Changing Attitudes towards the Conservation of Monuments', in Tournikiotis (ed.), cited above, pp. 310–39.

For general accounts of the Parthenon sculptures, see:

J. Boardman and D. Finn, *The Parthenon and its Sculptures*, London 1985.

A. Delivorrias, 'The Sculptures of the Parthenon', in Tournikiotis (ed.), cited above, pp. 100–135.

I. Jenkins, *Greek Architecture and its Sculpture in the British Museum*, London 2006, ch. 4, pp.71–107.

Library of Congress Cataloging-in-Publication Data

Putnam, Michael, 1937–

Silent screens: the decline and transformation of the American movie theater /
Michael Putnam.

p. cm. — (Creating the North American landscape)

ISBN 0-8018-6329-5 (alk. paper)

1. Motion picture theaters—United States—History.

I. Title. II. Series.

PN1993.5.U6 P885 2000

791.43'0973—dc21

99-053226